chaft ... Vielle...

wunderbaren Freundsc...

KINDERFEST

FEST
CHOR...STRAßE

...EN FREITAG
AM KIOSK!

SA. 15.6
12 UHR

KIEZFEST
CHORINERSTRAßE

KIEZFEST
CHORINERSTRAßE

SA. 15.6
12 UHR

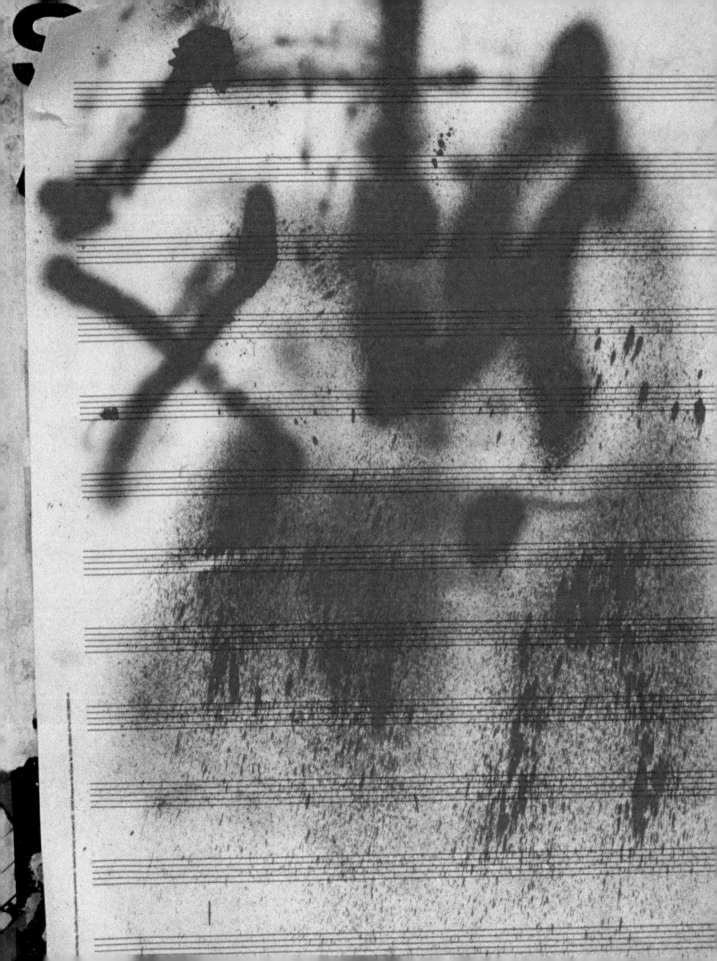

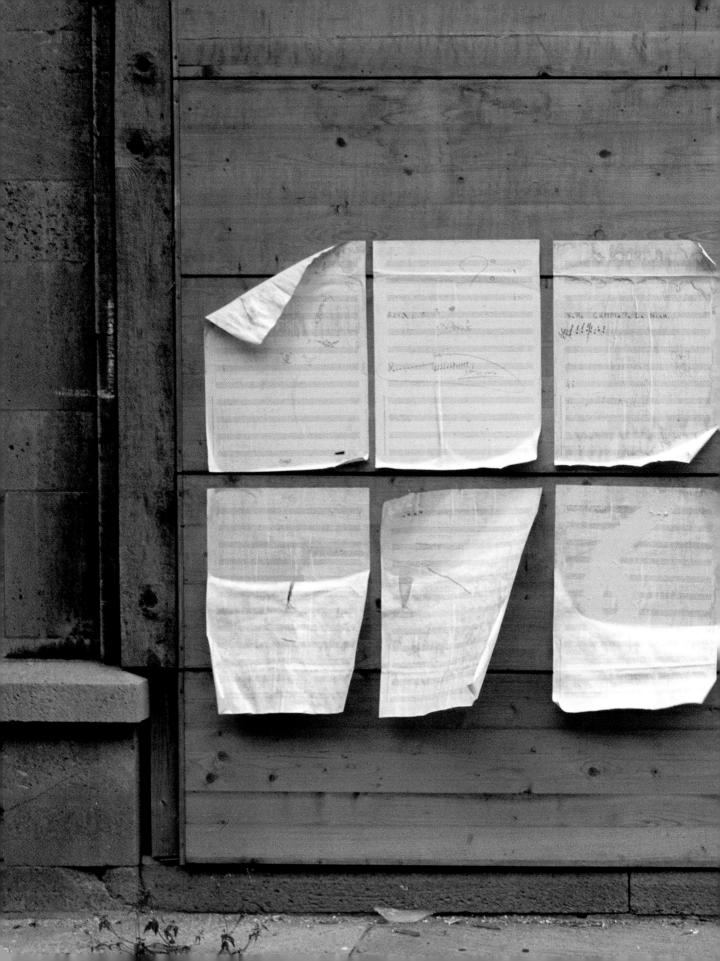

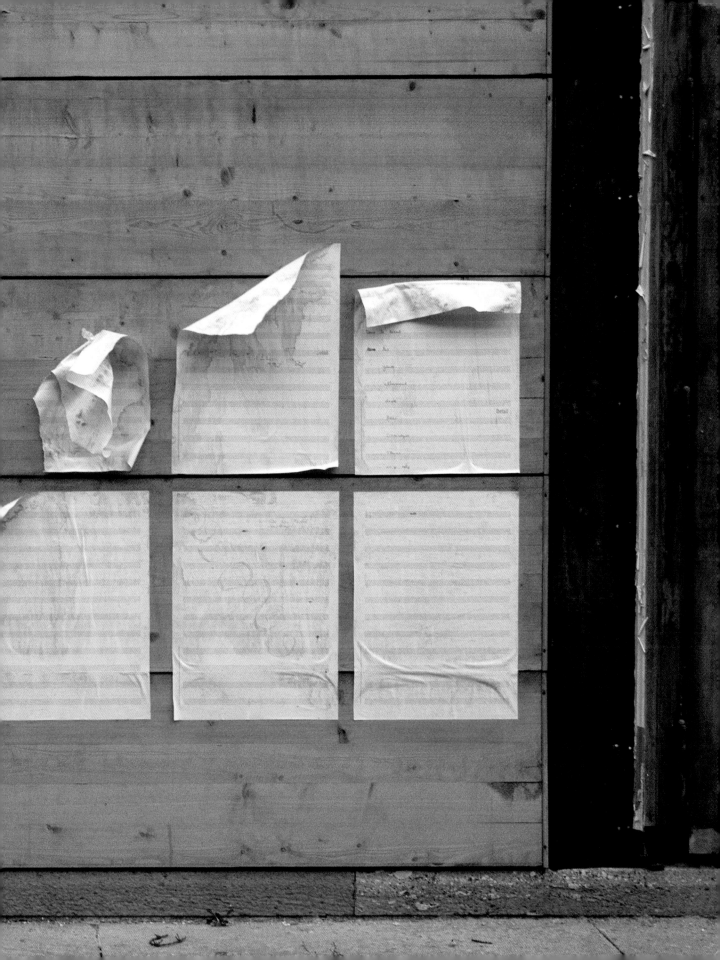

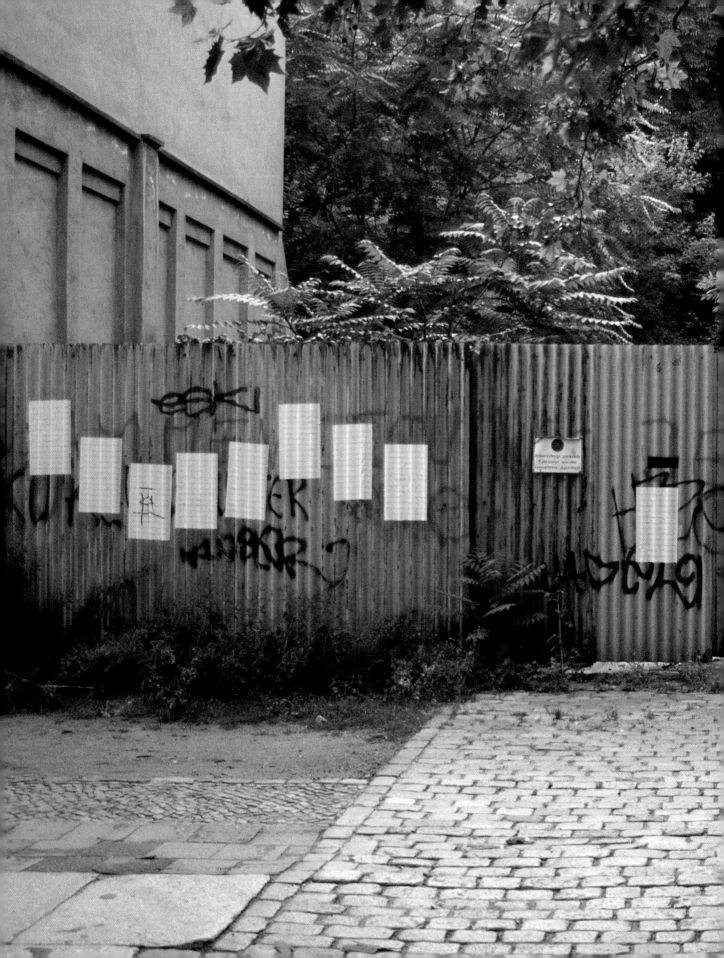

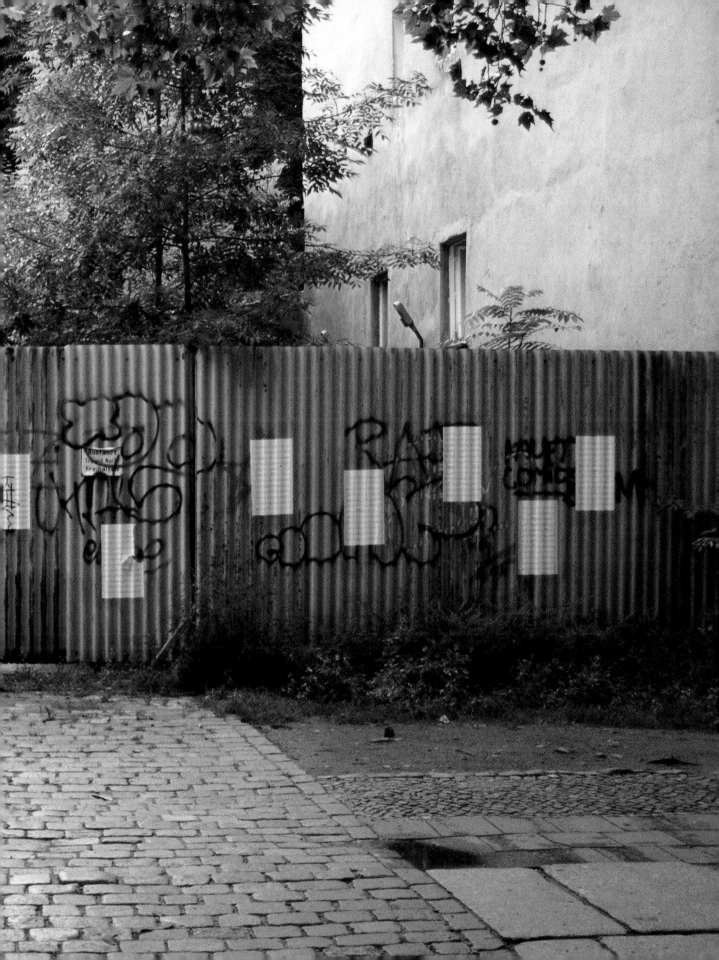

Christian Marclay

Organized by Russell Ferguson

Essays by
Russell Ferguson
Douglas Kahn
Miwon Kwon
Alan Licht

UCLA HAMMER MUSEUM
Steidl

This publication accompanies the
exhibition "Christian Marclay,"
organized by Russell Ferguson and
presented at the UCLA Hammer
Museum, Los Angeles, 1 June–
31 August, 2003; The Center for
Curatorial Studies Museum, Bard
College, Annandale-on-Hudson,
New York, 28 September–19
December, 2003; The Seattle
Art Museum, 5 February–2 May,
2004; Kunstmuseum Thun,
12 June–6 September, 2004.

The exhibition is made possible
by generous support from
Eileen Harris Norton and the
Peter Norton Family Foundation.
Additional support has been
provided by the LLWW Foundation;
Pro Helvetia, the Arts Council
of Switzerland; LEF Foundation;
and Art for Arts Sake.

A series of performances at the
Hammer Museum is funded by
the American Center Foundation.

Copy Editor: Jane Hyun
Designers: Georgianna Stout and
Glen Cummings, 2x4, New York
Printer: Steidl, Göttingen, Germany

ISBN: 3-88243-931-9
Printed and bound in Germany
cover and opening spreads: *Graffiti
Composition*, 1996-2002. Installation
views of posters, Sonambiente:
Festival für Hören und Sehen,
Berlin, 1996

Contents

11 **Director's Foreword**

19 **The Variety of Din**
Russell Ferguson

59 **Surround Sound**
Douglas Kahn

89 **CBGB as Imaginary Landscape: The Music of Christian Marclay**
Alan Licht

111 **Silence Is a Rhythm, Too**
Miwon Kwon

134 **Exhibition Checklist**
145 **Acknowledgments**
152 **Exhibition History**
166 **Selected Bibliography**
180 **Discography**
188 **Selected Performances**
201 **Contributors**

Director's Foreword

Ann Philbin

We are extremely pleased to present "Christian Marclay", the first museum survey devoted to this influential artist. With its focus on Marclay's career from 1980 to today, this exhibition reflects the Hammer Museum's commitment to the work of contemporary artists and to exploring the historical and social contexts in which that work is made.

Contemporary art is a wonderfully diverse proposition. An increasing number of artists, finding that established divisions seem arbitrary, are combining media and influences to form new hybrid practices. These new syntheses have been thoroughly embraced by the Hammer Museum; over the past several years exhibitions have featured artists working in everything from video, performance, sculpture, installation, painting, and drawing to any number of combinations of the above. These same artists have drawn from fields as diverse as theatrical performance, portraiture, cartoons, and architecture. The Hammer Conversations series hosts discussions between thinkers from disparate fields, bringing scientists, choreographers, writers, and artists together for evenings of intellectual exchange. For a museum that is an integral part of the University of California, Los Angeles (UCLA), this diversity of interests is especially relevant.

Given this focus, an exhibition of Christian Marclay's impressive work of the past two decades is particularly fitting. A consummate example of an artist who refuses to recognize established boundaries, Marclay draws from a wide field of influences in his exploration of the worlds of sight and sound. Trained as a visual artist, but known as both an artist and a musician, Marclay takes as his purview the convergence of two of our primary senses. What does sound look like? How is it manifested in objects? What about music? How is it mythologized and fetishized?

With pieces ranging from collaged records used in performance to altered instruments that are impossible to play, from public works soliciting the collaboration of passersby to virtuoso video installations, Marclay questions the traditional divisions between objects and performance, private and public, craft and high art. Rather than a repudiation, this blending represents a new look at the possibilities of art-making in the contemporary context.

Russell Ferguson, chief curator and director of exhibitions and programs at the Hammer Museum, has overseen this exhibition from its inception. His guiding vision, incisive scholarship, and nuanced understanding of Marclay's unique place within the world of contemporary art have resulted in a museum survey that brilliantly conveys the complexity and scope of this most innovative and eclectic of contemporary artists.

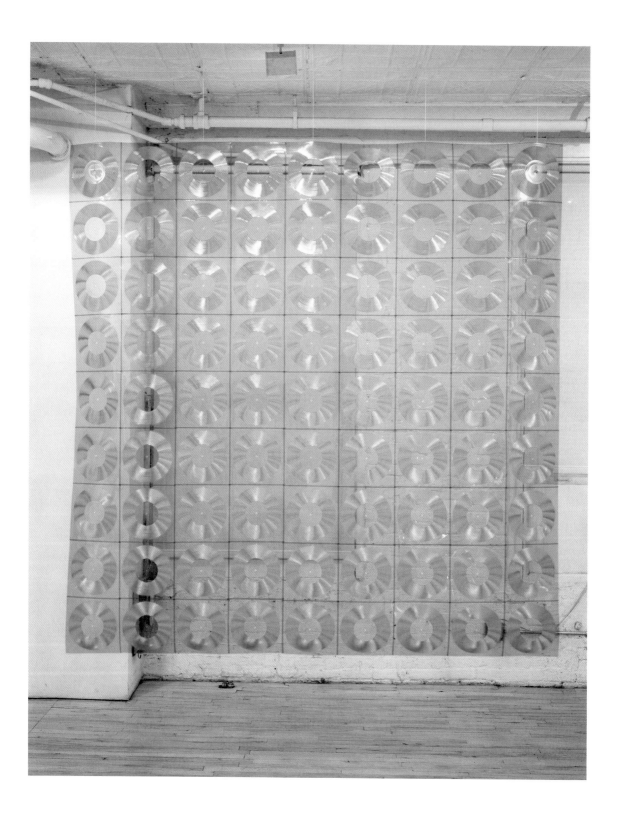

Soundsheet, 1990

I am especially pleased that we are able to accompany the exhibition with this catalogue examining Marclay's work from a number of vantage points. It truly does justice to Marclay's diverse work. My thanks to Miwon Kwon of UCLA's department of art history; to Douglas Kahn, Director of Technocultural Studies at the University of California, Davis; and to the musician and critic Alan Licht.

We are enormously grateful for the generosity of the exhibition's funders: Eileen Harris Norton and the Peter Norton Family Foundation; the LLWW Foundation; Pro Helvetia, the Arts Council of Switzerland; LEF Foundation; and Art for Arts Sake. The series of performances by Christian Marclay and his collaborators has been supported by the American Center Foundation.

An undertaking such as this is never accomplished alone. I want to thank Amada Cruz, Director of the Center for Curatorial Studies Museum, Bard College; Mimi Gates, Director of the Seattle Art Museum; and Madeleine Schuppli, Director of the Kunstmuseum Thun, for sharing our vision and collaborating on the exhibition.

Most of all our thanks go to Christian Marclay, who has been more than generous with his time and energy in the making of this exhibition.

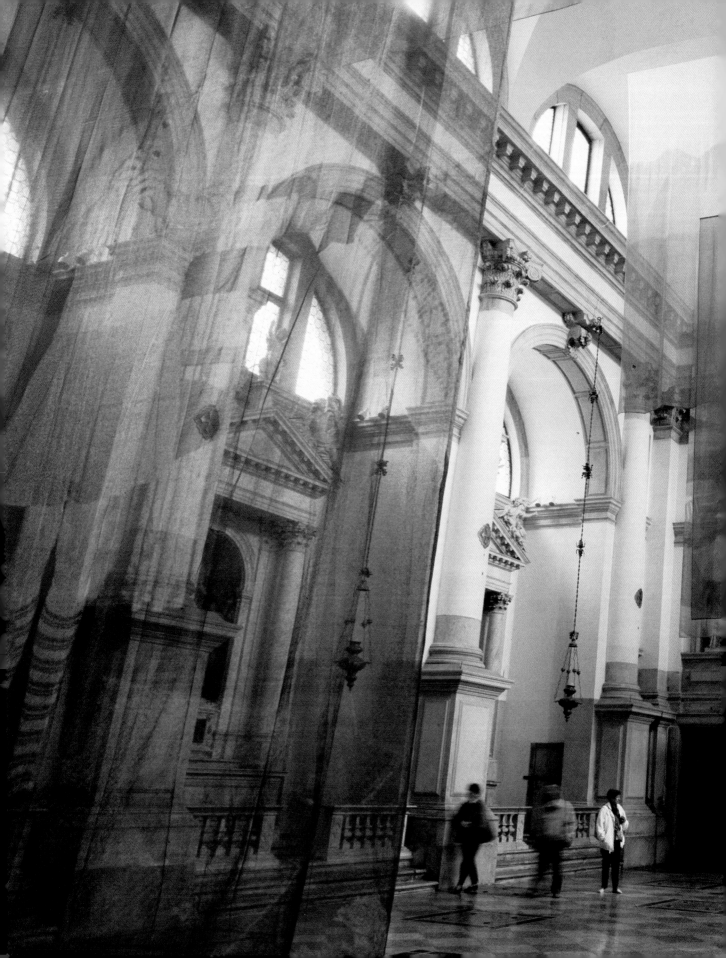

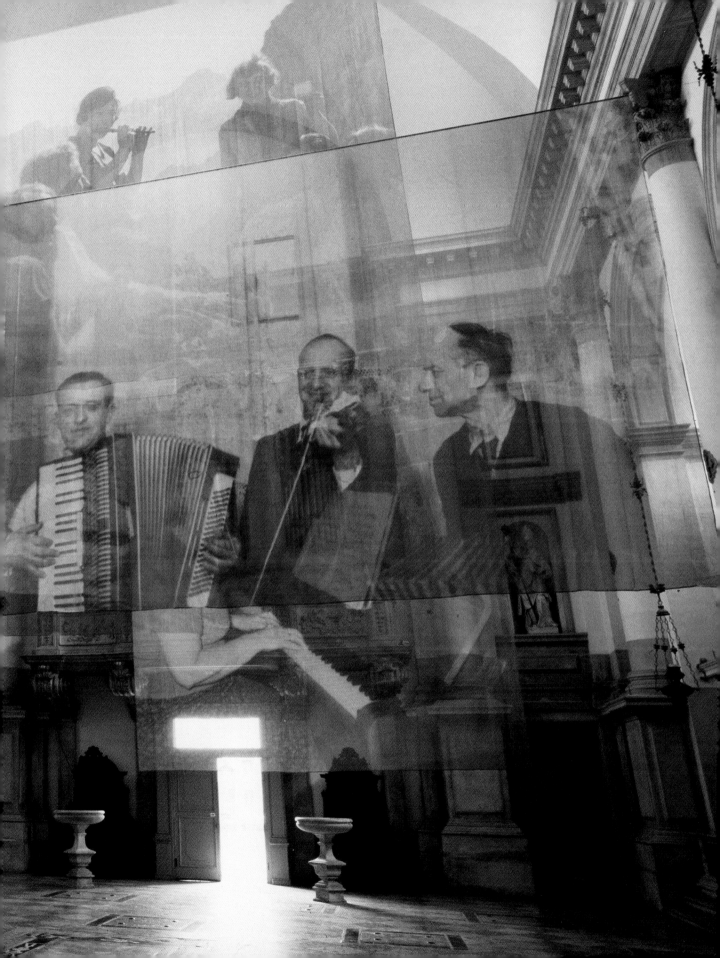

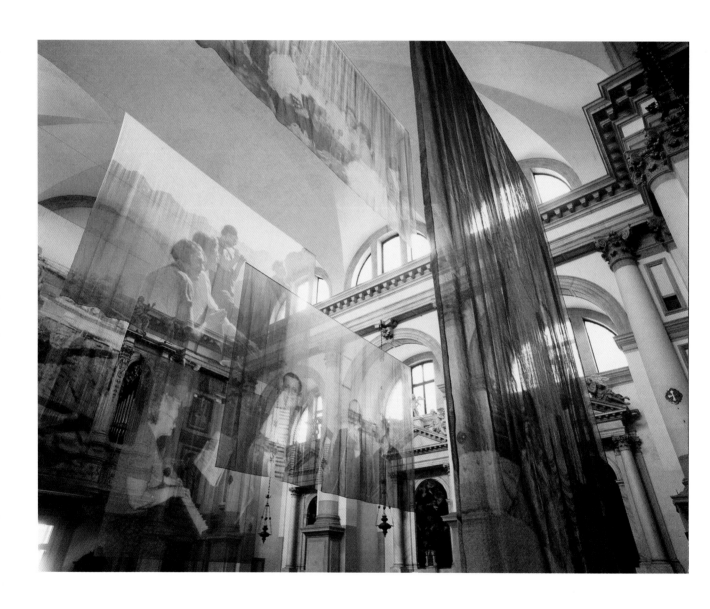

Previous page and these pages:
Amplification, 1995. Installation
views, Chiesa di San Stae,
Venice Biennale, 1995

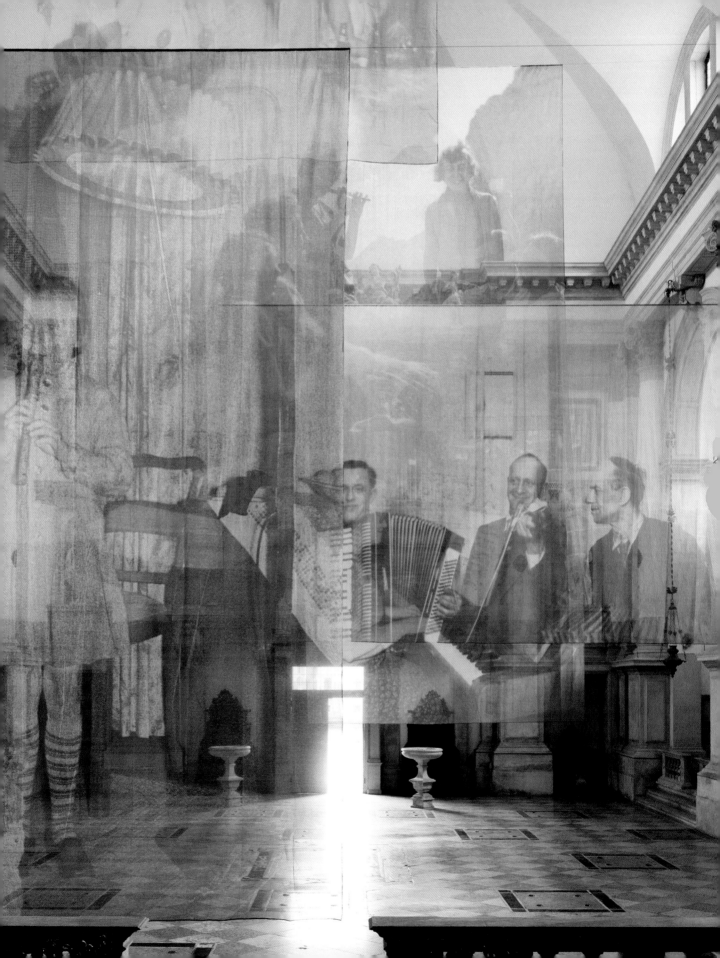

The Variety of Din

Russell Ferguson

In an index, I found Christian Marclay appropriately situated between Annunzio Mantovani, the easy-listening orchestra leader whose "cascading strings" were enormously popular in the 1950s, and the Futurist Filippo Marinetti, who thought the roar of a racing car engine more beautiful than ancient Greek sculpture.[1] For Marclay both poles are equally appealing. All music and all sound comprise the vocabulary with which he works. From sugary orchestration to screeching noise, it is sound—and our culturally determined reactions to it—that forms the basis of his art. Marclay is fascinated by the translation of the audible into the visual, and the theme that informs all his work is the space between what we hear and what we see.

He recognizes the gulf between the two, even as he moves back and forth across it. "To attempt to visually represent sound or music, which is by nature immaterial and invisible, is always a sort of failure because this visualization excludes the aural. A silent representation of sound, as in a painting or sculpture, intrigues me because its muteness underscores sound's intangible nature. The image becomes instead the representation of an absence."[2]

The melancholy of this absence recurs time and again in Marclay's work, and even though it can also be monumental, funny, pointed, and politically charged, there is always a certain haunting awareness of what is missing, lost, or unattainable. In *Chorus II* (1988), twenty-nine mouths gape open in unison, but not a sound is heard, nor ever will be. We cannot even know whether they are singing, laughing, or crying out in pain. Similarly, in *Full-color Stereo* (1988) six speakers assertively painted in primary colors seem to yearn for audibility, but remain silent nevertheless.

The overwhelming majority of Marclay's works make no sound. This is less because he is interested in the translation of the audible into the visible than because he wants to tap into the connotations that each viewer will bring to the work. "My pieces are silent," he has said, "so that you can fill in the blank. I want people to use their memory, their own memory. Memory is our own recording device, so instead of imposing a standardized memory like a record, we have our own personal memories, which are more selective."[3] A work from 1988, *The Sound of Silence*, illustrates the point. It is simply a photograph that shows the Simon and Garfunkel single, "The Sounds of Silence." The photograph itself is silent, but when we look at it the familiar song starts up in our head anyway, along with whatever memories or associations we hold along with it.

The division between the realms of the audible and the visible echoes throughout Marclay's career. He is well known as a musician. He was one of the first to use record turntables as his instrument, and in that role has been a hugely

The Sound of Silence, 1988

Full-color Stereo, 1988

influential figure for the ever-increasing numbers of younger "turntablists." Yet at the same time he has always been a visual artist. For Marclay the two elements of his work are inseparable, and to him the distinction is perhaps most evident in his audiences. "Art and music are for me totally intertwined and connected," he has said, "part of the same thinking process. The audience is mostly different. When I perform in music clubs the audience knows me as a musician. In the art world, they see me as an artist and a lot of times never hear my music or see my performances."[4]

Breaking down these barriers has been a large part of his project. But it isn't easy. We live in a culture in which the visual habitually trumps the audible. Marclay's video *Telephones* (1995) consists of a long sequence of movie clips in which actors are talking on the telephone. Although they cannot see each other, only hear, one of their most frequent remarks is, "I see." When we say, "I see," we mean we have achieved clarity. When we say "I hear" something, we mean that it is doubtful, unverified, a rumor. We trust our eyes more than our ears.

Marclay began to perform music in the late 1970s, while still a student at the Massachusetts College of Art in Boston, at which he had enrolled after attending art school in Geneva, where he had grown up. On trips to New York, he had become interested in the performance art of Vito Acconci and Laurie Anderson.[5] These artists were breaking new ground in the range of practices and influences that they brought to bear in their work. In addition, the prevailing punk ethos at that time contributed to a widespread feeling that a lack of technical skills need not be a barrier to expression.

Vito Acconci, *The Red Tapes*, 1976-77. Video still

On returning to Massachusetts from New York in 1979, Marclay's first idea was to make a film: a musical. For this, of course, he would need songs, and he began to write lyrics, for which he asked his friend Kurt Henry to provide music.

This collaboration led the two of them to form their own group, with the Duchampian name of The Bachelors, even. They began performing, with Marclay singing and playing percussion, and Henry on guitar. They would play in front of projected 16–mm and super-8 film loops, often cartoons, whose audio would become part of the performance along with the live music. On one notable occasion in 1980, The Bachelors, even performed at Club Foot in San Francisco, one of the centers of that city's punk scene, with Bruce Conner providing multiple projections as they played. Conner's assemblage films would be a significant influence on Marclay's later work. Such events would also be the precursor of much collaboration for Marclay, including, notably, partnerships with John Zorn, Lawrence "Butch" Morris, Zeena Parkins, Shelley Hirsch, Sonic Youth, Elliott Sharp, and Merce Cunningham, as well as with his ongoing project, djTRIO.

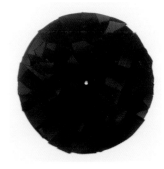

Mosaic, 1987

The Bachelors, even supplied their own rhythm section, in the form of cassette tapes played on a boom box. These backing tapes, initially made by Marclay as an adjunct to his songs, turned out to be the basis of his future as a performer. They had their origin in his discovery one day of a broken record in the street, the theme tune from the Batman TV program. He took this home and played it. Finding that it skipped in an interesting way, he then taped it, looped it, and made it into a rhythm track. From there it was a short step to abandoning cassette tapes and using actual turntables in live performance. By this point music had become inseparable from Marclay's work as an artist.

With his series of *Recycled Records* (1980 – 86), Marclay took the first steps towards converting the records he was using in performance into art objects. These cut up and reassembled records could still (just) be played. Their visual qualities, however, increasingly disrupted their capacity to deliver any coherent music. *Mosaic* (1987) marked a decisive turning point. It was reassembled without aligning the grooves, and was thus unplayable. *Untitled* (1987) went even further. It is a record without any groove at all. A record without a groove is a pure fetish object, and Marclay presented it as such, in an elaborate ultrasuede bag rather than a cardboard sleeve. In *Endless Column* (1988) records became monumental, rising higher than the human head. Disassembled, these records could still be played. *Untitled* (1989), however, consists of nine melted records. These spherical blobs have decisively left the turntable behind. Marclay emphasized the transition the following year with a series of prints that explicitly make use of records as vehicles rather than as objects in themselves.

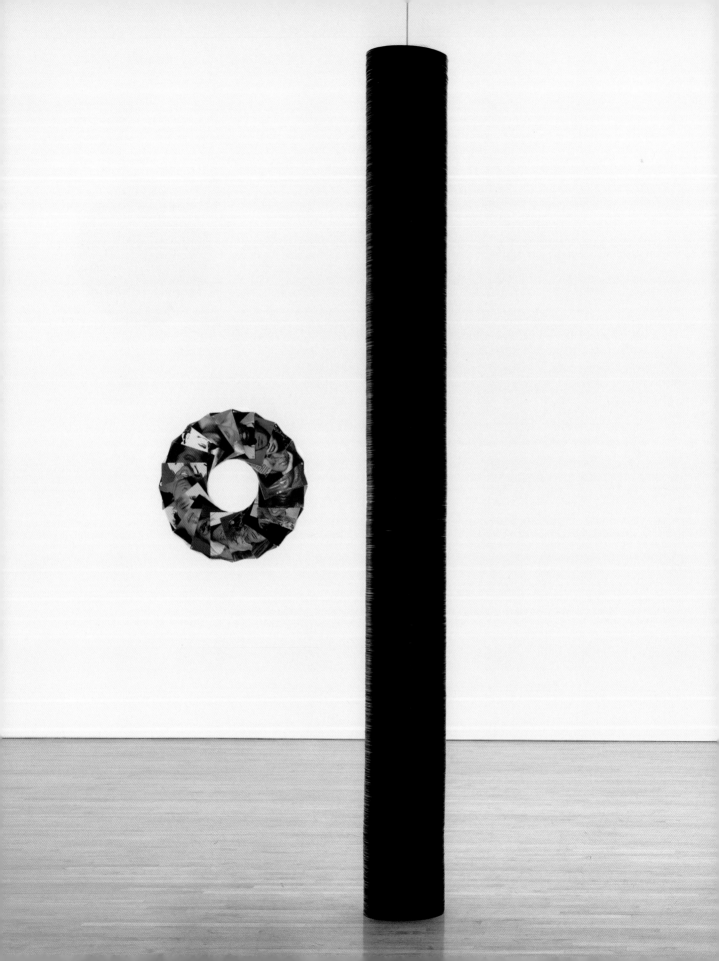

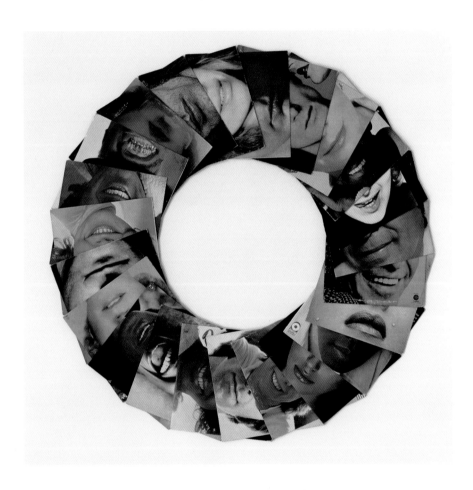

Opposite page: *Endless Column*, 1988;
Untitled (Small Circle), 1992 (on wall)
Above: *Untitled (Large Circle)*, 1992
Following spread: *Möbius Loop*, 1994

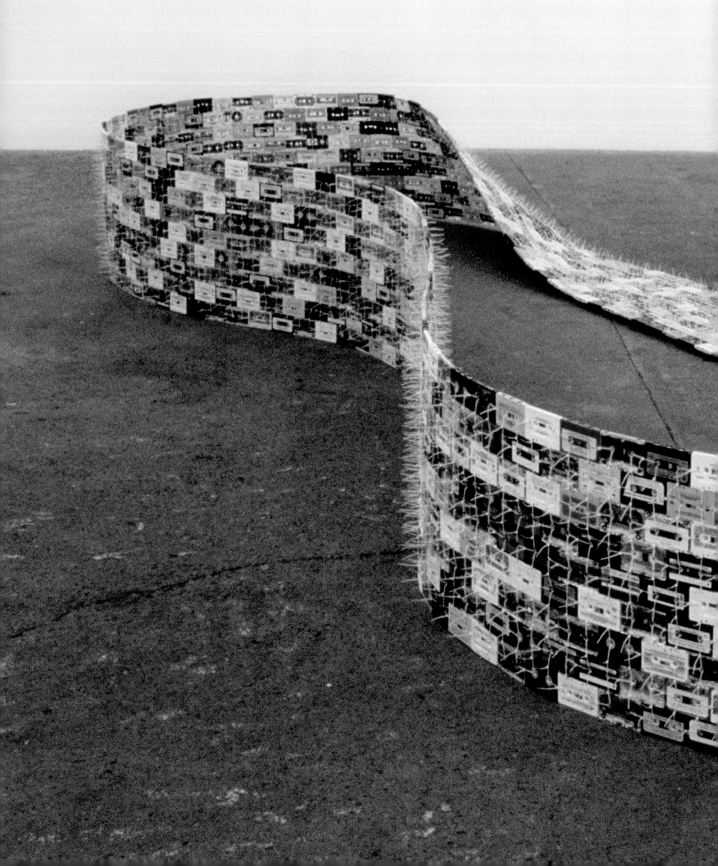

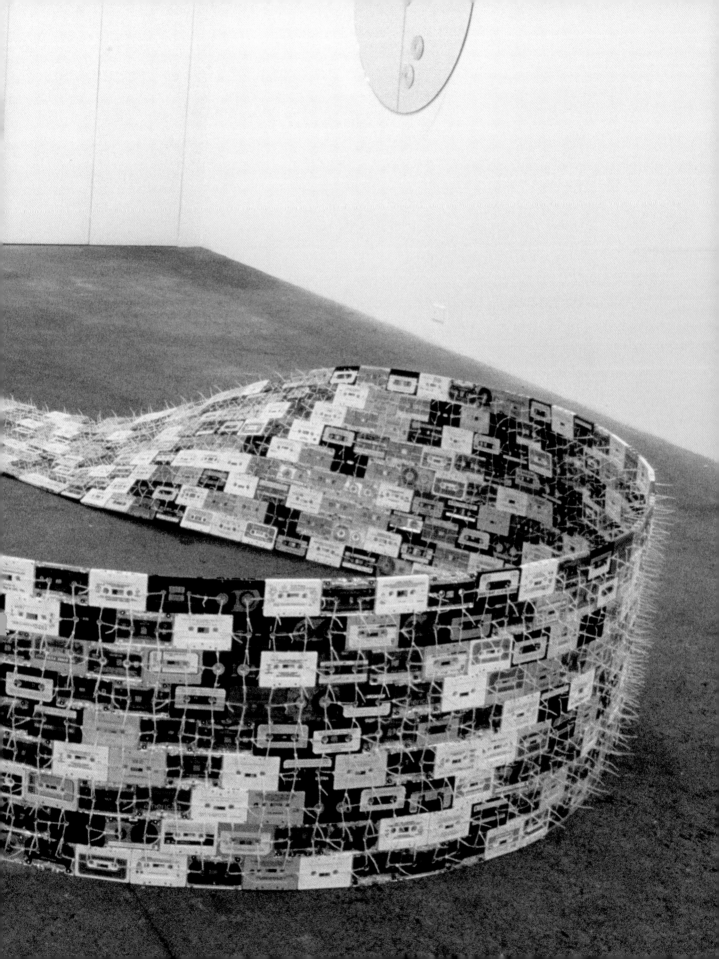

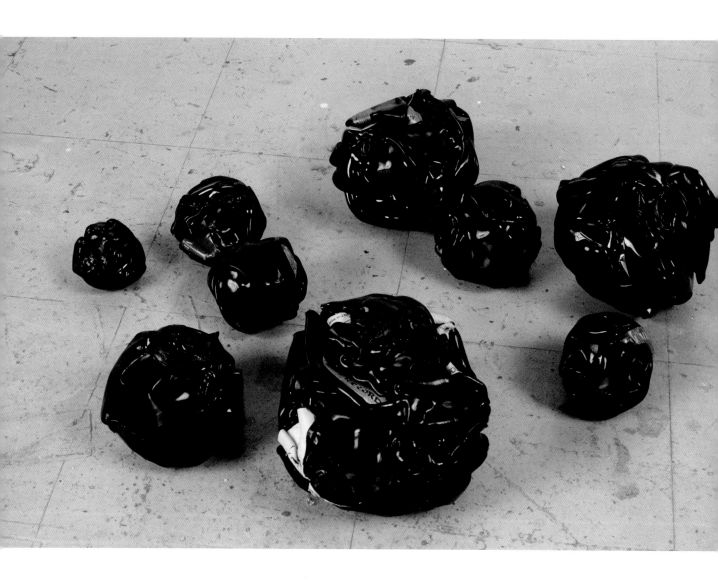

Above: *Untitled*, 1989
Opposite top: *Wheel*, 1994
Opposite bottom: *Ring*, 1988

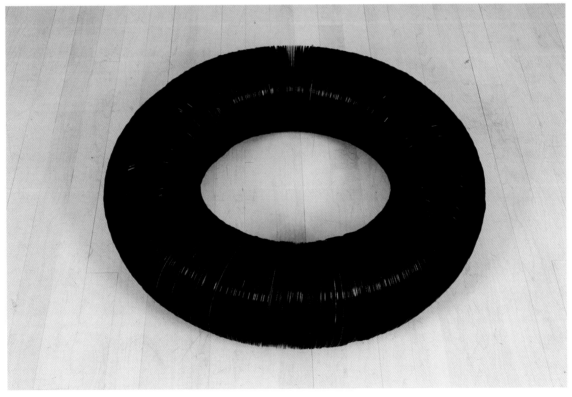

"All art," Walter Pater wrote, "aspires towards the condition of music."[6] Marclay is not, however, attempting a contemporary version of synaesthesia. Unlike Kandinsky, for example, who, early in the twentieth century, sought "the inner essence of things,"[7] a quality that would ideally be the same in both music and visual art, Marclay seeks no absolute correspondence between music and the visible. He is interested, rather, in the social context in which the two become bound together. "In the early nineties," he recalls, "I didn't think records were going to last, so I was ready to retire, because for me it was always very important to make something with objects that were really part of the culture."[8]

The culture, however, can certainly encompass synaesthetic concepts. The Abstract Music series of 1989 – 90 taps into a popularized version of such ideas. In Abstract Music Marclay takes as his starting point a genre of fifties and sixties album cover that aspired to associate certain kinds of music (especially jazz and contemporary classical music) with the cachet of abstract painting. Both the music and the art were seen as inherently progressive, and representative of the most up-to-date versions of their respective forms. Josef Albers did a whole series of such covers for Command Records during the sixties, but many more generic examples

Untitled, 1989

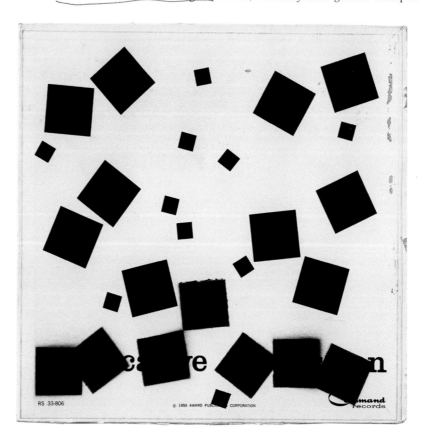

were also produced by less well-known artists, and it is these in which Marclay is particularly interested.

The covers are printed reproductions, and in that sense somewhat like the recordings themselves, which function as reproductions of apparently live performances. The paintings, however, are, in the context of an album cover, unequivocally subordinated to the music and its performers. Marclay's interventions, obliterating most of the printed information about the recording, but preserving the original artist's signature when one is visible, swing the pendulum in the other direction. His own painted marks blur the distance between original and reproduction, and restore to the (by now quite distant) original painting something of the presence that its originator, we assume, would have wanted for it. The original record all but disappears, becoming merely a vehicle for the new, original, painting.

Except, of course, that the familiar twelve-inch-square format will in the end always give the game away. All these works began as, and in some sense remain, album covers. It is in the oscillation between cover and Marclay's paintings—his "cover versions" of the covers—that the content and the pleasure of these works lie.

Record cover designed by Josef Albers, 1960

Historically, the function of the recording was to elevate auditory data to the same level of reproducibility as the photograph had already achieved for the visible. If anything, the breakthrough represented by the advent of recorded sound was even more remarkable. The appearance of things had, after all, become reproducible through drawing, painting, and printmaking long before photography. Until the widespread marketing of Edison's cylinders in the 1890s, the closest sound had come to reproducibility was in musical staff notation, obviously very far from the breakthrough represented by the arrival of recording technology. Marclay's *The Sound of Silence* makes the connection between photography and phonography explicit, since it is literally a photograph of a recording. We can see the grooves of the record that reproduce the sound reproduced visually as a different kind of recording.

In the earliest years of sound recording, its function was unambiguous. It existed to provide as accurate a record as possible of sounds as they had been present in the world, whether the sound of the human voice speaking or of musical performance. The goal was to capture as exactly as possible what someone present at the site of the recording would have heard. Marclay is sometimes drawn to this straightforward idea of recording as a trace. *Candle* (1988) is a wax candle cast from the horn of an old phonograph, along with the horn itself. The candle, which

potentially could be burned away to nothing, is inherently ephemeral. At the same time, the wax of the candle evokes the early wax cylinders into which a needle would inscribe the trace of an otherwise ephemeral song. The candle itself is the trace of the horn. The wax remains relatively soft and yielding, still susceptible to new markings.

By the early 1960s, however, recording had already begun to separate itself from the direct trace of performance. Phil Spector's "wall of sound," and its echo-chamber imitators, was unequivocally a studio assemblage. As the sixties progressed, studio experimentation became *de rigeur* for ambitious musicians of all kinds. There was less and less reason for audiences to register a recording as a one-to-one documentation of a live performance. The production of a recording became more like a composition, more a work of art in itself than a transcription of one.

From early in the rock-and-roll era, then, it was the record rather than the live performance that became the primary locus of music. Unlike, say, jazz or classical music, rock music recording ceased to be even nominally a transcription of live performance: instead, the goal of performance became to recreate the record.[9] Jacques Attali has written that:

> The advent of recording thoroughly shattered representation. First produced as a way of preserving its trace, it instead replaced it as the driving force of the economy of music. Since then, representation survives when it is useful in record promotion or among artists who do not command a significant record audience. For those trapped by the record, public performance becomes a simulacrum of the record: an audience generally familiar with the artist's recordings attends to hear their live replication.[10]

Attali's turn of phrase—"trapped by the record"—betrays a lingering adherence to an older model of listening which gives primacy to the live performance, but his point is an important one nevertheless. One of the most notable aspects of Marclay's live performance is that he understands this fundamental shift, and completely conflates the recording with the performance.

The connection between contemporary art and pop music was decisively made as early as 1956, when Richard Hamilton included a jukebox loaded with popular hits as part of his installation for "This Is Tomorrow," the path-breaking exhibition at the Institute of Contemporary Arts in London that celebrated everything modern and up-to-date. Hamilton and his colleagues in the Independent Group introduced the concept of pop art as something that could take its place alongside pop music,

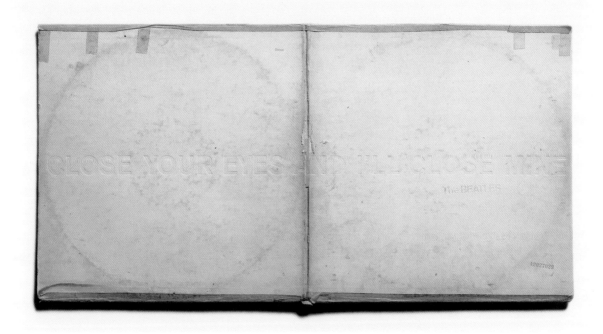

without necessarily claiming any superiority over it. In 1967, the English pop artist Peter Blake would design the cover for the Beatles' *Sergeant Pepper's Lonely Hearts Club Band*. The collage aesthetic that Blake used here and throughout his work is directly comparable to the elaborate studio overlayering that went into the recording, and in 1990 Marclay overlayed his own prints onto the interior of the gatefold sleeve.

In 1969, Hamilton himself took a very different tack when he designed the cover for the group's White Album (*The Beatles*): an individually numbered edition of more than five million white monochromes, eagerly snatched up by a massive audience worldwide, most of whom had certainly never heard of the artist. Hamilton actively pursued the apparent contradiction between the Beatles' massive popularity and the comparatively tiny art world. "I suggested a plain white cover so pure and reticent that it would seem to place it in the context of the most esoteric art publications. To further this ambiguity I took it more into the little press field by individually numbering each cover."[11] Hamilton's counterintuitive approach to the design of a pop album cover ironically resulted in one of the best-known and most distinctive covers ever produced.

In 1990, Marclay made his own prints on top of this already highly overdetermined cover, embossing fragments of the Beatles' lyrics on top of it. The used album covers that were the support for this work were notable for having already become a different kind of print. Accumulated dirt had marked the circular shape of the record onto the exterior of the cover, a tangible memorial to hundreds of playings, the trace of the record's passage through the physical world.

For Marclay, the Beatles are important not just because of their music, but because of the position they occupy in the social fabric of his own generation. The

White Album (Close your eyes and I'll close mine), 1990

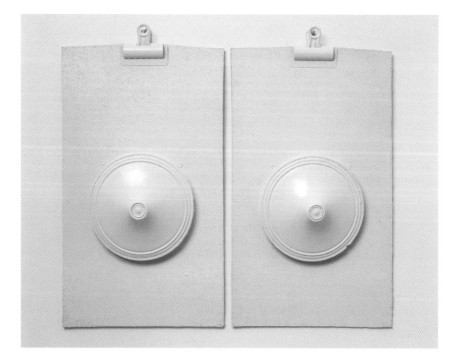

Breasts, 1989

music of the Beatles generates specific connections in the memories of a vast number of people. "I like the Beatles because they are very popular," Marclay says, sounding almost like Andy Warhol in his conflation of popularity and affection. "Everybody knows about the Beatles, everybody has a relationship to them. Their songs have been rearranged and performed by all kinds of bands, from elevator Muzak to big bands to folk singers."[12] In 1989, he recorded the collected works of the Beatles on quarter-inch audiotapes and had them crocheted into a pillow—a soft, familiar place to rest one's head: "In the case of the pillow, I thought it would be the perfect music to use, because everybody feels comfortable with it."[13] In dreams, any music plays inside one's head. *The Beatles* makes dreaming of old songs visible, but not audible.

Similarly, the series of photographs Marclay has made over the past ten years are documents of the silent integration of the musical into everyday life: notes sprinkled on an umbrella like rain; instruments in a shop window; a dog's collar that becomes the HMV logo.

Marcel Duchamp, *A bruit secret*
(With hidden noise), 1916

But here I want to move back from the familiarity of such things, and return instead to a single mysterious object made in 1916. Marcel Duchamp's *A bruit secret* (With hidden noise) marks an alternative way of thinking about the relationship of art and sound, this time privileging the hermetic over the popular. Duchamp described this "assisted readymade" as "a ball of twine between two brass plates joined by four long screws. Inside the ball of twine Walter Arensberg added secretly a small object that makes a noise when you shake it. And to this day I don't know what it is, nor, I imagine, does anyone else."[14] Duchamp's work gives sound a mysterious quality, and the secret noise is if anything even more secret today, since *A bruit*

secret is now a prized work in the collection of the Philadelphia Museum of Art, and is presumably shaken only on rare occasions. Marclay's own *Secret* (1988) consists of a metal master disc (the template used to produce vinyl records) containing its own secret sound in the form of a recording, rendered unlistenable by means of a padlock that locks through it. As in *A bruit secret*, any sound here is hidden, potential rather than actual.

Throughout Marclay's work there are echoes of Duchamp. In *Violin* (1988), for example, a violin is wrapped up in audiotape that unspools from its reel. The piece not only echoes Duchamp's wrapping up of a sound, but extends the concept by making the wrapping material itself the potential preserver of the sound that the violin can no longer make, precisely because it is wrapped up. Other examples are *Door* (1988), *Breasts* (1989), and *Bouche-Oreille* (1990), all of which take their starting point in works by Duchamp, but are folded into the world of sound and its reproduction.

Duchamp's *La Mariée mise à nu par ses célibataires, même* (The Bride Stripped Bare by Her Bachelors, Even, 1915–23), also known as *The Large Glass*, was declared complete by Duchamp when the work's glass surface accidentally cracked. This is the work that gave part of its title to Marclay's first group. Marclay loves not only the layers of superimposed references that fill the work, but also the aleatory element doubly introduced by the transparency of the glass and by the crack in it. In a way, Duchamp's embrace of the accidental crack can be seen as a kind of improvisation. The attraction to improvisation and chance, always in tandem with a parallel impulse towards precise control, is as characteristic of Marclay's work as it is of Duchamp's. Marclay is currently engaged in a project for the Philadelphia Museum of Art, which owns *The Large Glass*, that will link it with another Philadelphia landmark, the Liberty Bell. Like *The Large Glass*, the Liberty Bell is decisively cracked,

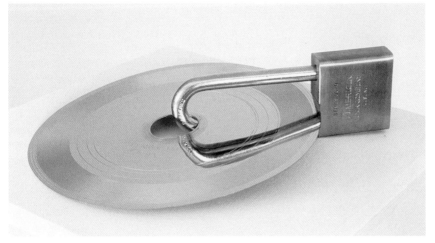

Secret, 1988

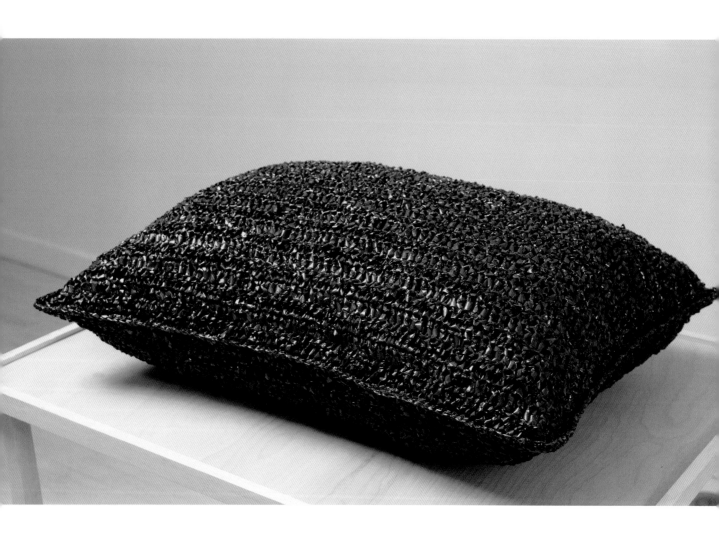

Above: *The Beatles*, 1989
Opposite: *Door*, 1988
Following spread: *Candle*, 1988

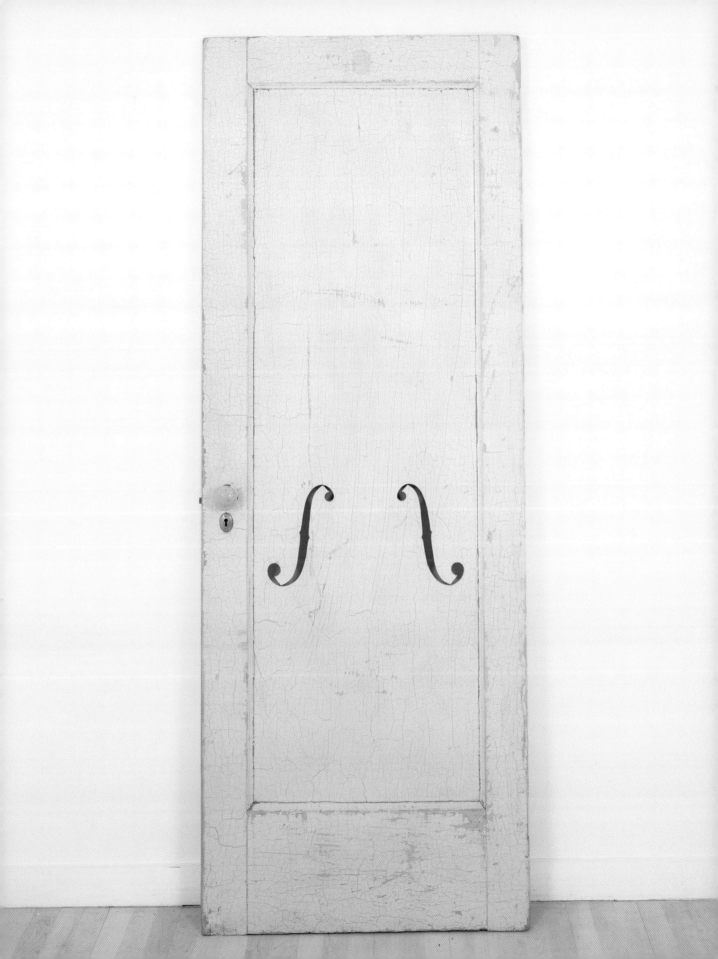

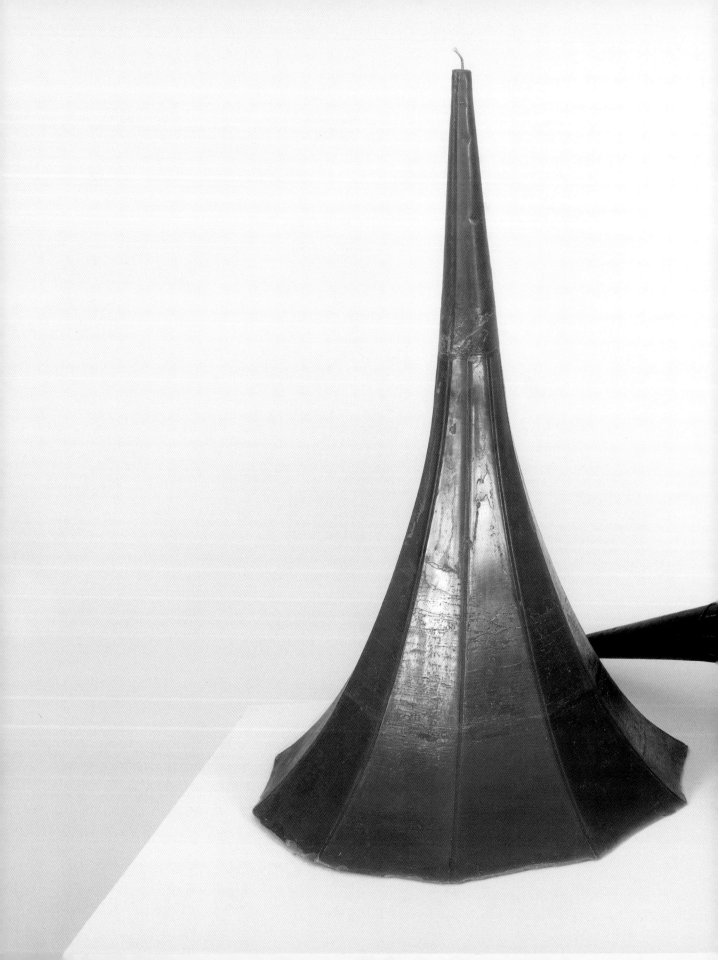

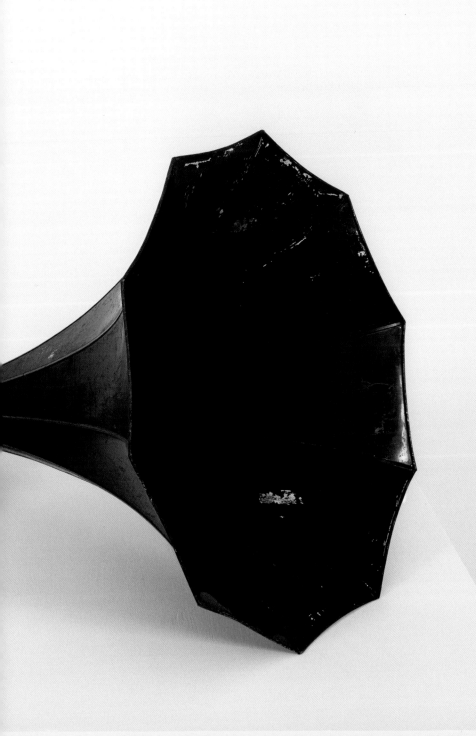

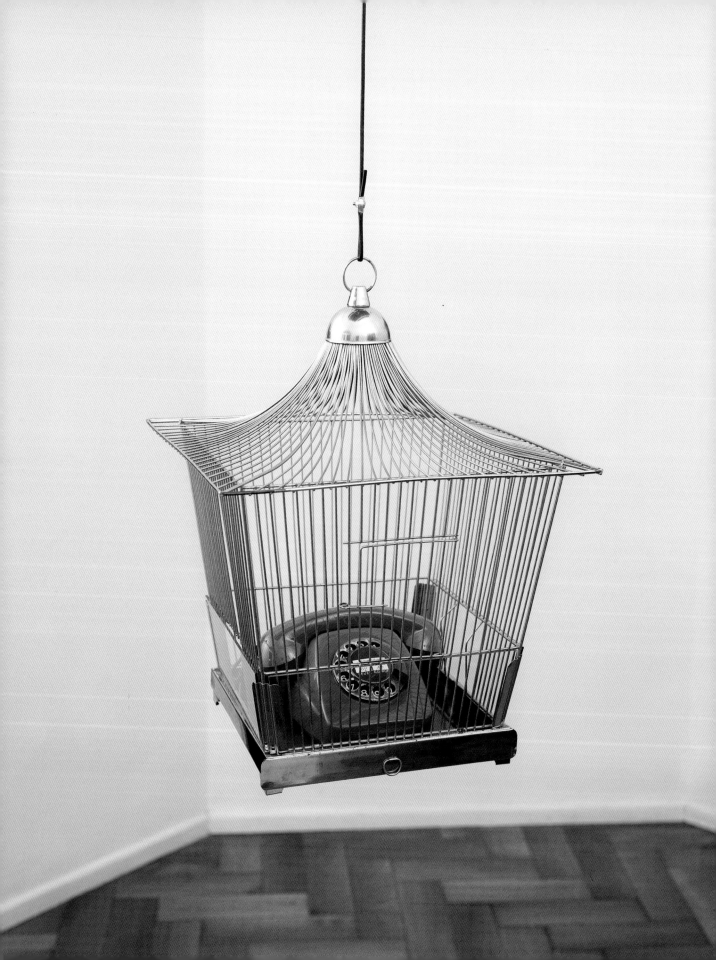

Opposite: *Cage*, 1993
Above: *From Hand to Ear*, 1994

False Advertising, 1994, installation views in Geneva.

and like *A bruit secret*, it is an object that was defined originally by its capacity to make sound, but that exists now in a state of exalted and continuing silence.

As often as Marclay refers to specific works by Duchamp, however, it is Duchamp's broader concept of the readymade—a pre-existing object that becomes a work of art by virtue of its nomination as such by the artist—that has had perhaps the most far-reaching influence on his work. One of Marclay's breakthroughs was his realization that recorded music could be treated as a form of readymade, and incorporated directly into his own work. Even in what might be called his self-portraits, Marclay makes use of the readymade. Some of his Imaginary Records invoke his presence—*Christian Marclay at the St. Regis* (1981), *1955* (1988), *Swiss Savage* (1997)—but only in pre-existing disguises. He is equally disguised in his *False Advertising* posters of 1994, where the readymade elements are design cliches; or in *From Hand to Ear* (1994), in which he reconfigures Bruce Nauman's *From Hand to Mouth* (1967). Perhaps his most authentic self-portrait is *My Weight in Records* (1995), a heap of vinyl records tossed into cardboard boxes. In this work Marclay implies that his own identity amounts to nothing more (or less) than an accumulation of records, acknowledging the degree to which all his work has revolved around this raw material.

It is important to note, however, that even though Marclay began to work in this way at a moment in New York when the idea of the readymade was resurgent among artists, he has never made what one might call "pure" readymades. While he certainly appropriates, he is not an appropriation artist in the sense that his contemporaries Sherrie Levine and Richard Prince were early in their careers. Marclay has always manipulated the material with which he chooses to work. By its very nature, however, recorded music tends to carry with it an unshakeable residue of its original context. Marclay's work, then, tends to hover between the conventionally defined poles of original creation and Duchampian appropriation. Duchamp himself said of the readymade that, "It is a kind of rendezvous,"[15] and this is precisely how Marclay uses his readymade materials, not just recordings themselves but also their visible correlatives, including instruments, speakers, and record covers. Each work constitutes a meeting point between its own specificity and the trail of associations that each viewer brings

to it through the source material. Just as his work exists between sound and vision, it also exists somewhere between a new object and the huge mass of pre-existing culture.

Alongside Marclay's fascination with the potential of the readymade, whether an old album cover or the Liberty Bell, he also shares with Duchamp a love of puns. In both cases, no doubt, this is an attraction heightened by the artists' movement back and forth between their native French and the English of their daily lives, with the concomitant attention to words that the monolingual take for granted. *Stereo Volume*, (1989) two loudspeakers placed on their backs with vitrines rising above them, puns on the double meaning of volume itself, both audible and three-dimensional. Again, it is impossible not to be reminded of Duchamp, in this case of his love for the secret hidden in plain sight. Marclay complicates the otherwise simple pun by having the vitrines protect volumes that are both invisible and silent.

Cage (1993), a bird cage with a silent telephone inside, is a double homage, evoking simultaneously Duchamp's *Why Not Sneeze Rose Sélavy?* (1921), a bird cage full of marble cubes intended to look like sugar; and the name of another figure whose influence on Marclay has been enormous: John Cage.[16] While Cage's *Imaginary Landscape No. 1* incorporated records (and a radio) as early as 1939, his influence on Marclay is perhaps more broadly evident in his embrace of music as part of a wider field of audible experience. Cage often said that he didn't particularly like to listen to recorded music as such, but enjoyed it if he heard it coming from an open window as he was walking down the street. This attitude is very close to the way in which Marclay deals with recordings. The music they contain is heard only in the context of the overall sound environment. That environment can include not just ambient or interfering noise, but also the conventionally unwanted and ignored traces of the apparatus itself. In performance, the records he plays *sound like records*, not just like music. As Marclay describes it,

> I want to disrupt our listening habits. When a record skips or pops or we hear the surface noise, we try very hard to make an abstraction of it so it doesn't disrupt the musical flow. I try to make people aware of these imperfections, and accept them as music; the recording is a sort of illusion while the scratch on the record is more real.[17]

This is a subtle but crucial distinction. The pops and scratches that punctuate Marclay's music are the audible trace of records as real-world artifacts rather than as transparent media.[18]

Bruce Nauman, *From Hand to Mouth*, 1967

Marcel Duchamp, *Why Not Sneeze Rose Sélavy?*, 1921.

Drumsticks, 2000

Cage's most famous work, the so-called "silent" piece, *4' 33"*, of 1952, is not really about silence at all. Rather it is about an enhanced listening—an active listening that opens up the listener to sounds that are normally ignored. David Toop has written about a recorded version he has of *4' 33"*: "The idea seems ridiculous yet, for the first time, I listened to the surface noise of a bad vinyl pressing from Italy with interest rather than irritation."[19] This anecdote makes clear the connection between *4' 33"* and Marclay's *Record Without a Cover* (1985), a vinyl record that was distributed, just as the title indicates, without any kind of protective cover, and thus accumulates a series of scratches that in the end constitute an integral part of the audible element of the record. In both cases, precisely what the listener will actually hear is largely determined by chance.

In Marclay's case, the embrace of sounds of all kinds can take him far from silence, and at one of his performances listeners are perhaps less likely to think of John Cage than of those Futurists who championed "The Art of Noises": "the crashing down of metal shop blinds, slamming doors, the hubbub of crowds, the variety of din, from stations, railways, iron foundries, spinning mills, printing works, electric power stations and underground railways."[20] His music demands an engaged listener, one willing to accept the challenge posed by the barrage of sound that constitutes one of his performances. And the barrage is not merely audible; it is tactile too. He leaves behind him a trail of shattered records littering the floor.

Marclay recognizes that, if music's primary incarnation is as an object, rather than as an activity or a service, then music enters the world of exchange value. As he has said, "The invention of recording technology has transformed sound into tangible objects and thus commodities (i.e. records, magnetic tapes, CDs). The contradiction between the transitory nature of sound and those material objects continues to fascinate me."[21]

It is not coincidental that it was through violence—broken and melted records—that the transition between object and sound was made. Destruction of the commodity is a common thread throughout Marclay's work, beginning with the countless records scratched and smashed in performance.[22] *Footsteps* (1989)

challenged taboos by calling for its audience to walk all over a floor tiled with pristine records. Even works that are not themselves broken, like his drumsticks made of glass, often seem to imply destruction. It is the potlatch of destruction that makes the commodity visible. In the name of the aleatory, the spontaneous, and the excessive, the capacity of the recording to deliver endless, unchanging reproduction is disrupted.

Instead of the perfection of repetition, which is the Platonic essence of commodification, Marclay invokes the pleasure of the fragmentary. Snatches of familiar melodies and glimpses of half-forgotten record covers appear and disappear in his work. As the novelist Thomas Bernhard has his character Reger say: "Our greatest pleasure, surely, is in fragments, just as we derive the most pleasure from life if we regard it as a fragment, whereas the whole and the complete and perfect are basically abhorrent to us."[23] The fragment resists the smoothness of perfection and insists on its own rough edges.

Throughout Marclay's work we can trace an attraction not just to the fragmented object, but to complete erasure. Even in his early Imaginary Records series, this theme is already evident. Works such as *Ghost* (1988) or *Smoke Rings* (1999) make that clear, as does *Remember* (1991), the ripped cover that is almost literally not there. Other Imaginary Records go beyond erasure to death itself. One group of them addresses directly the theme of the memento mori, including *Skull* (1989), *Mort* (1992), *Blind Faith* (1997), *Bubbles* (1997), and *Blue Candle* (1997) (the last recycled from Gerhard Richter via Sonic Youth).

Erasure is perhaps most powerfully present, if one can say that, in *Tape Fall* (1989). *Tape Fall* consists of a reel-to-reel tape recorder mounted near the ceiling. A tape plays the sound of trickling water. There is, however, no pick-up reel, so that after the tape has passed over the heads and given up the sound, it flows downwards into an ever-growing mound on the floor. The piece must be constantly replenished with new reels of tape.

On one level *Tape Fall* pays homage to a Fluxus tradition of ephemerality expressed through the sound of dripping water, including George Brecht's *Drip Music* (1959–62) and Mieko Shiomi's *Water Music* (1964, and its "record variation" of 1965).[24] But it also speaks more broadly to the irrevocable passing of time, and counters the idea of ephemerality even as it incarnates it, by leaving visible the physical evidence of sound's passage. *Tape Fall* is a rare and profoundly contradictory object. It is a monumental sculpture that memorializes nothing more than the passage of time, and destroys its own materials in the process of creating itself.

Mieko Shiomi, *Water Music*, 1964/1969

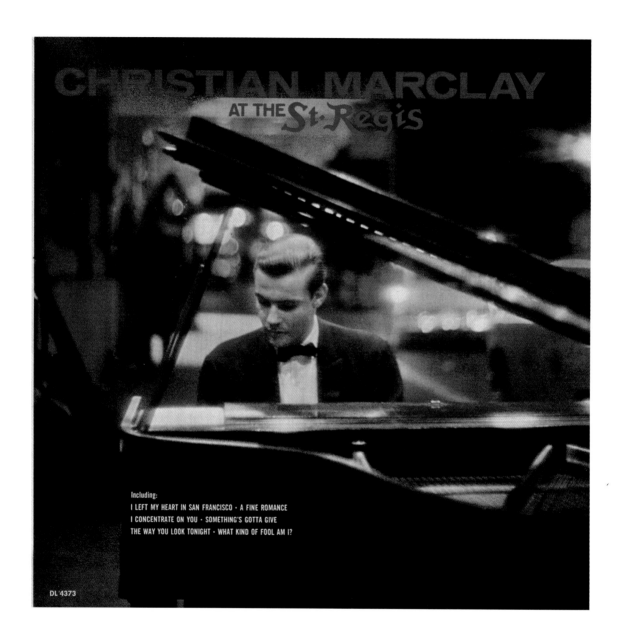

CHRISTIAN MARCLAY

AT THE *St. Regis*

Including:

I LEFT MY HEART IN SAN FRANCISCO · A FINE ROMANCE
I CONCENTRATE ON YOU · SOMETHING'S GOTTA GIVE
THE WAY YOU LOOK TONIGHT · WHAT KIND OF FOOL AM I?

DL 4373

Christian Marclay at the
St. Regis, 1981

1955, 1988

Following spread (from left to right)
Top row: Smoke Rings, 1999; Silence, 1990;
Echoes, 1997; Whisper, 1990
Middle row: Again, 1988; Skull, 1989;
Bubbles, 1997; Live!, 1988
Bottom row: Great Sounds, 1997;
Remember, 1991; Mort, 1992; Forever, 1989

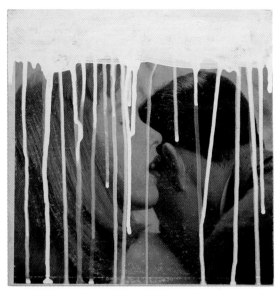

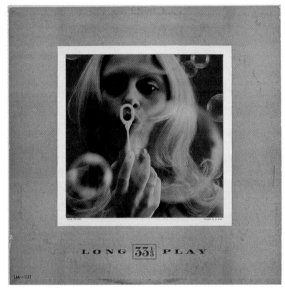

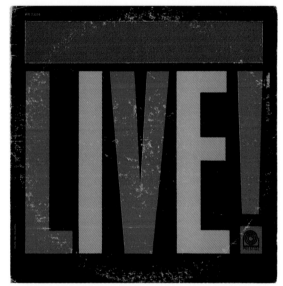

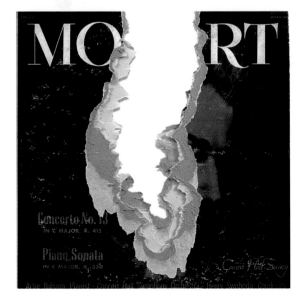

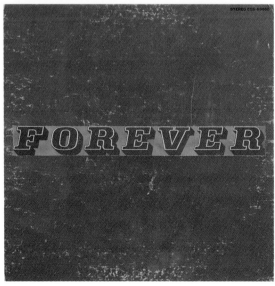

Hangman's Noose, 1987

Equally elegiac is *Boneyard* (1990), seven hundred and fifty casts of telephone hand-sets strewn across the floor, marmoreally white, never to make or receive a call.

Marclay's frequent embrace of destruction and obliteration is not fundamentally directed at music itself, as he makes clear in discussing his response to the attack on the World Trade Center in 2001. Marclay's loft is almost adjacent to the site, and he was displaced for several weeks after the attack.

> I stayed at a friend's apartment in Brooklyn and kept the TV on all day. Although the television could only pick up one station, I found its staticky drone almost reassuring; a sound connecting me to the outside world and the neighborhood I had to flee. I spent the first week in limbo, still numb and confused, listening to the endless flow of news reports. Unable to return to my loft, I worried about my work, my deadlines, and felt guilty for even thinking of making art. One morning I was startled to hear music coming from the TV. I suddenly realized that I had not heard music in the past week. Music had been cut out from the broadcast, no cheery publicity spots, nothing but an anxious stream of talk. The music I heard was so refreshing and beautiful, I went to see what it was. An orchestra was playing at a memorial for fallen firefighters. It made me aware of how starved I was for music. I realized how, even in the most tragic moments, music is a fundamental need. The reason for going back to work was evident again.[25]

The anecdote is telling, in that it demonstrates not only that Marclay has a way of listening that can find static "reassuring," but also that, more importantly, music for him is always contextual, always imbricated in the social situation in which it is made and heard.

With this in mind, Marclay is capable of plunging into the harshest of contemporary situations. His *Guitar Drag* (2000) is a video installation with an abrasively loud soundtrack. It makes Marclay's earlier exercises in destruction seem playful by comparison. We see an electric guitar, plugged into an amplifier and speaker stack mounted on the bed of a pickup truck. The guitar is dragged, bouncing, along Texas country roads to the accompaniment of its own destruction. On one level the piece refers to the spectacular guitar-smashing carried out by Pete Townshend and Jimi Hendrix, and on another to the contemporary embrace of dissonance in the work of Sonic Youth and Glenn Branca. Informing the entire work, however, is the murder of James Byrd in 1998. Byrd was dragged behind a truck in what has often been

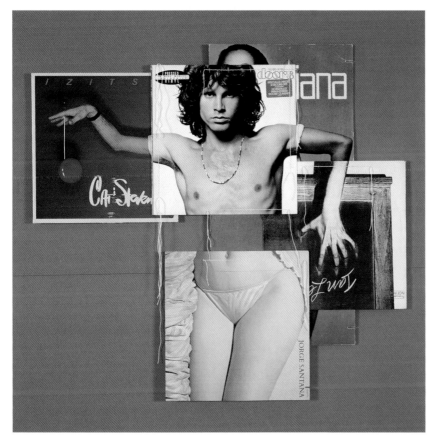

Doorsiana, 1991

referred to as a kind of contemporary lynching. Marclay's *Hangman's Noose* (1987), then, might be seen as a precursor to this piece, and he accepts all the resonances:

> All these references are there, and I think it really depends on the viewer's interest, knowledge, and state of mind. People will have different readings of the video, and I want all these to be legitimate. Ultimately I made the video because of what happened to James Byrd, but all these other references allowed me to think of the guitar as this very anthropomorphic instrument that was already associated with violence, and with rebellion, and crazy youth. I think it's fine when people walk out of there disgusted. I think it's also fine when they walk out of there exhilarated.[26]

The guitar is at its most gruesomely anthropomorphized in *Guitar Drag*, but Marclay is only taking to an extreme an impulse that is everywhere in representations of the instrument. *Guitar Neck* (1992), for example, plays up the more common sexual connotations of the instrument, while the limp *Prosthesis* (2000) offers a more pathetic version of the trope. He has never shied away from the resonances of musical instruments with the human body, as in *Stool* (1992) or *Lip Lock* (2000).

Sexual politics has been one of Marclay's recurrent themes, and the iconography of record covers offers a cornucopia of material for him to work with. *Dictators*

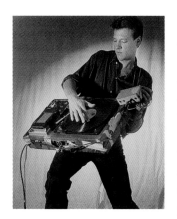

Marclay playing his
Phonoguitar, 1983

(1990) offers a grid of orchestra conductors, exemplars of male power and visibility. *Incognita* (1990), its companion piece, shows us anonymous women from the covers of easy-listening albums, there to be looked at, but powerless. *Guitar Neck*, *The Road to Romance* (1992), and works from the Body Mix series such as *Doorsiana*, *Footstompin'*, *Magnetic Fields* (all 1991) or *Slide Easy In* (1992), run riot through the exaggerated sexual stereotypes of rock.

The Body Mix series takes the inviting bodies displayed on album covers as the starting point for an orgy of excess, conjuring up new bodies that are extended, shape-shifting avatars of a sexualized culture. This embrace of excess is sometimes carried over into Marclay's sculptural objects even when no figural representation is present. *Tape Fall*, *Boneyard*, *Drumkit* (1999), and *Virtuoso* (2000), for example, all surrender in different ways to the pleasures of overflowing conventional boundaries.

Video Quartet (2002) is also highly excessive, but it marks a new stage in Marclay's work. As early as 1977, Attali had predicted that "There is an innovation that is only now beginning to play out its role...: the recording of images. Today the recording of images is intended to be an instrument for the visual stockpiling of concerts and films and as a means of pedagogy, in other words, as a tool of repetition. Soon, however, it may become one of the essential technologies of composition."[27]

Twenty-five years later, Marclay has proven Attali right. *Video Quartet*'s quadruple projections release a barrage of brief quotations from films, with their audio tracks. Among the ingredients are scenes from *Psycho* (1960), *The Sound of Music* (1965), *Barbarella* (1968), *Woodstock* (1970), *Deliverance* (1972), *Poltergeist* (1982), *Back to the Future* (1985), and *Captain Corelli's Mandolin* (2001). Among the recognizable faces are Julie Andrews, Jimi Hendrix, Janet Leigh, the Marx Brothers, Elvis Presley, Darryl Hannah, and Liza Minelli. It might seem that I am describing a cacophony, but in fact the piece is held together by its soundtrack, which constitutes a completely integrated composition, albeit one made up entirely of sampled material. It is the music that brings coherence to the diverse visual images. Reversing the usual hierarchy in our culture, the music is the driving force of the entire work. For viewers accustomed to the primacy of the visual, the result is an unusually finely balanced combination.

Equally unexpected, Marclay has taken the aesthetic of the fragment that has meant so much to his work, and transcended it without renouncing it. *Video Quartet* brings a new level of formal unity to Marclay's practice, although all the joints continue to remain completely visible. It thus represents the apogee to date

of Marclay's assemblage technique. *Video Quartet* is a fully realized new entity, standing alongside, but separate from, his ongoing attraction to the missing, to fragmentation and erasure. It has its discordant moments, but the end result is an undeniable harmony.

Laurie Anderson,
Viophonograph, 1975

1. The index in question is to David Toop's *Ocean of Sound* (London: Serpent's Tail, 1995). For Marinetti, see his "Manifesto of Futurism" (1909) in Charles Harrison and Paul Wood, eds., *Art in Theory, 1900–1990* (Oxford: Blackwell, 1992), 147: "A racing car whose hood is adorned with great pipes, like serpents of explosive breath—a roaring car that seems to ride on grapeshot is more beautiful than the *Victory of Samothrace*."
2. Marclay in *The Alpert Award in the Arts* (Santa Monica: Alpert Foundation, 2002), n.p.
3. Marclay in Rahma Khazam, "Jumpcut Jockey," *The Wire*, no. 195 (May 2000): 29.
4. Marclay in Lars Soderkvist and Philip von Zweck, "Turning the Tables on Music and Art: A Conversation with Christian Marclay" *Ten by Ten* 1 no. 3 (2001): 13.
5. Anderson was particularly relevant in the degree to which she made use of music in her performance work. Marclay's *Phonoguitar* (1980), a turntable mounted like a guitar that he used to accompany a performance—*Guitar Crash*—by the dancer Yoshiko Chuma at the club Danceteria in 1982, has a precursor in Anderson's *Viophonograph* (1975), a violin with a seven-inch, 45-rpm record mounted on it, and a stylus in the violin bow. The record has one note per track, and it is played by placing the bow onto the spinning record.
6. Pater, "The School of Giorgione" (1873) in *The Renaissance: Studies in Art and Poetry* (Oxford: Oxford University Press), 1998.

7. Wassily Kandinsky, "Concerning the Spiritual in Art" (1912) in K. C. Lindsay and P. Vergo, eds. and trans., *Kandinsky: Complete Writings on Art* (London: Faber, 1982), 127.
8. Marclay in Soderkvist and von Zweck, "Turning the Tables on Music and Art: A Conversation with Christian Marclay," 13.
9. On this topic, see Theodore Gracyk, *Rhythm and Noise: An Aesthetics of Rock* (Durham: Duke University Press, 1996), 37–67.
10. Attali, *Noise: The Political Economy of Music* (1977), trans. Brian Massumi (Minneapolis: University of Minnesota Press, 1999), 85.
11. Hamilton, "The Swinging Sixties" in *Collected Words* (London: Thames and Hudson, 1982), 104–105.
12. Marclay in Vincent Katz, "Interview with Christian Marclay" in *The Print Collector's Newsletter* 22, no. 1 (March–April 1991): 5–6.
13. Ibid.
14. Anne d'Harnoncourt and Kynaston McShine, eds., *Marcel Duchamp* (New York: Museum of Modern Art, and Philadelphia: Philadelphia Museum of Art, 1973), 280.
15. Duchamp in Michel Sanouillet and Elmer Peterson, eds., *The Writings of Marcel Duchamp* (New York: Da Capo, 1973), 32.
16. Walter De Maria made a comparable *Cage* in 1965, the original version of which (1961) was more overtly titled *Statue of John Cage*. See d'Harnoncourt and McShine, *Marcel Duchamp*, 174–75.
17. Marclay in Jan Estep, "Words and Music: Interview with Christian Marclay," *New Art Examiner* (September–October, 2001), 81.

18. Run-D.M.C.'s "Peter Piper" (1986) is believed to be the first rap record to include samples of records with audible damage. See Gracyk, *Rhythm and Noise*, 56.
19. Toop, *Ocean of Sound*, 140–141.
20. Luigi Russolo, "The Art of Noises" (1913) in Umbro Apollonio, ed., *Futurist Manifestos* (New York: Viking, 1973), 74–75.
21. Marclay in *The Alpert Award in the Arts*. See also Theodor Adorno, "The Form of the Phonograph Record" trans. Thomas Levin, *October* 55, (Winter 1990), 74–88.
22. Marclay remembers that the first sculpture to make an impact on him was Jean Tinguely's *Eureka* (1964), which he saw in Zurich when he was nine years old. Tinguely's work, of course, almost always plays with the possibility of its own potential collapse.
23. Bernhard, *Old Masters* (1985) trans. Ewald Osers. (Chicago: University of Chicago Press, 1992), 18.
24. The "Water Flows and Flux" section of Douglas Kahn's *Noise Water Meat: A History of Sound in the Arts* (Cambridge, Massachusetts: MIT Press, 1999), 242–288, gives a thorough account of the dripping water motif. Kahn notes that at the first performance of John Cage's *4' 33"* in Woodstock, New York, it began to rain during the second movement.
25. Marclay in *The Alpert Award in the Arts*.
26. Marclay in Soderkvist and von Zweck, "Turning the Tables on Music and Art: A Conversation with Christian Marclay," 13.
27. Attali, *Noise*, 144.

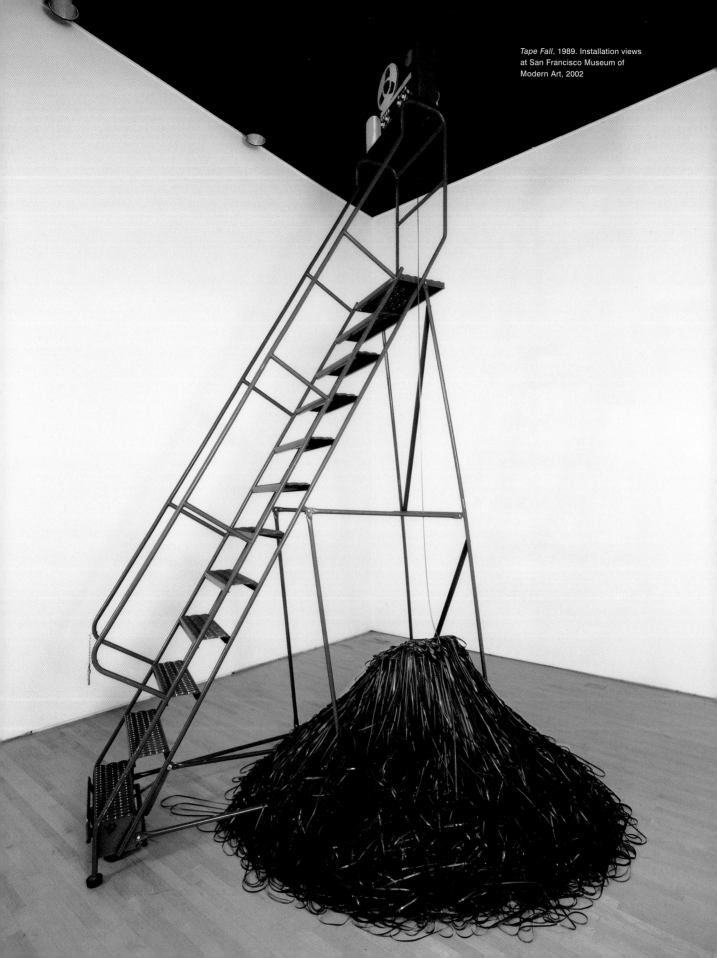

Tape Fall, 1989. Installation views
at San Francisco Museum of
Modern Art, 2002

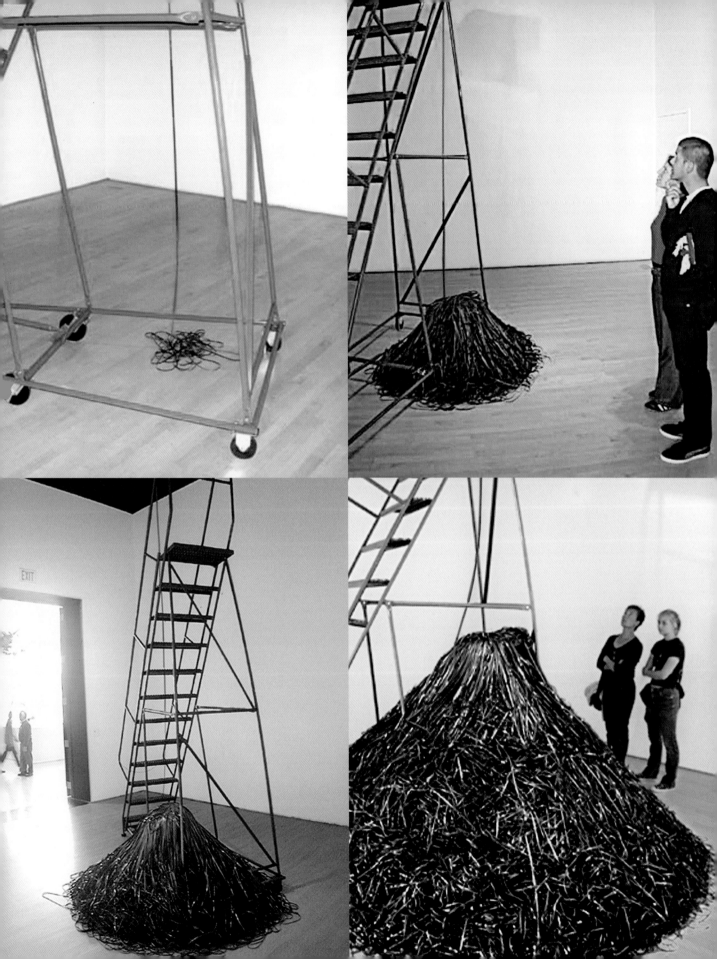

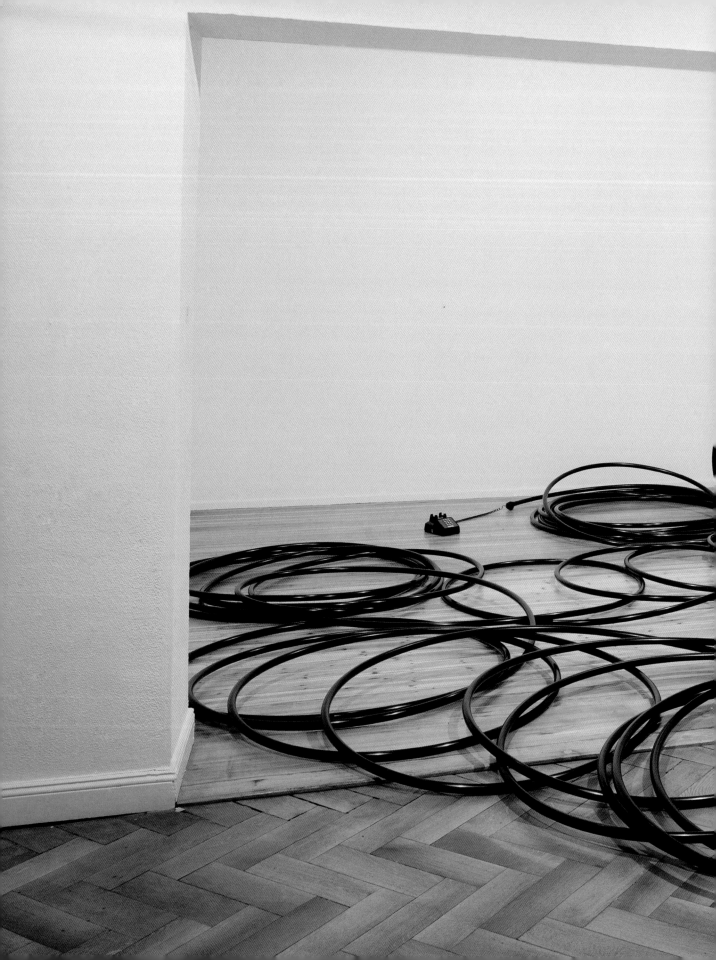

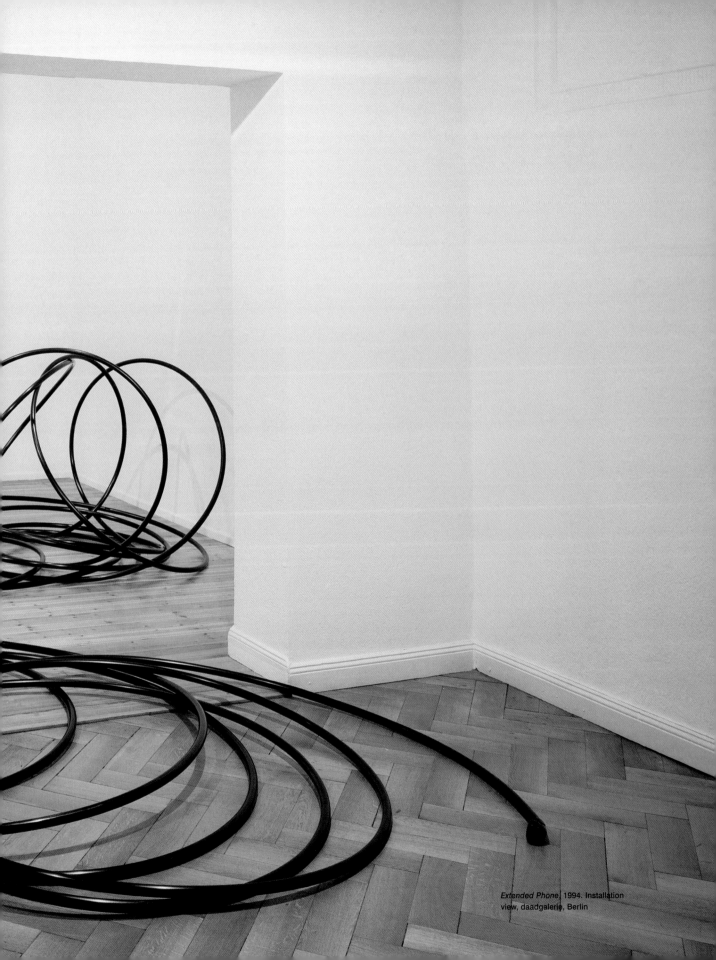

Extended Phone, 1994. Installation
view, daadgalerie, Berlin

Above: *Dialogue of the Giants*
(Version 1), 1988
Opposite: *Boneyard*, 1990

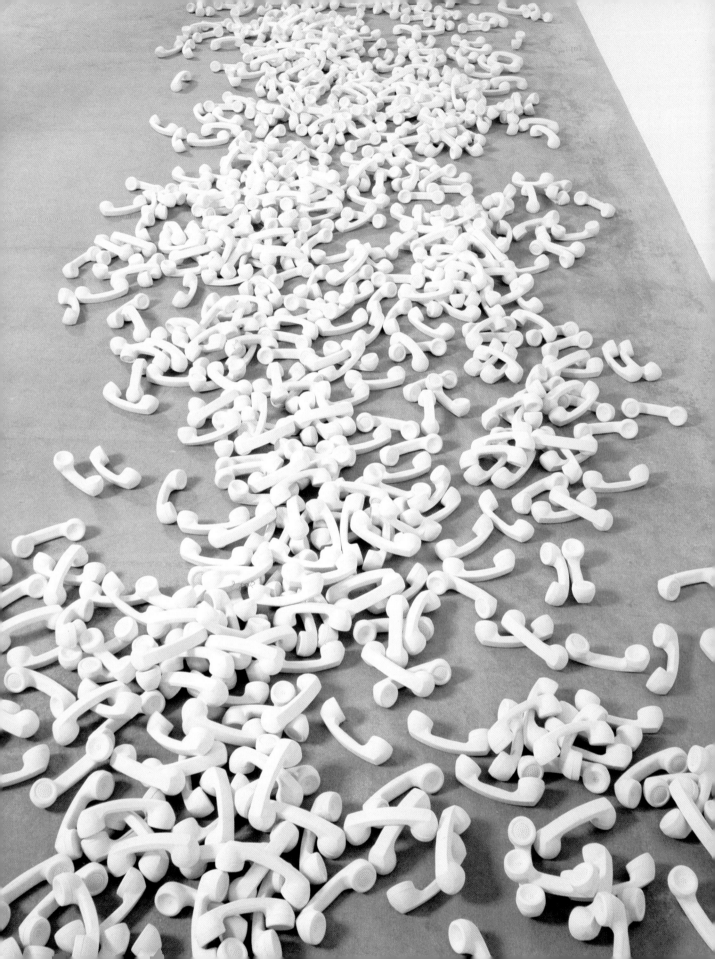

Surround Sound

Douglas Kahn

Christian Marclay is an artist who works with the embedded ubiquity of sound. He has located sounds in so many settings that their accumulation has begun to signal a new sense of how wide-ranging the state of sound might be. An important part of this effort has been aided by his willingness to pursue sound where it is ostensibly silent, harbored in the private audition of thought or registered in normally mute materials and representations. Sound is often thought to be dependent upon an action or force to lend it a fleeting, ephemeral existence. However, when the embeddedness of sound is sought, all the effects and intimations of sound are included, even those that exist long before or after a sound in the conventional sense.

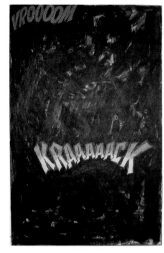

Onomatopoeia (Kraaaaack), 1989

To take a concrete example of the various ways in which a sound may be *embedded*: when the Indonesian volcano Krakatoa blew in 1883, the eruption was heard for hundreds of miles. "Blew" evokes explosion and blowing, a violent venting that includes a variety of materials both real and imagined, fused in an incendiary event. It is where action, sound, and listening are joined, but even then there are different *reports*. The force of Krakatoa's echo arrayed infinite scenes of destruction, both the remains and the absence of the island. At the time the eruption was heard very far away, and was carried much further by a journalistic echo that continues in histories, casual citations such as this, and vulgar references to pustules. Today, the name alone conjures up ideas of an explosive sound on a massive scale, aided no doubt by the onomatopoetic KRAK lodged in its name, as if it were the attack of the sound itself.

The closest example of the *ubiquity* of sound is in Western ideas of a *totality* of sound. Such ideas go back to antiquity, to a cosmological sound that saturated terrestrial existence so completely that no one could hear it except for an adept like Pythagoras, who happened to have championed the idea. This of course underscores the notion of the "music of the spheres," which people have contemplated off and on for centuries and survives in different versions to this day. In the modern period, such ideas were left to the big plans and big designs of Western art-music composers and commentators, from the utterances of the Romantics through the grandiloquently humble listening of John Cage, assigned to the metaphysical beat. The notion of a totality of sound relied on subsuming the expanse of sound under the inherited precepts of Western art music. Twentieth-century composers who sought hitherto extramusical sounds as sonic material clipped sounds from their roots, from their embeddedness in the world, leaving only phonic, socially deracinated remains, in order to make the claim that they were dealing with all sound. These composers shied away from the musical and sonic actualities of popular culture and mass culture, while nevertheless showing a willingness to appropriate

Arthur Køpcke, *Music while you work*, 1972

more distant cultures and musics. They avoided material cultures and the corporeal, removing themselves from whole realms of daily experience.

This modernist totality of sound should not be confused with the ubiquity of sound that Marclay is beginning to demonstrate. A totality can be grasped all at once; conceptually it is contained, a top-down approach where the importance of the particulars is diminished in service of the whole. Ubiquity, on the other hand, can only be experienced through its particulars, through a bottom-up approach. As such it will always be incomplete, in a state of formation, never achieving the closure that a totality claims at its inception.

Other artists have explored many states and types of sound without appealing to totality. This is particularly true of the generation of artists coming of age in the late-1950s and 60s: Joe Jones, George Maciunas, Yoko Ono, Nam June Paik, Ben Patterson, Mieko Shiomi, and many other inter-media artists, including Michael Snow, Bruce Conner, Max Neuhaus, and Annea Lockwood. Unwitting influences and various precursors to specific Marclay methods, including his cut-up and modified LPs, can also be culled from the work of Arthur Køpcke and Milan Knížák. At the same time Spike Jones and Ernie Kovacs ushered in and extended the vaudevillian tradition, with its slapstick and melancholic sound and sound effects, into mass media, which even found fans among some of the artists just mentioned. Indeed, the acceptance of popular culture was pivotal for artists such as Paik, Ono, and Conner. It should be mentioned that none of these artists, despite their varied insights on the embeddedness of sound, ever produced the diversity of work to signal a ubiquity of sound.

In 1977 Marclay was exposed first hand to the latest in the club scene's punk, new wave, and performance art while participating in an exchange program at the Cooper Union in New York, where he studied with Hans Haacke. Back in Boston, his burgeoning interest in music and performance rendered him useless to the sculpture department at the Massachusetts College of Art (MassArt) where he was a student, so he retreated to the hospitality of its Studio for Interrelated Media. Soon thereafter he took the stage in a Duchampian punk duo, The Bachelors, even, playing recordings on old turntables commandeered from the audio-visual department, unaware until several years later of the contemporaneous scratching by Grandmaster Flash, Afrika Bambaataa, and others. In 1980 Marclay organized Eventworks '80 in order to explore the relationships between punk rock music and performance art, and brought to Boston such acts as DNA, Karole Armitage and

Rhys Chatham, Dan Graham, Johanna Went, Beth B and Scott B, Julia Heyward, and Eric Bogosian. Roselee Goldberg lectured on the historical background. Here, in the fusion of performance with music, is how many people first encountered Marclay, playing turntables for mercurial groups of the Lower East Side improv scene in New York City.

The vibrant trade between music and the other arts conducted under the umbrella of performance opened new artistic possibilities, just as more recently they have opened up under the auspices of sound. Marclay has long been in position to develop the relatively unexplored territory of sound. He is moving past the particularizations characteristic of postmodernism, whether in the scattershot of pastiche or the melange of identities, and developing, almost by default, a comprehensiveness characteristic of modernism, yet without the presumptions underlying notions of modernist totality.

Marclay's sense of the expanse of sound hearkens back to discourses of the nineteenth century, before sound began to be filtered through the reductive tropes of Western art music in the early twentieth century. The development of scientific instruments for visualizing sound, and of audio-phonic media and communication technologies exemplified by the telephone and phonograph, encouraged ideas of bringing sounds into visual and textual registers, into inscriptions (the jagged lines of phonography) and objects (cylinders, discs, amplifying horns, telephones), bringing sounds from far off distances and different times and equalizing them as phenomena in the very idea of "sound." More and more sounds were brought into daily existence, into visual, material, and commodity culture, in unprecedented ways, subsequently transforming the listening to, making of, and understanding of sounds.

Untitled, 1989

Writers were the first to put the potential of these new developments to work. Luckily, they were only required to work with the ideas of the mechanics, avoiding the limitations of the mechanism itself. Thus, early instances of sound in the arts were within the realm of the conceptual. Alfred Jarry, the eccentric Frenchman whose famous "Merdre!" launched the avant-garde, could very well be the earliest precursor of Marclay, as well as the first turntablist. Mixing modern technology, the mythological, and the rampant misogyny of the time, Jarry spun a short tale about a cylinder in "Phonographe" (1884), in which the contraption becomes a

"mineral siren." Here one of the castrating songstresses is sunk into the perch of her coastal rock in the same manner that Echo—an uppity nymph always getting in the last word, punished by repeating nothing but last words—had been banished to the monotonous task of reproducibility as a rock face. About a century later, Marclay melded technology and mythology when he tiled a floor with thousands of compact discs in *Echo and Narcissus* (1992): a hard space of pending audio-phonic replay played the female lead of Echo, released from repeating everyone else's sounds by the grit and grain in her voice, and the pooling of mirrored surfaces played the male role of Narcissus, looking his very best until the wear and tear of gallery visitors walking on water took its toll.

Several projects by Marclay suggest that the expanse of sound has roots in art that go back much further than the discourses of the nineteenth century. In a facsimile issue of *Züritip* (5–26 September 1997), a supplement of the Zurich newspaper *Tages Anzeiger* that he edited in conjunction with an exhibition, Marclay included a reprint of Richard Woodbridge's 1969 paper from the Institute of Electrical and Electronic Engineers calling for an "Acoustic Archaeology," which would provide means for detecting sounds caught in pottery and paint strokes. This led Woodbridge to consider other sites for "adventitious acoustic recording," such as "Scratches, markings, engravings, grooves, chasings, smears, etc., on or in 'plastic' materials encompassing metal, wax, wood, bone, mud, paint, crystal, and many others. Artifacts could include objects of personal adornment, sword blades, arrow shafts, pots, engraving plates, paintings, and various items of calligraphic interest."[1] Acoustic archaeology, in this regard, suggests that the existence of sound in that historical phenomenon known as "art" was preceded by thousands of years at the inception of material culture.

With his 1997 installation at the Whitney Museum of American Art at Philip Morris in New York, *Pictures at an Exhibition*, Marclay became a musical iconographer in order to suggest how sound has always played its part in art (earlier versions of this idea were presented as *Accompagnement musical,* Musée d'Art et d'Histoire, Geneva, 1995; *Musical Chairs*, Villa Merkel, Esslingen, 1996; and *Arranged and Conducted*, Kunsthaus Zurich, 1997). Following Modest Mussorgsky's composition of the same name, itself inspired by Victor Hartmann's drawings, Marclay's Whitney installation used a wide repertoire of drawings, paintings, photographs, and other artworks to create a composition that turned each viewer into a composer/performer of mental music. Over forty works from the museum's collection were hung salon-style, with Richard Artschwager's *Organ of Cause and Effect III* (1986) off to the side. Facing the

wall, arrayed pew-like (the Artschwager organ contributed to the church reference),
were several benches, each with a cushion covered in kitschy music-related fabric.
The images on the wall were all realist depictions of sound and music, even as
realism extends to a Roy Lichtenstein cartoon explosion. Many images elicited an
implied sound. Other images generated sounds through acts of interpolation; that
is, where images did not telegraph implied sounds, the observer/listener became
free to imagine an array of auditive possibilities. Indeed, the entire wall of images
became transformed into a grand score, as the room itself dissolved into a veritable
stage for mind-music and conceptual sound improvisation. One might follow differ-
ent threads here and there, as in Nam June Paik's *Random Access* (1963, presented at
his "Exposition of Music-Electronic Television"), in which a tape recorder playback
head can be run over a pick-up-sticks-like array of prerecorded audio tape lengths
fixed to the wall; or venture off into improvisatory mixing, having already rehearsed
mental music from the elements of Marclay's Body Mix album covers.

Marclay's insistence on conceptual sounds poses a challenge for ideas of
listening, especially musical listening. It is usually thought that people cannot
grasp the multiple foci of musical and auditory phenomena in which many differ-
ent sounds can occupy the same space and time. The intricacy of a Bach fugue, for
instance, could not be fully experienced in real time. Attention is presumed to be
directed like a ray, scanning various parts in order to reconstitute the whole. In
this way, actual listening is understood to be inadequate. In turn, this may create a
source of humility that lends to the adoration of certain music. But what if private
audition was in fact capable of not only complex listening, but also handling even
more complex forms of internal performance? A complexly layered, infinitesimally
shifting mental performance could invoke innumerable genres and classes of sound
in continuous or disjunctive manners unavailable to composition, recorded forms,
or performance. It could become a rehearsal for even more complex forms of listen-
ing and musical or sound production. Music itself would become less an occasion
for adoration and more one for provocation. In a similar manner, the historio-
graphic listening and performance involved in Marclay's *Pictures* does not merely
unlock vibrations from the putative silence of the past, it does so for all images,
objects, and texts. Indeed, it is possible to think of mute images and objects only
if one can imagine a soundless imagination.

The intracranial stage is more active than many have imagined. The neurolo-
gist Wilder Penfield performed experiments to observe what happened when
different areas of the cerebral cortex were stimulated by a mild electric current.
He was, in effect, the first bio-turntablist, lowering a wire instead of a stylus onto

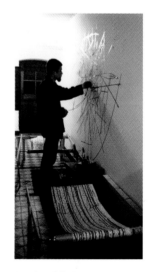

Nam June Paik, *Random Access*,
1963, installation view at Exposition
of Music–Electronic Television,
Galerie Parnass, Wuppertal, 1963

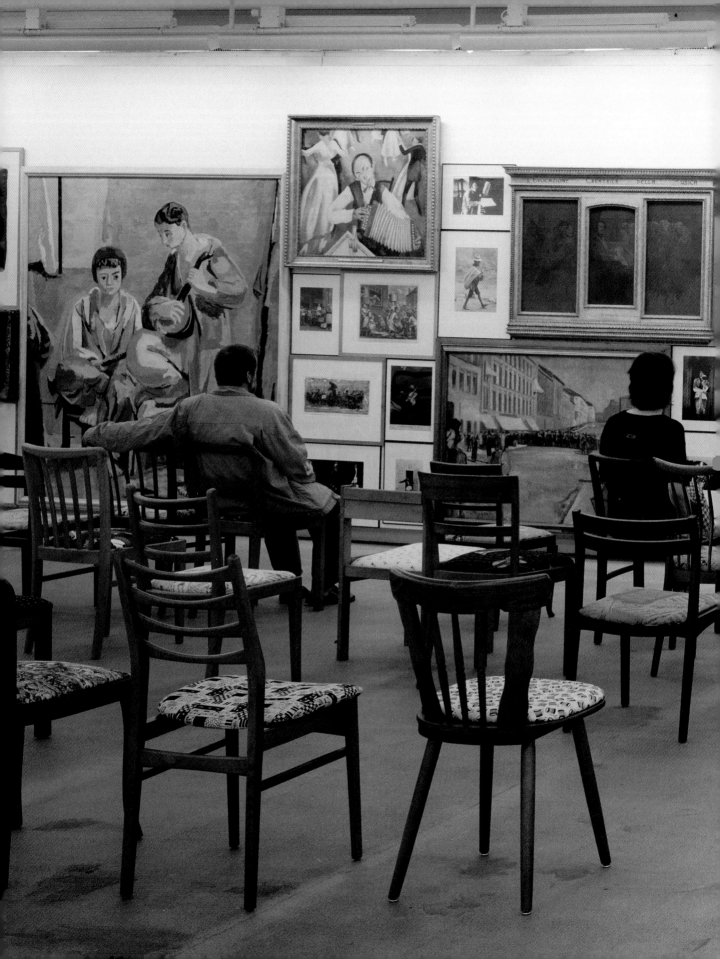

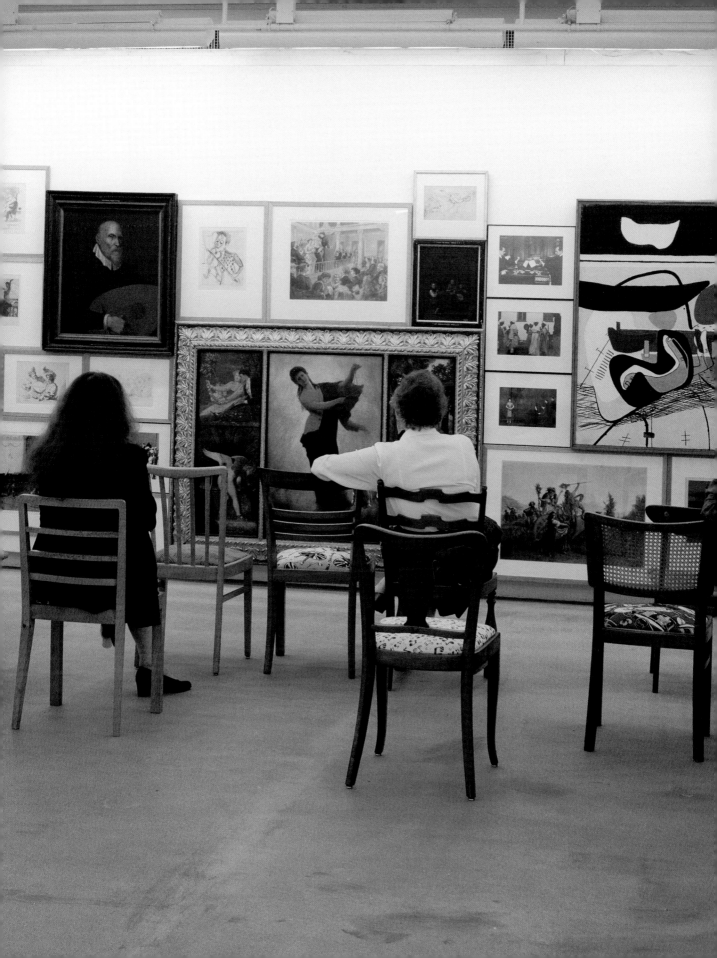

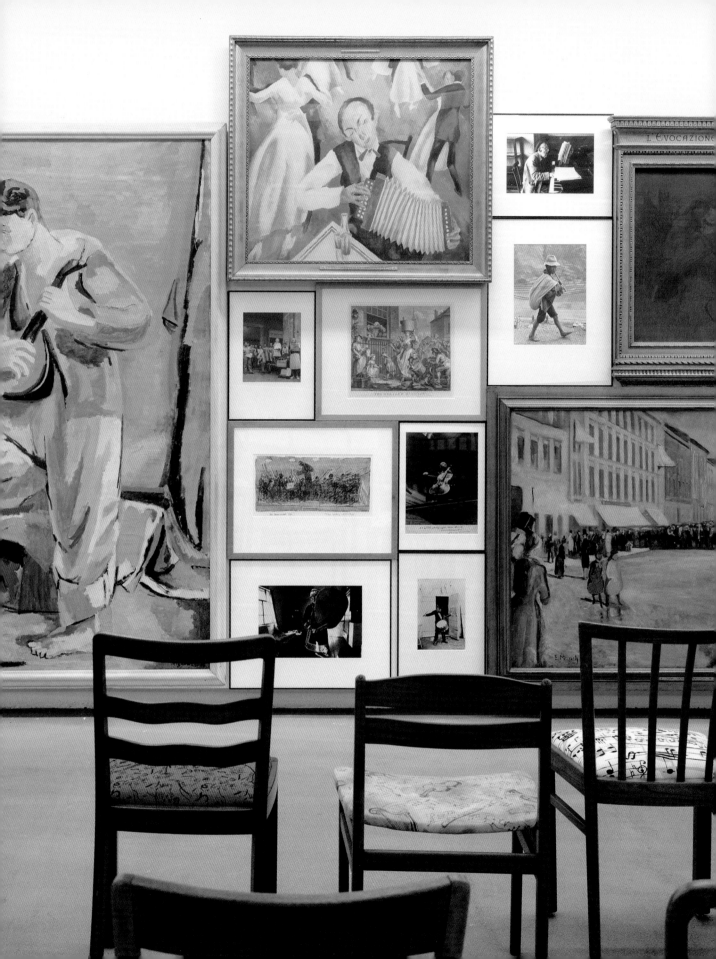

Previous spread and opposite:
Wall of Sound, 1997. From the
installation *Arranged and Conducted*,
at the Kunsthaus Zurich,1997
Above: *Interiors (Villa Merkel)*, 1996.
Installation view, Villa Merkel, Galerie
der Stadt Esslingen am Neckar,
Esslingen, Germany, 1996

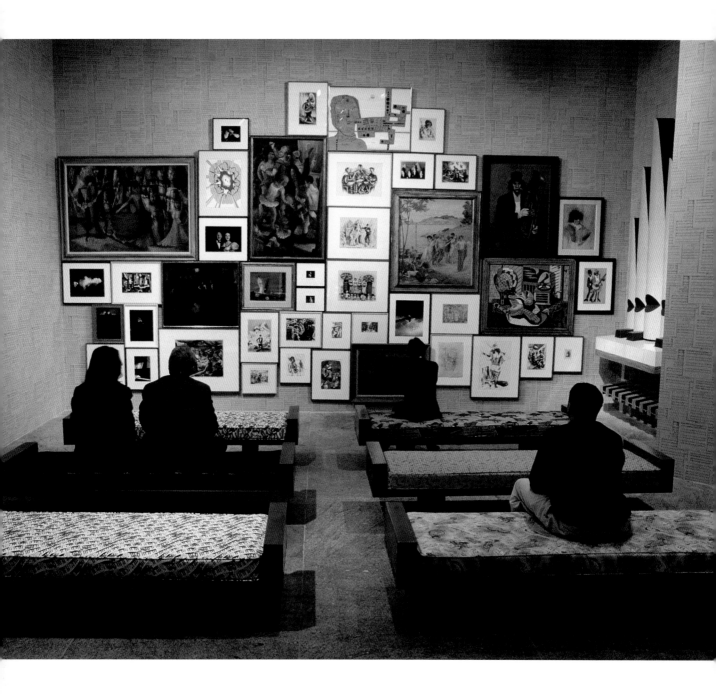

Above and opposite: *Pictures at an Exhibition*, 1997. Installation with artworks from the collection of the Whitney Museum of American Art, Whitney Museum of American Art at Phillip Morris, New York

the grooves of the brain. When Penfield brought the wire down on one patient's exposed brain, the patient, still conscious and alert, was convinced that there was a gramophone playing in the operating room.[2] Marclay has generated a commensurate understanding through less invasive means: "Everybody grew up listening to all this stuff, and all this music is, in a way, already sampled in our heads."[3] Playing with the records of memory turns everyone into a record player and fuses audiophonic technologies with neuro-technics. People in media-saturated societies have so many songs, noises, sound bites, and snippets recorded in their heads that they can register the type of quoting and referencing in Marclay's DJ work. Particular passages in a performance will be loaded only if they are already loaded, no matter how obliquely, in people's minds. One plays particular passages and plays with minds at the same time.

In other work, Marclay removes himself by asking the question why, if everyone already has all these recordings stacked in their bins, must a person wait for someone else to perform them to hear their contents? To this end he provides occasions for such performances. These are the performative parameters of Marclay's art—performing recordings and creating occasions for other people to perform—with which he plays both ends off the middle like an accordion. As the godfather of postmodern DJs, Marclay developed a formidable set of performance and improvisatory skills to manipulate materials and meanings. He improvises cuts and mixes between turntables and has cut up and mixed fragments of LPs themselves for these purposes. When he collages an LP he provides an occasion for others to perform the composition using latent sounds. In this way records ape that other form of recording on the front end of music: notation in a score. His *Recycled Records* (1980–86) are not neutral shards of a collage but the visual notation of stutter-step rhythms and curt segues among different musics, musicians, and their attendant social scenes. A *Recycled Record*, for instance, can become an icon, trumping all the framed gold and platinum records that stand for one-in-a-million by existing as one-of-a-kind.

In one respect, Marclay is bringing submerged cuts to the surface, working with a medium not designed to be cut or, more accurately, not designed to be cut anymore. After all, in the production process a disc lathe carves a jagged and bumpy groove onto the surface of the master recording, and this happens long after the producer confirms that a band is about to "cut a record." Just as Marclay plays off the term "record player," so too he may simply be taking this term literally. Cutting the surface relates to a second class of cuts: the scratches usually heard as distractions from the music. In this sense one of Marclay's cuts is a scratch from

Marclay in performance at the
Brooklyn Bridge Anchorage,
Brooklyn, New York, 1997

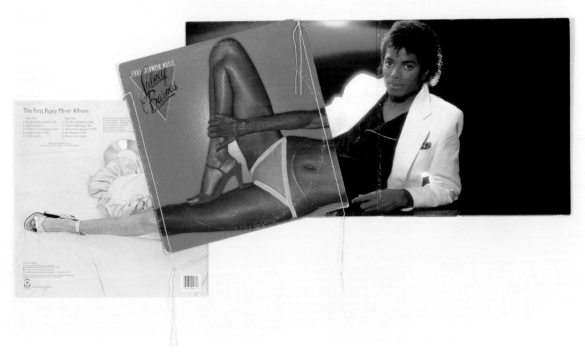

hell, an accidental skip that has been taken to extremes. Whereas the submerged character of the first class of cuts resembles genetic or computer code, the cuts apparent on the surface lead us back to that older artistic engineering form of montage.

Some of Marclay's Body Mixes undercut publicity by taking it literally, a tactic reminiscent of Jaroslav Hasek's Good Soldier Svejk, whose obedience, taken to a logical conclusion, resulted in sabotage. Thus *Footstompin'* (1991) contributes to the longtime transformation of another crotch grabber. Michael Jackson—seen here as an odalisque inherited from Edouard Manet via magazine centerfolds—morphs into Diana Ross, with whiteness beginning to creep up one leg. The corporate construction of Jackson as a celebrity along with his own internalization of surgical montage pushes Marclay's image perilously close to an act of documentary.

Bodies also extend to musical instruments, which as a class have a long history of anthropomorphism within the visual arts, such as in Salvador Dali's *Three Young Surrealist Women Holding in Their Arms the Skins of an Orchestra* (1936); Claes Oldenburg's similarly detumescent *Giant Soft Drum Set* (1967), deflating male aggression years before soft rock; or Charlotte Moorman and Nam June Paik's variations on a cello. Indeed, the tradition is so strong that when Marclay puts F-holes on *Door* (1988), we are prone to recall Man Ray's *Ingres' Violin* (1924), in which the nude Kiki sits with F-holes on her back, rather like a cello or double bass.

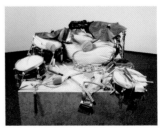

Claes Oldenburg, *Giant Soft Drum Set*, 1967

Installation view of works from the Body
Mix series at the Margo Leavin Gallery,
Los Angeles, 1993

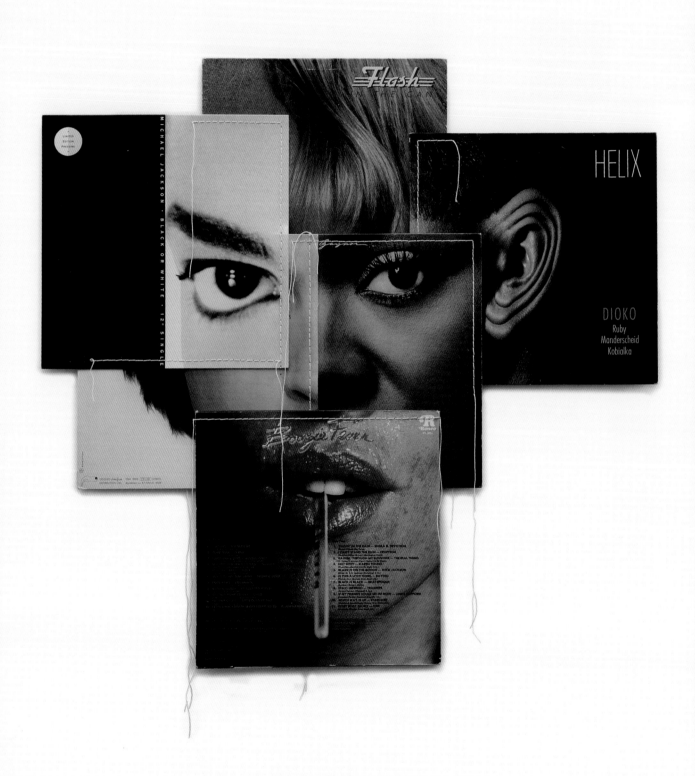

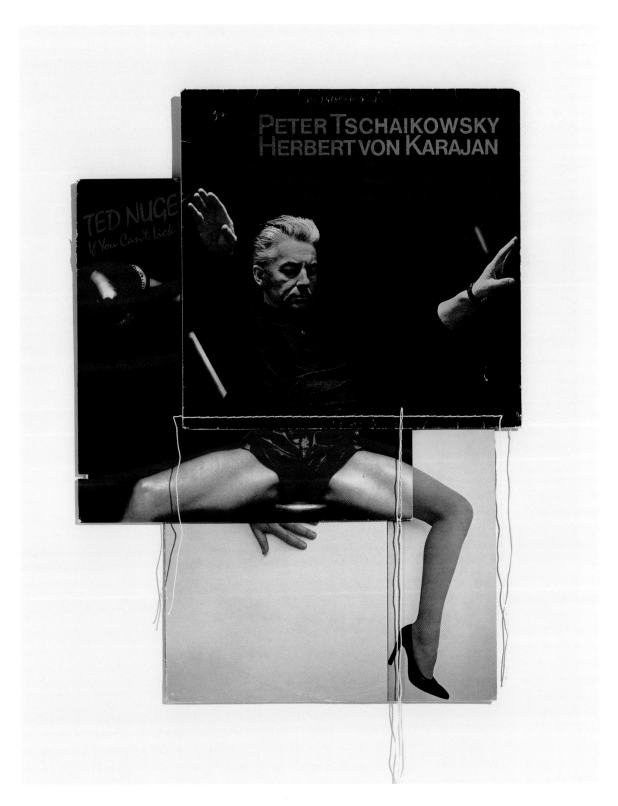

Opposite: *Black or White*, 1992
Above: *If You Can't Lick*, 1992

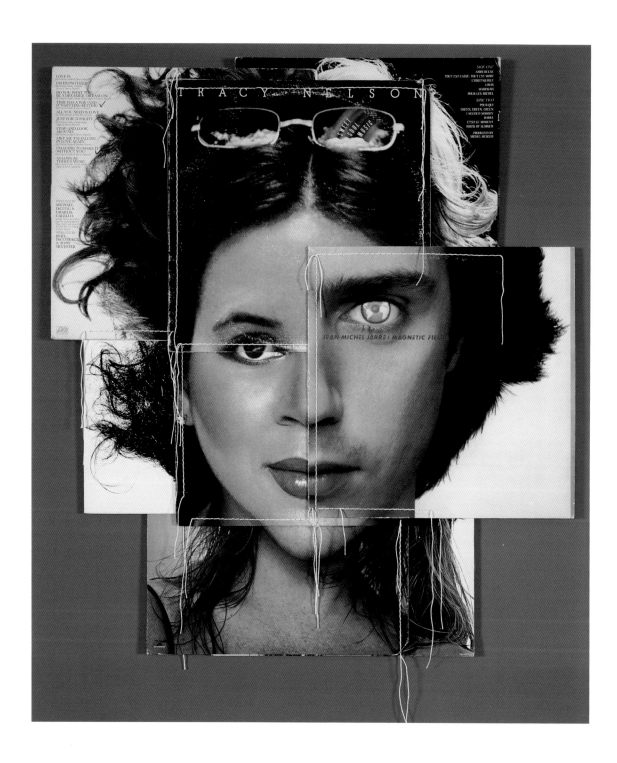

Above: *Magnetic Fields*, 1991
Opposite: *Slide Easy In*, 1992

Marcel Duchamp, *Door, 11 rue Larrey*, 1927

Likewise, *Door* invokes Duchamp's *Door, 11 rue Larrey* (1927), which he had built in a corner of his apartment so that it simultaneously closed on one room while opening to another. When closed, Marclay's *Door* would formalize the status of any room as a resonant chamber and, just like a lounge act, would "play the room."

Just as a record silently contains a characteristic set of sounds residing under the skin of an album cover, so too are all musical instruments examples of intrinsic sound (as is any object lacking the proper action to produce an audible sound). One room of *Accompagnement musical*, which was populated by the open, empty cases of instruments in the museum's collection, amplified the phantom character of the instruments, while the instrumental modification piece *Virtuoso* (2000) virtually broadcasts the long sustained tones it contains. Here Marclay plays on the instruments' own anthropomorphism—the lungs of its bellows and larynx of its reeds—and by doing so generates both a new music and a new scale of musician.

Anthropomorphism also underscores *Guitar Drag* (2000), certainly Marclay's grisliest work. *Guitar Drag* is a video of an electric guitar being dragged on a dirt road behind a pickup truck. Each bump in the road jars loose an additional reference. The most immediate is the tradition of guitar destruction in rock performance. Instrument destruction provided comic relief in many a vaudeville routine; it was up to rock to elevate it to dramatic spectacle. Inspired in part by Gustav Metzger's auto-destruction, guitar abuse and the noises it produced became signature moments for The Who and Jimi Hendrix. Marclay's pickup truck is not going down just any dirt road; it is a road in Texas. The piece refers to the modern-day lynching of James Byrd, an African-American man killed by three white men who chained and dragged him by his ankles outside Jasper, Texas. In this work you have Hendrix, but also Billie Holiday's "Strange Fruit," the aggression of young males, noise as transgression and as an ecstatic sound of hate.

Marclay has engaged film sound and music from the beginning of his career. While at MassArt he wanted to film a musical of sorts, because he liked the surreal manner in which people in musicals break out into song for little or no apparent reason. On John Zorn's concept album of the film music of Ennio Morricone, *The Big Gundown* (1985), Marclay can be heard at times spinning turntable sounds that reinstate the cinematic roots of the music. He contributed to the soundtrack for Abigail Child's short experimental film *Perils* (1985–87). More recently he has gone into conceptual overdrive with his video *Up and Out* (1998), a radical expression of the asynchronous sound-image principles first formulated by Russian revolutionary filmmakers in the 1920s and used to good effect by Jean-Luc Godard in *Je vous salue, Marie* (Hail Mary, 1985). More specifically, Marclay's interest in asynchronous sound-

image relationships derives from watching Merce Cunningham's dance company perform with John Cage's music: the choreography and the music are produced independently, and relate to one another only in that they are performed at the same time. Marclay was fascinated by how connections could be so easily made between the music and dance despite their functional independence. To make *Up and Out* Marclay stripped the soundtrack from Michelangelo Antonioni's *Blow-Up* (1966) and replaced it with the soundtrack from Brian De Palma's *Blow Out* (1981), itself an homage to *Blow-Up*. The visual images and soundtrack make a beautiful pair because the photographer (David Hemmings in *Blow-Up*) and the sound-effects specialist (John Travolta in *Blow Out*) are both forced into forensic roles, as are the viewers of *Up and Out*, who must use their wits to piece the images and sounds together. *Up and Out* also provokes insights into the workings of Euro-American media culture by cutting between two continents and two decades: here the counterculture's cry in *Blow-Up* clashes with the loud implosion of the early Reagan years in *Blow Out.*

His most recent video work is the masterful cinematic installation *Video Quartet* (2002), a four-screen projection made up of clips from hundreds of movie scenes depicting musical performance, along with other scenes of vocalization, general noise making, and even the calligraphic lilt of a ball rolling to a standstill. Although Bruce Conner is the Picasso of these parts (Conner accompanied The Bachelors, even on film during a performance at a club in San Francisco in the early 1980s), the earliest major practitioner of "compilation films," or films made with other films, was the Russian revolutionary filmmaker Esfir Shub, who used private home movies of Tsar Nicholas II in her *The Fall of the Romanov Dynasty* (1927).[4] *Video Quartet*'s meticulous composition of sound and image, from which the sound alone could easily stand, represents a departure for Marclay. Although he may not have been the first person to cut up and perform with records, he was perhaps the first to freely improvise with turntables. He has kept the primacy of performance attached to his music, while composition has largely been reserved for his visual work. In *Video Quartet* he is composing with both the visual and audio components of recorded performances, since the post-production techniques of cinema in general render it a compositional medium. The question arises whether Marclay will reinstate the recorded performances of cinema into live performative mode.

Through the diversity of his work, of which we have only scratched the surface, Marclay reveals the breadth of phenomena at the center of a general artistic and cultural shift toward sound. It is not an ecstatic revelation, but rather a slow burn that has developed as his oeuvre has grown and his approach matured.

Michelangelo Antonioni, stills from *Blow-up*, 1966

Marclay has gone beyond the limits of the modernist battery of sounds to include everything we can and cannot hear, and will never hear: all the symbolic and imagined sounds with their poetic, corporeal, and political resonances on display. He includes the sounds he has tracked to their existence in bodies, objects, images, scenes, texts, inscriptions, and in the mix of their complex relationships, where they can be heard as at least a whimper of an echo, as background radiation, as misfired memory. He releases sounds from their obligations as vibrating air, puts them in new lodgings, and relocates them through performance. The diligence with which he has investigated so many sites has had a cumulative effect. The work progressively generates an unfolding parallel of the embedded and ubiquitous nature of sound in the world. The way Marclay operates as a general discoverer of sounds wherever they might occur and however they might operate makes us all better listeners as a result. What makes Marclay's work thrive is how the context within which it can be understood has itself grown. Marclay is working the groove, cultivating the surround sound.

1. Richard G. Woodbridge, III, "Acoustic Recordings from Antiquity," *Proceedings of the IEEE* 57, no. 8 (August 1969): 1465–66.

2. Jefferson Lewis, *Something Hidden: A Biography of Wilder Penfield* (New York: Doubleday, 1981).

3. Marclay, in Vincent Katz, "Interview with Christian Marclay," *The Print Collector's Newsletter*, 22, no. 1 (March–April 1991): 7.

4. See Jay Leyda, *Films Beget Films: A Study of the Compilation Film* (New York: Hill and Wang, 1964).

Record cover for *Untitled*, 1996

Following three spreads:
Video Quartet, 2002. Installation
view, San Francisco Museum of
Modern Art, 2002

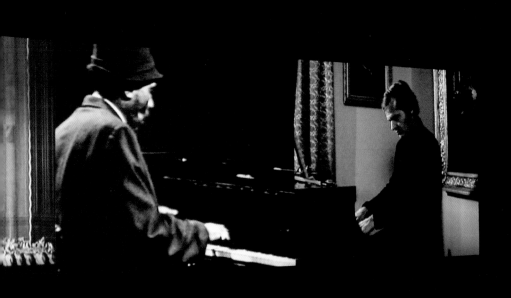

CBGB as Imaginary Landscape:

The Music of Christian Marclay

Alan Licht

In the late 1970s Christian Marclay was an art student interested in the performance art of the decade and, by extension, the punk and No Wave music scenes then peaking in New York. "At the time I felt what was happening in the clubs was more interesting than what was going on in the galleries," Marclay remembers.

> Punk rock was physically aggressive in the same way that Vito Acconci's body works of the time were. Vito was a punk before punk in some ways. He was always very interested in rock-and-roll even though it may not be obvious. I think that aesthetic attracted him and I remember seeing him a few times in clubs. In some cases punk performances were virtually interchangeable with the body art of the era.[1]

Marclay witnessed one Sid Vicious set at Max's Kansas City "that was almost like an Actionist performance. The guy was such a wreck, bruised and cut; it was almost a kind of public sacrifice with him hurting himself onstage. It was bizarre." Marclay had no formal background in music either as a player or a listener, but the near amateur status of the bands he was seeing made him feel that he could be a participant. (DNA, for example, had literally picked up their instruments just weeks before their first performance.) Inspired by his experiences at punk clubs, he returned to art school in Boston and formed a performance duo with Kurt Henry, The Bachelors, even. Unlike many others inspired by punk to form a band, he didn't bother to try to learn an instrument. Although he was singing songs, he was also playing scratched-up records on turntables as a rhythm device. "The more I worked with the records the more I realized the potential of all the sounds generated with just a turntable and a record and started to appreciate all these unwanted sounds that were traditionally rejected: skipping, clicks and pops, all this stuff that people didn't want. I started using these sounds for their musical quality and doing all kinds of aggressive, destructive stuff to the records for the purpose of creating new music." Following the punk taste for cheap equipment, Marclay used Califone turntables, the old models commonly used in schools. He also relied on trashed fifty-cent records retrieved from thrift stores.

The Bachelors, even were equally visual and aural. They used slide projections and film loops. They chopped wood and smashed glass, lights, TV sets, and mirrors onstage. But it was the physical manhandling of the records that provided the freshest avenue to express the punk aesthetic and also to update certain experimental pop trends of the 1960s. Jimi Hendrix and The Who used amplification sounds of feedback and noise and incorporated them into pop songs. Hendrix played with his teeth; The Who's Pete Townshend used to cut himself by windmill-

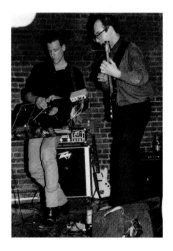

Marclay performing with Elliott Sharp at the Ski Lodge, New York, 1983

Nam June Paik performing his *One for Violin Solo*, Neo-Dada in Der Musik, Düsseldorf, 1962

strumming his guitar—both gestures akin to the later performance/body art scene. More importantly, both destroyed their instruments on stage as part of their shows. Townshend has cited the Auto-destructive artist Gustav Metzger as an influence; Metzger had lectured at the art school Townshend attended, and destroyed a bass guitar during his lecture. Metzger also painted with acids, so that a picture was consumed as it was executed. Interestingly, Marclay has written that, "the natural fate of live music" is "to disappear as it's being played, and I prefer it that way."[2] Fluxus performances during the 1960s often involved the destruction of instruments—in one case La Monte Young burned a violin onstage (as Hendrix would do to his guitar at the Monterey Pop Festival several years later). Marclay also witnessed a later Nam June Paik performance at CBGB during which he smashed a violin.

Marclay's abuse of the then-sacred vinyl LP, which most people took pains to avoid scratching or scuffing, is inherited from the pop/Fluxus tradition. Records, however, are household objects. To destroy them was not the act of a rock star breaking a valuable instrument. It was closer to the punk aesthetic of everyday demolition. Using records also demystified the music-creating process, as it did not involve mastering or even utilizing instruments few knew how to operate—virtually anyone could use a turntable. It took the do-it-yourself ethos of punk to a new level. Marclay also let the audience see as much of his music-making as possible. "I always tried to play in clubs where you had a closer relationship to the audience, where people could see what I was doing. It was important to show the process, how the music was made." Indeed, The Bachelors, even had originally used cassettes of skipping records for a rhythm track until Marclay realized he could show the audience how the sounds were generated by bringing the turntables onstage.

In art school Marclay had been making art that was rooted in performances and more site-specific installations that would exist for a few days at the most. Graduating in the early 1980s, he found himself much busier as a touring musician than as an artist. "The only objects I was making then were these homemade records, the *Recycled Records* I used in performances or displayed on turntables so people could listen to them. I liked the idea of making a record that was unique; every time you play it it plays differently, the needle jumps around." Although he was performing carefully rehearsed solo pieces for multiple turntables, the unpredictability of the recycled records made them a natural fit in the free improvisation scene that was growing in downtown New York. The scene centered around John Zorn, a composer and saxophonist who was blending composition and improvisation

The Bachelors, even (Marclay and Kurt Henry) in their installation *Free Coffee*, Gallery Naga, Boston, 1980

in game pieces whose structures grew out of rules for sporting events rather than conventional music scores. Marclay had never heard of Zorn, who called him out of the blue in 1983 to invite him to play in a piece called "Track and Field." "John really enjoyed my stuff. I could throw the band into a totally different direction just by a drop of the needle. I was using a lot of quotations, a little jazz, a little classical, rhythmic stuff, disco, polka. My eclectic taste fit perfectly with John's ideas of collage, using jump cuts. I became really important to his aesthetic."

Zorn was zealous about the fast cut-up methods of cartoon composer Carl Stalling and avant-gardists like Earle Brown and Mauricio Kagel. However, while Marclay was aware of certain Fluxus music pieces and John Cage's "Imaginary Landscape No. 5" (1952), he was neither coming from nor aiming for that realm. "I never even thought of what I did as music; why would I call myself a musician? I never studied music. I was trying to make performance music. It was such a different environment than serious contemporary music." Creating sound collages with thrift-store records and Califone turntables as opposed to expensive reel-to-reel tape in an expensive or government-funded studio, as Musique Concrète composers like Pierre Schaeffer and Pierre Henry did, is in line with the punk ideology. It was also in sync with the postmodern trends of the art scene at the time. "In the early 80s art world there was a lot of appropriation before hip-hop became big. Richard

Above and following spread:
Recycled Records, 1980-86.

The label on the record reads:

RED SPOT

SIDE A
SUB 15
33⅓ rpm

8:30
2:52
4:30
2:07

1. MINIMAL MAN: DRONE SEQUENCE
2. RESEARCH LIBRARY: INSOMNIA
3. RESEARCH LIBRARY: BLIND LOVE
4. MOON: CIÊLO 07 FOXBOT

Prince would take ads and mess around with them. Sherrie Levine would re-photograph Walker Evans. Why create something new and unique when there's so much around to deal with? The idea of sampling things, collaging them, transforming them, that was a natural way of making things for my generation."

With the exception of DNA's Arto Lindsay and Ikue Mori, who also began performing with Zorn, most of the other game-piece participants were trained musicians. "I always felt like the outsider. It was a huge learning experience to be around these musicians who could really play. Those game pieces were very performance-oriented, and they were fun to do. The process was partly revealed to the audience, but to really enjoy it you had to be an insider, be doing it." Improvisation itself was a new experience for him.

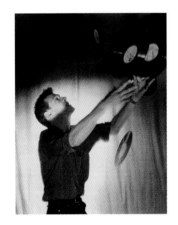

Marclay, 1982

> Unlike a DJ that would segue one record into the other, in the game pieces you had to be quick, in some cases rely on chance. I learned how to accept and believe in improvisation. It took me a while because when I did my solo pieces I was totally into rehearsing, organizing my records, which were numbered. I had everything worked out: a beginning, a middle, and an end. I would spend a lot of time rehearsing and in the process damage the fragile records; some loops would disintegrate after a while. The rehearsal process was contradictory with the fragility of the instrument. I was spending too much time trying to achieve what I had in my head instead of listening to what was happening during the performance. So I started trusting my ears more and performing with no preparation. It took me many years before I could just show up at a gig with just a bunch of records and no idea of what I was going to do. It was very encouraging to hear trained musicians say, "oh, don't even try to learn." They were sometimes envious of my very naïve approach. They enjoyed it because it didn't come out of the training that they were sometimes enslaved by.

Like Brian Eno and Lindsay, Marclay is an untrained musician whose musicality puts him in demand with trained musicians. Marclay began performing with David Moss's Dense Band and in various improvised contexts with many of Zorn's other associates—Wayne Horvitz, Zeena Parkins, Elliott Sharp, Fred Frith, Tom Cora, and others. This arrangement sat well with the performance orientation he had started with—for the most part recordings of these concerts were not released.

> I was not very interested in putting out records to document the performances, to freeze the spontaneity. I liked that it happened at a certain time, whoever

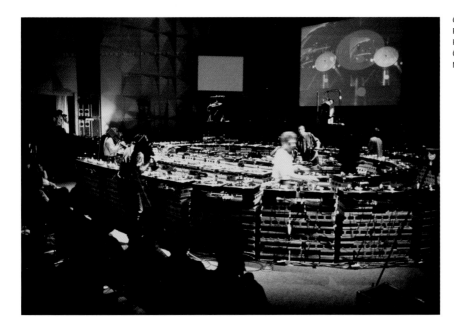

One Hundred Turntables, 1991.
Performance with Nicolas Collins,
Perry Hoberman, Jazzy Joyce, and
Otomo Yoshihide at Panasonic
National Hall, Tokyo

was there experienced it, and then it was over. We tend to think of music as this sightless thing because recordings have distorted our understanding of music. We think it's this totally abstract thing that comes from nowhere and just exists as a recording, a disembodied invisible performance. Going to a club and experiencing music being made on the spot is totally different. What I don't like about "live" recording is it never gives you the full picture.

I'd seen Marclay perform as an improviser many times in New York over the past decade, in duos with Shelley Hirsch, Christian Wolff, and Lee Ranaldo, or trios with Yasunao Tone and Jim O'Rourke, Erik M and Catherine Jauniaux, and others. I'd always admired his skills as an improviser—he would listen carefully to his co-players and always come up with unexpected and exhilarating contributions. I also recall one solo set at the Knot Room of the Knitting Factory that memorably ended with four records spinning so fast they sounded like an army of dental drills.

I've since performed on guitar with Marclay as part of the group Text of Light, with Lee Ranaldo on guitar, William Hooker on drums, and Ulrich Krieger on saxophone, which improvises musical accompaniment to films by Stan Brakhage. With a wealth of recordings at his disposal Marclay's presence consistently changes the performances in interesting ways. Some records he chooses will seem to comment on what the rest of us are doing, playing a sax or drum record for instance, or

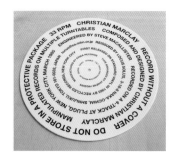

Record Without a Cover, 1999
(re-issue of 1985 LP)

he'll interact texturally or rhythmically with another instrument. Sometimes he'll create a loop in tandem with loops that Lee or I have created. His scratching and changing of speeds will sometimes initiate a response on the guitars' part with the vibrato arm or manipulating controls on a delay unit to simulate his sound bending. The sheer density of sound Marclay can conjure with multiple turntables and effects also makes Text of Light's music more ambient and spacious than it might be otherwise—it keeps everyone else's playing from getting too cluttered, and without it the music would tend more toward electric free jazz. The variety of sounds available to him also steers the group away from genre—a string quartet or a Hawaiian band can be summoned out of nowhere (this is a good part of why Marclay was so welcome in New York's non-idiomatic improvisation scene). As it stands, the continuous flow of sounds into one another is perhaps a twenty-first century style of psychedelia that is still being developed.

Marclay released *Record Without a Cover* in 1985, a record that is completely referential to, and highly critical of, the medium itself. It was sold without any protective packaging, its title and credits engraved on one side and the music on the other. Inevitably it was damaged before it even left the stores and would play differently each time as it deteriorated. Recorded using several turntables, *Record Without a Cover* is a recording of Marclay playing records, and it becomes difficult if not impossible to tell if the skips and pops one hears are recorded or are surface noise on the vinyl itself. When one drops a needle at the beginning of a record, one is accustomed to hearing a few snaps or clicks on the outer groove before the first track starts. On *Record Without a Cover*, however, this goes on for ten minutes, as if delaying the start of the music. As the music stops near the end the bare clicks return, but then a minute or two later more music resumes. "It underlines the fragility and pitfalls of the medium; instead of lamenting over the failure, I used it. This awareness of the medium comes out of an art practice rather than music."

Marclay cites as a parallel Michael Snow's films, which foreground camera movement, film stock, filters, splice marks, and other technical elements of film in a structural approach that never lets you forget that you are watching a movie. Bruce Conner's films, with their use of repeated countdown leader tape, false endings, loops, and found footage, might be an even better comparison. The beginning of *Record Without a Cover* certainly recalls the start of Conner's *A MOVIE* (1958), which fixates on the title card for an extended duration. "I wanted people to listen to this record with this kind of push-and-pull of the attention, never able to forget the record spinning on the turntable, thinking twice about what they were hearing, instead of the traditional playback where you just sit back and listen to the recording

Bruce Conner, *A MOVIE* (stills), 1958.

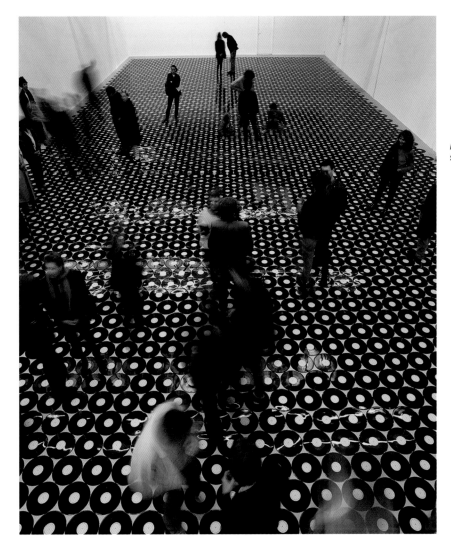

Footsteps, 1989. Installation view,
Shedhalle, Zurich

and ideally forget that it's a recording." In 1989 Marclay made another record,
Footsteps, of his own footsteps as well as a tap dancer's. He then covered a gallery
floor of the Shedhalle in Zurich with 3,500 of these records. At the end of the exhi-
bition the "defective" (this time from the gallery visitors' footsteps) records were
packaged in boxes and sold, thereby shifting the performance to the playing of the
record itself, rather than the record as a document of a performance. Since the
footsteps created sounds much like a record's skips and pops, each record plays a
well-matched improvisation between the surface noise and the recorded sounds.

The CD *Records: 1981–1989* (1997), a compendium of stray compilation tracks
and home recordings, provides the best overview of Marclay's solo music activities
during the eighties. The key characteristic of the music is the juxtaposition of
kitschy jazz, exotica, dance music, and classical sounds, often looped or warped by
changing turntable speeds and scratching, with the records' actual surface noise
always present to remind the listener of the vinyl as the sound source. In a way
Marclay prepares records as Cage prepared a piano, so that recognizable sounds

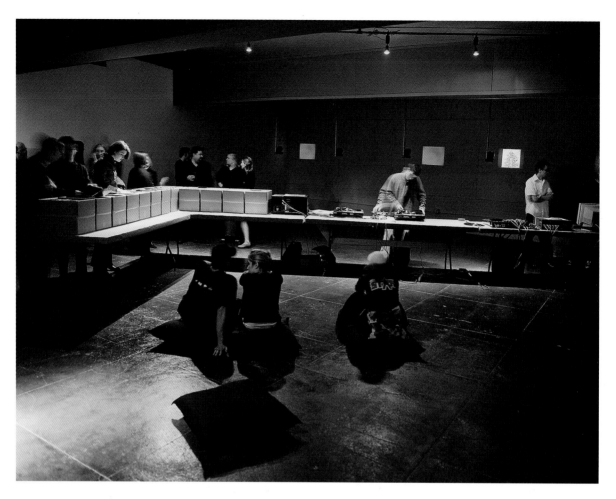

The Sounds of Christmas, 1999.
Installation view at ArtPace, A
Foundation for Contemporary Art,
San Antonio, Texas, 1999

would be modified in an unfamiliar way. Other sounds are only familiar as accidents, like the needle skidding across the surface of a disc—a sound usually to be avoided, but an integral part of Marclay's music. Some pieces try to band together related genre sounds, while others play mix and match with the recorded spectrum. In "Pandora's Box" he adds wobbly sax solos from other records to a big band backdrop "Brown Rice" has the sax solos on top of a rhumba beat and steel drums, while "Jukebox Capriccio" has a big band overlaid with classical orchestra recordings spinning at hyperspeed. "Neutral" starts off with whistling and grinding noises that morph into a murky, noirish ambience, and ends up with swing jazz. On other tracks the sound sources comment on each other more specifically. "His Master's Voice" combines a fire-and-brimstone anti-rock-and-roll sermon with the disco hit "Push Push in the Bush"; "Second Coming" loops a rock dance beat with moaning and groaning from a porno flexi-disc mixed in. "Black Stucco" features a deluge of scraping-needle sounds with suspenseful movie music, much like a section of *Record Without a Cover* where organ chords seem to melt as Marclay slows the record down, giving way to a squall of needle attacks. Though many pieces are structured by one sound leading to the next, or have the seeming randomness of spinning a

radio dial between stations (static included, of course), others display a gradual build that feels more predetermined. In "Smoker" white noise builds in density and volume to maximum effect; "Groove" layers loops gradually from a single drone to a thick nest of them powered by heavy beats. While much of his music is free form, "Groove" is one of several pieces that feature a continuous rhythm. "1,000 Cycles" employs one of Marclay's recycled records to keep a beat, while "Phonodrum" documents him performing on his homemade rhythm machine of the same name.

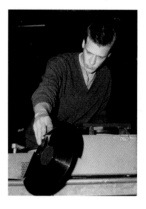

Marclay performing at Spit, Boston, 1985

The record industry's conversion to CDs in the late 1980s caused a crisis for Marclay's use of vinyl. Records were no longer the dominant medium. "I was ready to give up turntables in the early 90s. I felt it was kind of over. It didn't have the same meaning. Then with the whole alternative DJ movement, it became relevant again in a totally different way. I had people to play with; there was a DJ scene open to improvisation and experiments." The burgeoning New York DJ scene in the early and mid-90s featured performers like DJ Olive and DJ Spooky who were conversant with both hip-hop's scratching lexicon and Marclay's work in the experimental music world. Marclay initiated a project called djTRIO in which he would perform with two other DJs—often DJ Olive and Toshio Kajiwara. This was a group effort that hadn't previously been attempted by Marclay or anyone else. Additionally, people like Markus Popp and Christian Fennesz were creating audio collages including "unwanted" digital glitches with home computers and ultimately laptops, the next technological step from Marclay's adaptation of Musique Concrète techniques to turntables.

In two recent video works, Marclay has accommodated his interest in showing how sounds are made. In *Guitar Drag* (2000), a new Fender Stratocaster is plugged into an amplifier on a pickup truck, tied by its neck to the rear of the truck, and dragged across fields and highways in Texas. The Fluxus influence is evident here. Marclay has a photo in his studio of a Nam June Paik performance in which he dragged a violin on a rope behind him (*Violin with String*, 1961); there was also a 1960 precedent in which La Monte Young dragged a gong behind him. While the Hendrix and Townshend guitar destructions lasted only a minute or two, Marclay's decimation of the instrument lasts fifteen minutes. Like the records, the instrument gets progressively damaged as the piece goes on. As the terrain changes, so does the sound coming from the guitar. "I wanted to see how it would react to the different textures. It is almost like a needle scraping against different kinds of grooves, amplifying the ground. I think of it as being a piece about the landscape as well because it goes through these textures. It has a sense of place."

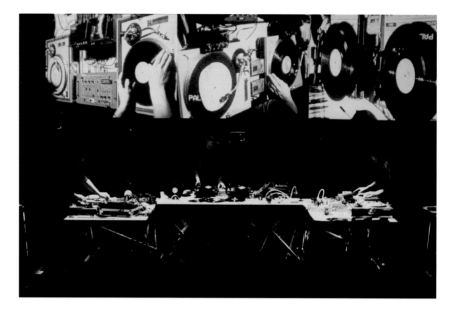

Video Quartet (2002) has a strong narrative arc and introduces a visual component to a structure that was established by the process he used in composing music. Four video screens show different film clips of people playing instruments or making sound in one way or another, mostly from Hollywood feature films but also from concert documentaries. Marclay recognizes its basis in his turntable work. "It's the same vocabulary of techniques, using snippets of sound and putting them all together to create a new unified composition." Marclay often favored four turntables in his performances, and on *Records: 1981–1989* there's an early piece called "Dust Breeding" that combines different solo-instrument records to make a kind of quartet. The piece starts with quick shards of sound creating a distinct pulse that accelerates in both speed and duration until four distinct instrumental sounds, introduced one by one, are playing nearly continuously. In *Video Quartet* the usual anonymity of his sound extracts is counteracted by the visual element, as most of the players are recognizable movie stars. In a turntable piece you might hear a toy xylophone juxtaposed with a piano; in *Video Quartet* you see and hear Dustin Hoffman playing a vibraphone in *Midnight Cowboy* (1969) and Jack Nicholson playing a piano in *Five Easy Pieces* (1970). The viewer must keep up with the synergetic associations between the sounds, the people making the sounds, and the film sources. The montage of sounds resembles the turntable pieces, but there is more control over what gets repeated and when. Some clips bounce from screen to screen or

alternate with each other at a speed that would be nearly impossible to achieve with turntables. As carefully composed and edited as it is, there is also an improvisational feel to parts of *Video Quartet*, as if each clip is reacting to another spontaneously.

"The image is always part of the sound," Marclay says of the selection process for the clips in *Video Quartet*. As music informs so much of his visual work, to call Marclay an artist/musician would be an oversimplification. Punk rock gave him license to intuitively forge a new music from the nexus between the art and music worlds of late-1970s New York. While the term performance artist could be applied to rock performers like Iggy Pop, Jim Morrison, Alan Vega, Hendrix, or Townshend, Marclay is the first to create music as an extension of performance art without using a traditional instrument, and without belonging completely to any one musical genre.

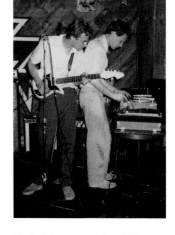

The Bachelors, even, Boston, 1980

1. All quotes unless otherwise specified are from Marclay, in conversation with the author, 2 January, 2003.

2. Marclay, in the liner notes for *Records: 1981–1989*, Atavistic CD 62, 1997.

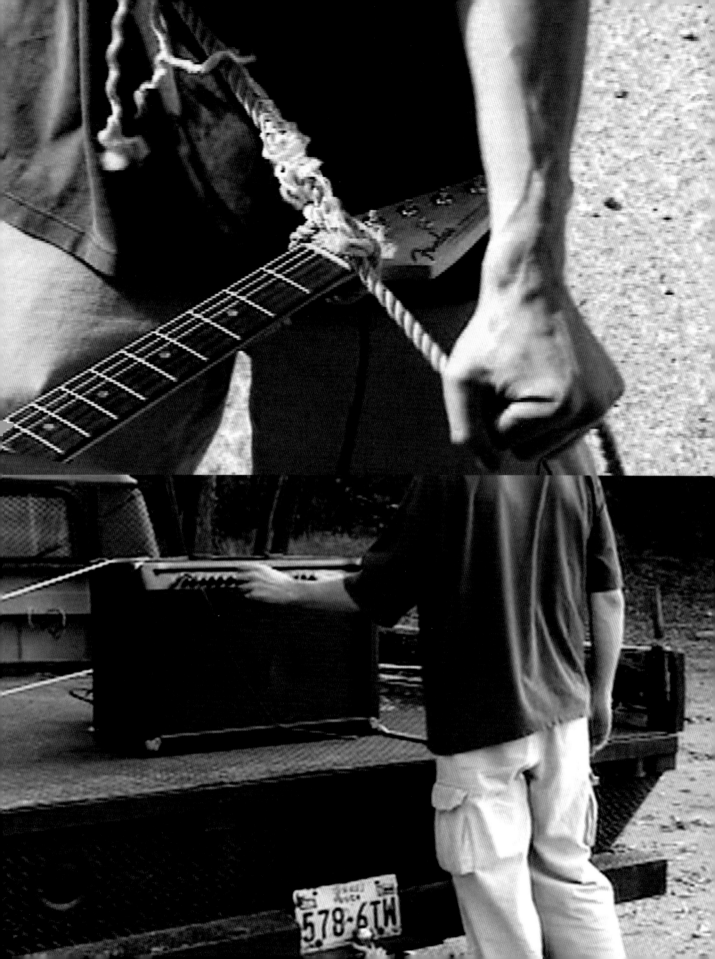

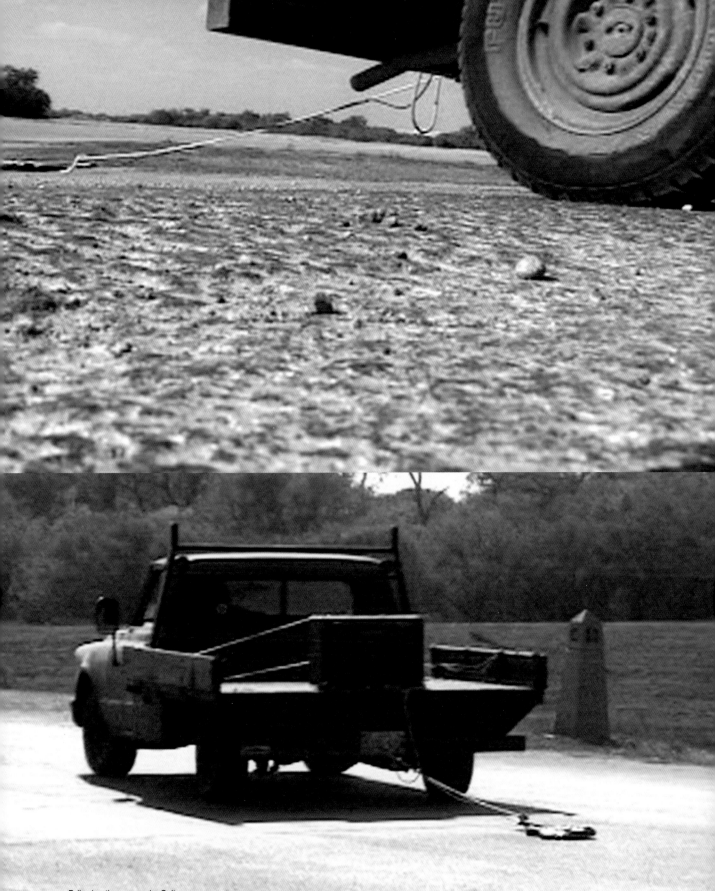

Following three spreads: *Guitar
Drag*, 2000. Video stills

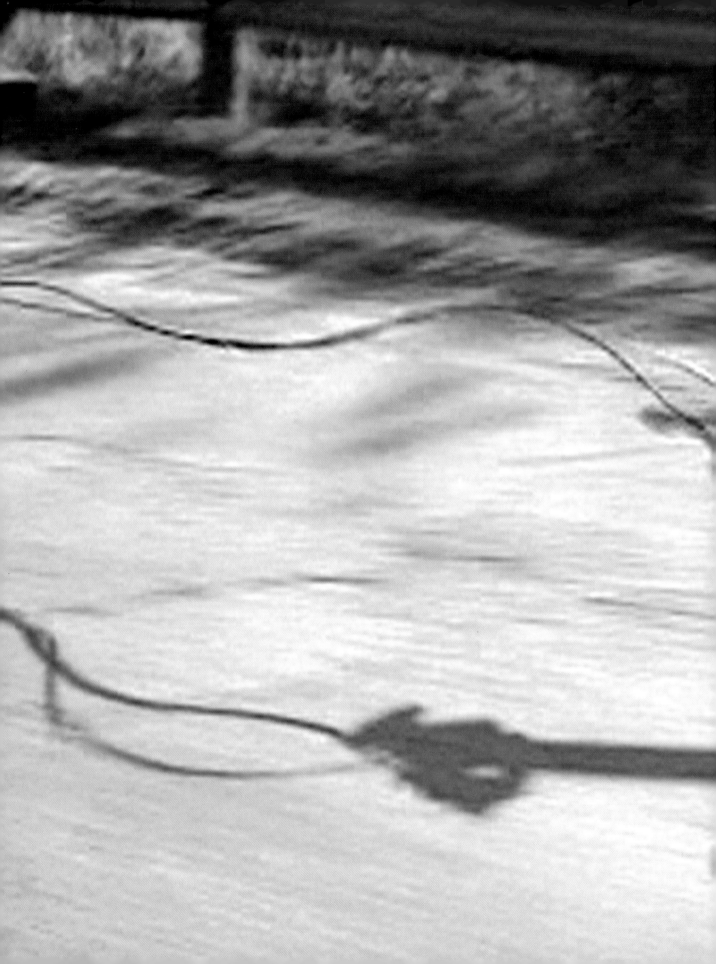

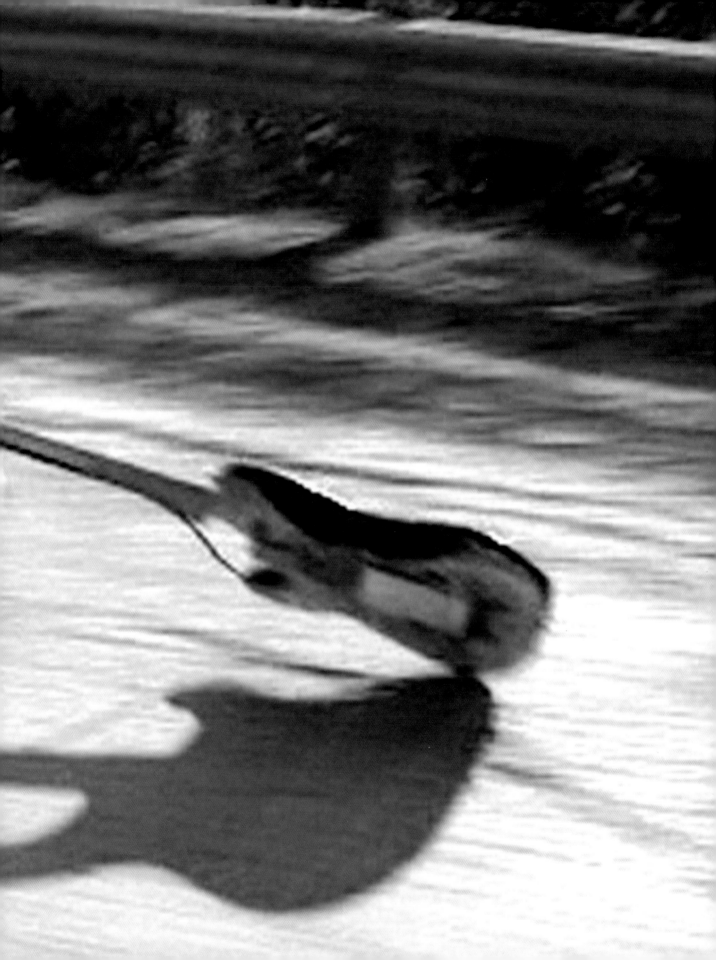

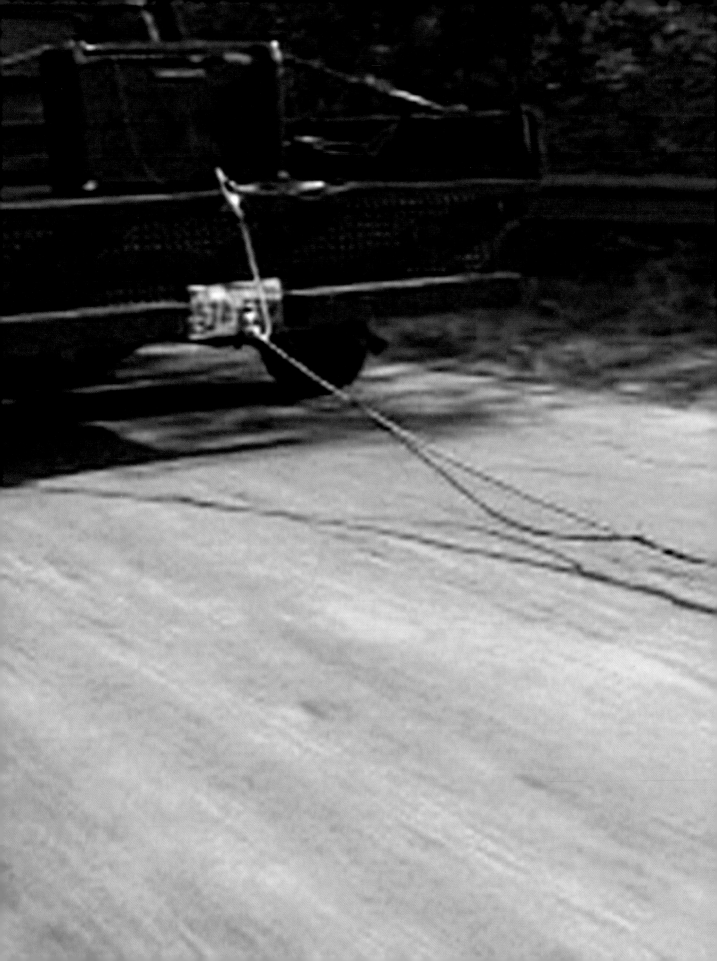

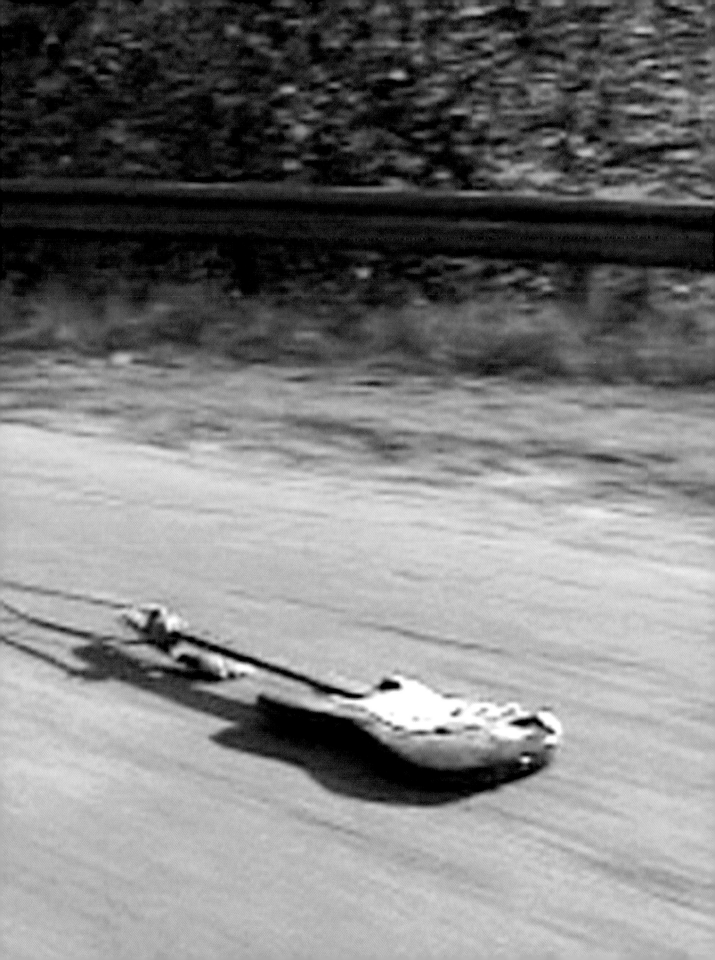

Silence Is a Rhythm, Too

Miwon Kwon

A "proper" appreciation of visual art has always been associated with silence. The beholder's encounter with a work of art has traditionally been imagined as a slow, contemplative, and solitary process requiring the suppression of worldly distractions. When we stand in front of a painting or walk around a sculpture, for instance, taking in its formal structure, use of colors, composition, scale, disposition, etc., we are to do so quietly. We may talk with a friend or companion, perhaps, but only in hushed voices (we do not want to disturb the next person's private and singular aesthetic experience). It is presumed that artworks "speak" their meaning in a way that demands such quiet, even when the work itself is "loud," full of incidents and movement. This is why museums have often been compared to cathedrals, places of non-verbal communion with a transcendent condition of higher truth or beauty.

In the more recent past, say of the last two or three decades, however, this paradigm of a quiet aesthetic experience has been strongly challenged; silence has become harder and harder to come by. The cathedral has been replaced by the shopping mall as a model. As art museums become further entrenched in the culture and tourist industries, competing with entertainment and retail enterprises for their audience, the art-viewing condition (constituted by the art as much as by the institutional sites of its presentation) has become more continuous with and less distinct from commercial, brand-conscious, and lifestyle-oriented "experiences" programmed for mass consumption. Within this context, Hollywood movies and architectural design have become dominant artistic reference points. The pervasiveness in recent years of elaborate video or DVD projections and design art installations indicate a major shift not only in the scale of artistic operation but also the nature of aesthetic experience, which now often places the viewer inside an overwhelming, multi-sensory environment.

At the same time, the various institutional critiques launched since the late 1960s have taught us that the imposition of silence upon art viewers serves an ideological function, not unlike the false objectivity enforced by the white "neutrality" of exhibition galleries. Such an imposition is understood as a means to maintain the status quo of certain aesthetic, social, and political values, and as a disciplining mechanism that makes the public passive consumers rather than active producers of culture. Which is to say, the silence that has been integral to a traditional understanding of aesthetic experience is held in suspicion in this case as a form of silencing of subjects, individuated against collectivity and encouraged to forget in that silence the structuring material and economic base of social life.

Stool, 1992

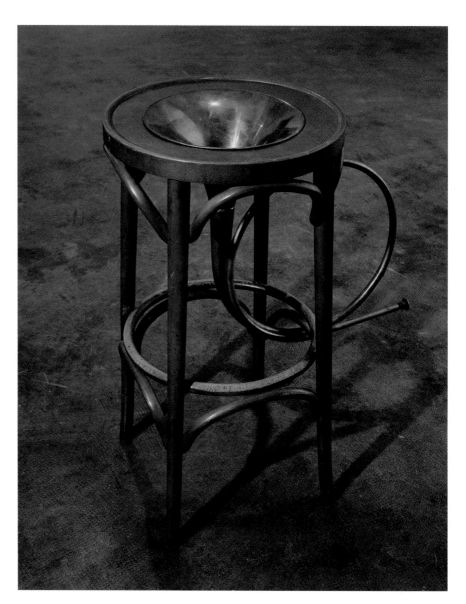

There is a complex way in which these two phenomena—the intensification of spectacularization in art and culture, and the discourse of institutional critique—are historically linked, with the latter sometimes functioning as an alibi for the former even as it critiques it. The point of outlining the phenomena as I have done

here, however, is not to pursue an investigation of their historical link (saved for another day) but to situate Christian Marclay's unique contribution in attending to a particular kind of silence that counters the limitations of both conditions. It may seem misguided for me to prioritize silence in relation to a body of work that prioritizes sound and music. But Marclay's sculptures and installations, as well as his audio work and musical performances, consistently resist the common tendency to fill in contemplative silence with distraction, or squeeze it out altogether, ostensibly to facilitate greater critical awareness and social interaction. As the artist noted in a 1997 interview: "Absence is a void to be filled with one's own stories. I find silence is much more powerful [than sound] because we are always surrounded with sounds, and in silence we can think about sound. Silence is the negative space that defines sound."[1] In his case, though, silence is not simply the absence of sound.

Most obviously, Marclay gives form and opportunity to this silence (very hard to describe in words) through various aesthetic strategies that cross the audience's sensory wires. Images and objects are to be heard as much as seen (no matter how mute), and sounds are to be seen as much as heard (no matter how immaterial). Looking at Marclay's eccentrically cut-up and reassembled vinyl records and objects (*Recycled Records,* 1980–86; *Glasses,* 1991; *Stool,* 1992), or his sculptures of peculiar disposition and function (*Endless Column,* 1988; *Violin,* 1988; *The Beatles,* 1989; *Tape Fall,* 1989), or his surrealistically modified musical instruments (*Drumkit* 1999; *Virtuoso, Lip Lock,* and *Drumsticks,* all 2000), we are made conscious of a silence that is not so much the absence of sound but, in its objectification, an opening for the imagination. As such, this silence delivers an extraordinary array of sounds—some lyrical, some grating, some brittle, some elegant, some remembered, some as yet to be heard—all strangely made palpable through our eyes. Without completely collapsing the two modes of perception—visual and auditory—Marclay's work insinuates their interdependence. By deprioritizing the visual in visual art while materially and visually articulating the ephemerality of sound and music, by giving form to the gulf between the two realms, he forces an expansion of the viewer/listener's self-awareness of the limits of perceptual faculties. The space of this mental expansion is exactly what characterizes Marclay's brand of silence. In some instances, such self-awareness leads to a reconsideration of value-laden institutional and social conventions, too, of how hierarchical organization of artifacts and knowledge arbitrarily determine cultural meaning.

Glasses, 1991

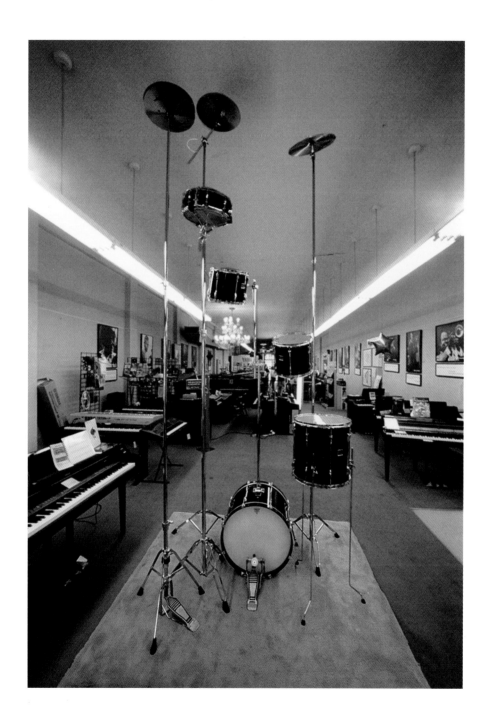

Opposite: *Lip Lock*, 2000
Above: *Drumkit*, 1999. Installation
view, Alamo Music Center, San
Antonio, Texas
Following spread: *Accordion*, 1999.
Installation view Alamo Music
Center, San Antonio, Texas

Above: *Vertebrate*, 2000
Opposite: *Prosthesis*, 2001

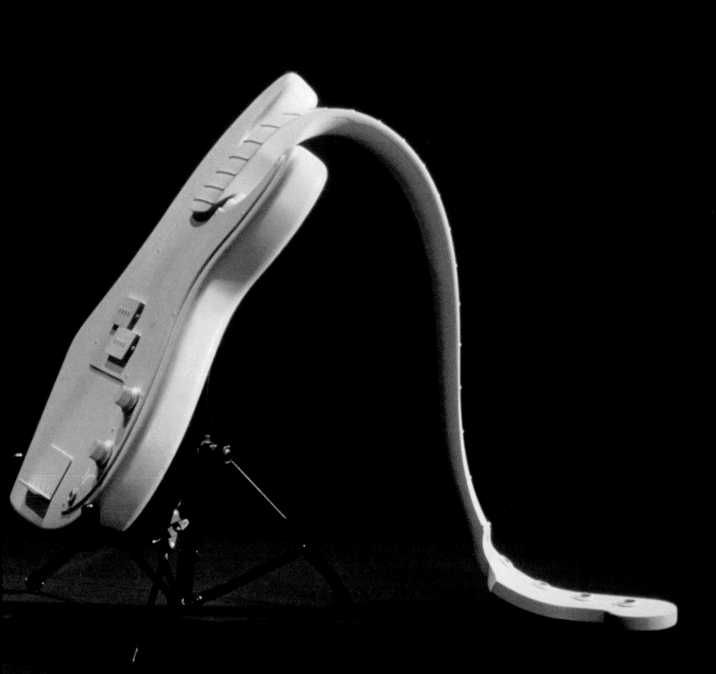

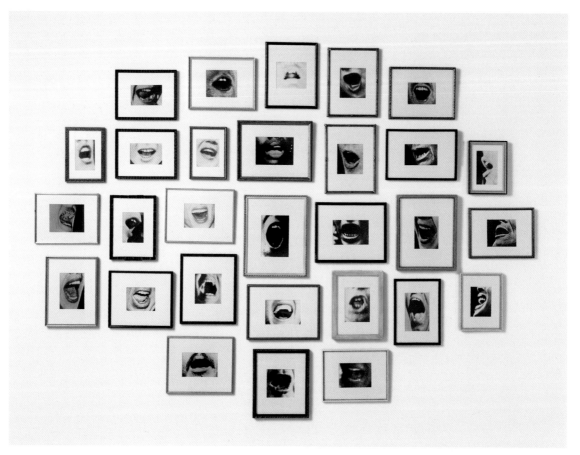

Chorus II, 1988

Among many possible examples in this regard is the 1998 project in Linz, Austria, entitled *Empty Cases (In Memoriam Tom Cora),* in which three hundred musical instrument cases gathered from a local museum were neatly displayed on a low platform encircling the gallery space.[2] Each case, left open to reveal the sensuality of the interior, looked like an open mouth caught in the midst of an utterance or a song. Together, the three hundred cases conjured a collective sounding of orchestral proportions and complexity, and recalled the density of voices invoked through the twenty-nine closely cropped photographs of open mouths in Marclay's *Chorus II* (1988). But here, with the cases replacing human mouths, the "sound" was not one of exuberant energy like a triumphal cry or a symphonic declaration as in *Chorus II,* but one of some solemnity, like a lament, as it seemed to emerge from the depths of a literal and metaphorical absence. For the vacant cases, which exposed the precise

indentations meant to house the fragile bodies of particular musical instruments, also alluded to open caskets, missing bodies, a collective funeral. By bringing to center stage objects usually deemed not important or interesting enough to show in public (cases are typically thought of in functional terms only, as protective casings for the storage of instruments and nothing more), *Empty Cases* also undercut the cultural and institutional bias that elevates a work (instrument, considered primary) and ignores its frame (case, considered secondary). Or, more accurately, *Empty Cases* poignantly exposed the mutuality between work and frame, not unlike the mutuality of vision and sound, and revealed the capacity of *all* objects to "speak" in a historical and aesthetic sense.[3]

In projects such as these, the auditory realm of aesthetic experience is conjured by and through a presentation of static visual artifacts and images. In other projects, by contrast, visual elements are strategically withdrawn or repressed, rendering the muteness of objects and images into a blankness, a visual silence, that functions as a new ground for imaginary elaboration. *White Noise* (1994), for instance, is an installation in which hundreds of found photographs of varying sizes cover the walls from floor to ceiling. Delicately pinned like insect specimens, the anonymous images are turned away from the viewer so that only the backs of the photographs are visually available. The installation shows very little, in other words, and echoes the silent whiteness of the gallery itself. Yet at the same time, the fluttering surface of the walls, now a mosaic of lost intimate moments, reverberates as a forceful reminder of personal and social memory. Precisely in the absence of a visually verifiable reality, a recognition (or recollection) of another sensual world emerges. Indeed the lack of sensual and communicative access to the world has served as a point of departure for several recent projects in which literal blindness, muteness, and deafness figure centrally (*Keller and Caruso,* 2000; *Mixed Reviews,* 2001). But rather than being conditions of deprivation—of absence, silence, and lack—they open onto new sensorial knowledge and experience.

As central to Marclay's practice as the crossing of visual and auditory perceptions is how we almost always experience music today in technologically mediated ways, as captured recordings and decontextualized relays. Marclay has paid close attention to the processes and apparatuses of reproduction and mass distribution of music as a site and source of artistic intervention. Loosely interpreting various artistic strategies inherited from Cubism, Dada, and Surrealism, as channeled through Pop, Fluxus, and punk rock, he has created music, objects, images, and performances through sampling, appropriation, collage, and montage—all related techniques

Keller and Caruso, 2000. Installation views from the Peabody Conservatory of Music, Baltimore

Video stills from *Mixed Reviews*
(American Sign Language), 2001

of production based on radically redirected modes of consumption. In many ways, Marclay's early do-it-yourself punk sensibility as a "turntable player" around New York City in the early 1980s (when instead of being an obedient consumer he creatively misused record albums and record players to produce new music) still informs his practice today.

In his famous essay, "The Work of Art in the Age of Mechanical Reproduction" (1936), Walter Benjamin described the profound and pervasive impact of changing conditions of production and consumption via technologies of reproduction—photography and film in particular—that began in the early twentieth century. "The technique of reproduction detaches the reproduced object from the domain of tradition. By making many reproductions it substitutes a plurality of copies for a unique existence. And in permitting the reproduction to meet the beholder or listener in his own particular situation, it reactivates the object reproduced."[4] Benjamin's insights regarding the social and political ramifications of the altered status and function of a work of art in relation to authenticity, history, use and exhibition value, and audience, have by now become common wisdom, as we face another revolution in the techniques of reproduction. With current developments in digital and telecommunications technologies, the distinction between original and copy, sign and referent, produced and reproduced, are further pressured, testing their viability altogether. Today, the replacement of the unique by a plurality of copies—a condition advanced by techniques of mechanical reproduction as described by Benjamin—is itself a "domain of tradition." In fact, the culture of mechanical (i.e., analog) reproduction of images and sounds through photographs, tapes, and film, in which the distinction between original and copy remains clear (if complexly related), accrues a nostalgic allure today as a waning, if not already outmoded, tradition.

Marclay's artistic practice, visual and musical, is profoundly tied to this tradition—even as it complicates its logic—in its critical engagement with collage, an aesthetic inextricably tied to the age of mechanical reproduction. On the one hand, Marclay is keenly attuned to the ways in which technologies of reproduction petrify sounds and images. Most of us, indeed, accumulate recorded material as a means to "reactivate the object reproduced." On the other hand, he also knows that just as live music is impossible without physical bodies, recorded music, no matter how disembodied or technologically mediated, is also tethered to the material world and is tied to a sensual exchange with the human body. The vinyl album or CD is not merely a repository and conveyor of "dead" sounds. It is a cultural object in itself of specific shape, measurement, material, color, and surface, with its own

signifying capacities, that gets handled and accrues meaning across time. Marclay consistently reminds us that a mechanically reproduced, indexical copy of an original, authentic, real-time event, such as a photograph or an audio recording, also has itself a singular material existence, even as a copy, in the real-time of a person's encounter with it. That encounter or relationship, in turn, reinscribes the "original" (quite literally in works like *Record Without a Cover,* 1985; and *Footsteps,* 1989) with new meaning, overlaying fresh traces of history and life, rendering every copy into a unique "original" again and again.

Memory Lane, 2000. Installation view, P.S.1 Contemporary Art Center, New York

Of course, Marclay is hardly unique in using cut-and-paste techniques to create visual and audio works. It is a method that, especially since the advent of computers and digitalization, is now everywhere. From a Photoshop-manipulated composite image to the sampling of old tunes in hip-hop hits, the collage (or is it pastiche?) attitude dominates contemporary cultural production across the board. One crucial point of difference — what distinguishes Marclay's work from others who recombine fragments of found cultural material—is the extent to which the coming together of the parts remains intelligible as a structurally integral aspect of the work. That is, the "seams" are not smoothed over to create the illusion of a "natural" whole. Meaning lies in the seams. This is quite literally the case in his 1991–92 Body Mix series of collages made of commercial album covers. Various parts of bodies and faces as featured on album covers—posed to sell the product— are juxtaposed in each collage to create grotesque, sexually ambiguous creatures with exaggerated limbs and distorted physical proportions. At first glance, these collages seem like innocuously simple visual puns (which they are). But disturbing undercurrents creep into view the longer one studies them. The crude sewing-machine stitching that holds the new creatures together registers an indelicate violence, a rupturing of the body by machine. One might think of the Surrealist Hans Bellmer's dolls, or indeed of Frankenstein's monster. At the same time as the stitching announces the constructedness of the collage, it simultaneously exposes the constructedness of the "original" cover images produced for the purposes of seduction and sales. In effect, Marclay's grotesque composites allow us to see the true grotesquerie of the commercialized and fetishistic treatment of bodies and identities, especially those of women, in mass consumer societies.[5]

Hans Bellmer, *Die Puppe (The Doll)*, 1934

In this way, Marclay's deceptively simple methodology yields complex associations and meanings. These associations and meanings are not only a "critique," a reductive opposition to the commodification and marketing of music. They open up instead an imaginary terrain of possibilities for new compositions obscured

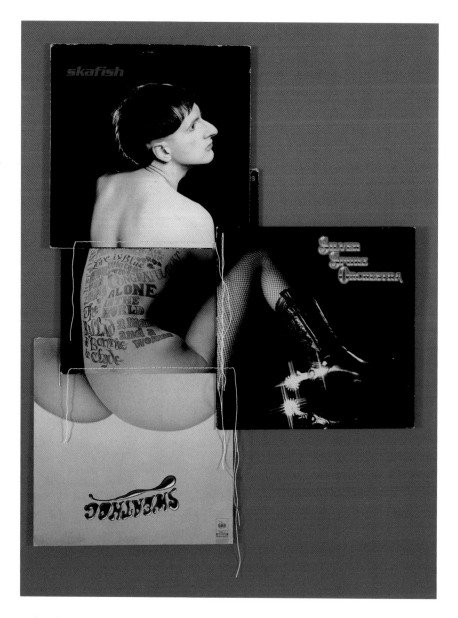

Sweathog, 1991

within the overdetermined context of commercialism. Marclay's more recent video collages do exactly this. *Telephones* (1995), a video compilation of very short film clips of actors speaking on the telephone, is an absurdly repetitive sequence of hellos that go unanswered. The call and the greeting never reach their destination or conclusion. Whether viewed as a musical composition or as video art, the staccato severity of the repetitive cuts in *Telephones* emphasizes the spatial and social distance that technologies of tele-phonic and tele-visual communication are meant to over-come. The work also acknowledges the extent to which such technologies may hinder rather than facilitate communication.

Another point of subtle yet fundamental difference between Marclay and other cut-and-paste artists, particularly celebrity DJs, is his uncanny ability to

extrapolate new meaning out of juxtaposition of fragments without asserting his identity as a master mixer. That is, while Marclay appears to share much with other samplers, re mixers, and appropriationists of pop culture, be they musicians or visual artists, he fundamentally departs from the normative insofar as his work is not about savvy connoisseurship of mass media. In Marclay's case, techniques of "stealing, displacing, chopping up"[6] of found images and riffs do not serve to affirm the author's taste code; the bits do not cohere to buttress or reflect the artist's persona. Instead, he helps the audience recognize the aesthetic logic of cut-and-paste techniques, based on discontinuity and fragmentation, as reflective not only of historical and social realities but also of historical and social possibilities.

Two projects done in post-unified Germany—*Berlin Mix* (1993) and *Graffiti Composition* (1996-2002)—attest to Marclay's almost utopian vision, one that is all the more powerful because it is so fragile, provisional, and unheroic. The first was a performance/concert at the Strassenbahndepot, a street-car depot. In this enormous industrial space, around 180 musicians of varying skills, age, nationality, ethnicity, religion, and affiliation (marching bands, turntablists, street musicians, singers, church choirs, neighborhood orchestras, etc.) representing over thirty different musical styles (from classical to rock to folk to experimental; from Turkish to African to German, etc.), came together under Marclay's direction. He "conducted" the mix through hand signals, walkie-talkies, and a numbering system. Taking cut-and-paste techniques to a live social situation, this "orchestra" without hierarchy, this "concert" without a score, captured in its chaotic cacophony the humor, eloquence, confusion, vulnerability, dignity, struggle, and beauty that was the texture of life in 1993 Berlin. While *Berlin Mix* was created in direct response to the wave of xenophobic violence in Germany following the fall of the Berlin Wall, it serves as a moving allegory of our collective cut-and-paste existence within postcolonial, postindustrial, postnational urban societies more generally. As with the smaller collages discussed already, the emphasis here is also on the "seams," the points of incongruity and difference where seemingly incommensurate musical styles, cultural histories, group identities, and traditions collide. Importantly, these "seams" are not glossed over to equalize the parts or to create a unified and harmonious whole, as many politically minded cultural practitioners are prone to do. They remain as the messy and thriving sites that fuel social collectivity. With this work, Marclay proposes a political interpretation of the "mix."

Graffiti Composition also proposes a collective, citywide musical experience based on discontinuity and fragmentation, but one in which participants serve

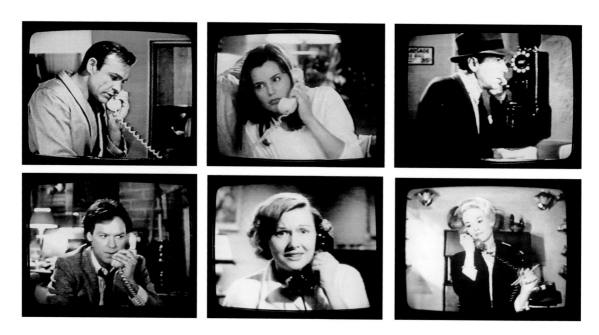

Stills from *Telephones*, 1995

(most of them unknowingly) as composers rather than performers. Initiated as a piece for Sonambiente, a sound art festival organized by the Akademie der Künste in the summer of 1996, the project entailed the flyposting of 5,000 blank music sheets (twelve lines of empty staffs) around the streets of the city, covering wall and kiosk spaces alongside other advertising. As might be expected, many of Marclay's blank sheets, refusing to communicate any information (no instructions or explanations accompanied the sheets), were rather quickly postered over, torn down, or otherwise destroyed. But many others served as surfaces upon which random passersby registered brief quips, doodled, and even jotted down musical notes. The various fates of these graffiti-ed sheets were photographed during the month-long festival. Subsequently, 150 of them have been printed as an edition. Reproduced, the prints are not mere documents; they are in themselves "scores" for performance.[7]

What is most striking to me about this project is not so much the resemblance of some of the images to artistic precedents like the French *Affichistes* of the 1950s or "graffiti art" of the 1980s. It is rather the extraordinary range of musical possibilities that I can almost hear as I view each "score." Whether it is a word, a scratch, a rip, a stain, a drawing, or even a passing fly, when caught in the five parallel lines of a musical staff they all magically become part of a new musical language, a new system of musical notation that promises melodies and rhythms never heard before. *Graffiti Composition,* then, is an as yet unplayed and unheard,

maybe even unimagined, collective "portrait" of Berlin, composed by its anonymous citizens.[8] Open to myriad permutations, recombinations, and interpretations, it is also a work whose conclusive articulation is forever deferred. While all musical composition is caught up in this deferral to some degree (it is written for performance by others at a later date, after all), *Graffiti Composition* is one that will never cohere into a stable set of sounds or images. Here, too, then, Marclay insinuates the aesthetics of collage as a social and political paradigm, one that embraces heterogeneity, the accidental, the disjointed, the forever incomplete. It is the delicacy and fragility of this unending projection of possibilities, in *Graffiti Composition* as elsewhere, that characterizes the generative quality of Marclay's silence, which I tried to describe at the outset of this essay. His silence is, paradoxically, both a ground of representation and a break with it.

1. Marclay in an interview by Bice Curiger, in the publication accompanying *Arranged and Conducted* (Zurich: Kunsthaus, 1997), 58.

2. The cellist Tom Cora (1953–98) was an important figure in the New York experimental music scene who often performed with Marclay.

3. Striking a very different mood was *Arranged and Conducted* (1997) at the Kunsthaus in Zurich. Here, one hundred paintings and drawings selected from the museum's permanent collection, each depicting people engaged in musical activities, were installed as a "wall of sound" (referencing Phil Spector's pop music innovation to make sound feel like an environmental enclosure). That is, the pictures were hung tightly abutting one another so that the singularity of each image became subsumed into an extended visual field comparable to the accumulation and overlap of singular notes to create an extended tonal field. The eclectic and playful variety of sounds imaged by the paintings was further reinforced by Marclay's decision to reupholster the museum furniture and dress the museum guards in colorful, almost garish, "musical" fabric. A similar project was shown at the Philip Morris branch of the Whitney Museum in 1997.

4. Walter Benjamin, "The Work of Art in the Age of Mechanical Reproduction" (1936), in *Illuminations* (New York: Schocken Books, 1969), 221.

5. For more detailed comments on the politics of gender regarding this series, see Marclay's interview with Jonathan Seliger, "Christian Marclay," *Journal of Contemporary Art: Interviews and Projects* (Spring 1992): 64–76.

6. Seliger, 74. This is Marclay's characterization of the fundaments of photography, which is analogous to techniques of sound recording.

7. *Grafitti Composition* will be performed at the UCLA Hammer Museum by Stephen Prina on 24 July 2003.

8. For an eloquent review of this project, see Susan Tallman, "Always This Tüdelditüt: Christian Marclay's 'Graffiti Composition,'" *Art On Paper* (July–August 2000): 28–33.

Following three spreads:
Berlin Mix, 1993. Performance at Strassenbahndepot, Berlin

21

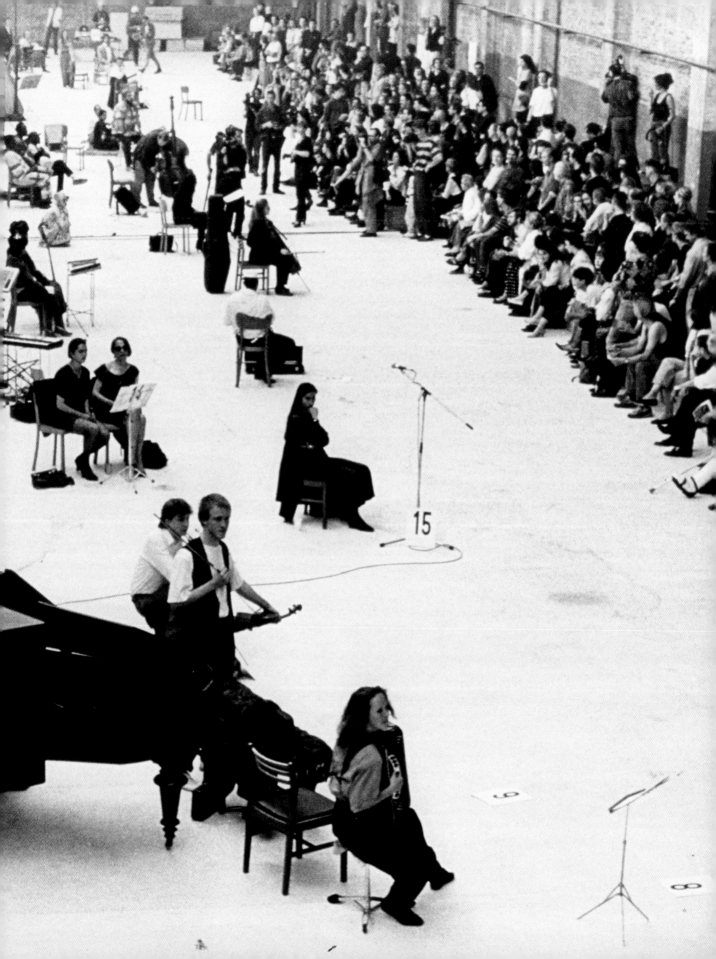

Exhibition Checklist

Recycled Records, 1980–86 (p.92-95)
Collaged records
12 in. (30.5 cm) diameter
Collection of the artist

Christian Marclay at the St. Regis, 1981 (p.44)
From the Imaginary Records series
Paint and letraset on record cover
12 ¼ x 12 ¼ in. (31.1 x 31.1 cm)
Collection of the artist

Record Without a Cover, 1985 (p.98)
Record
12 in. (30.5 cm) diameter
Collection of the artist

Hangman's Noose, 1987 (p.48)
Microphone and cord
77 x 3 x 2 in. (195.6 x 7.6 x 5.1 cm)
Edition of 2
Collection of the artist

Mosaic, 1987 (p.21)
Broken 78-rpm records on metal disc
12 in. (30.5 cm) diameter
Collection of the artist

Untitled, 1987 (p.180)
Record with ultrasuede pouch
Record: 12 in. (30.5 cm) diameter;
pouch: 18 x 12 ¼ in. (45.8 x 31.1 cm)
Published by Ecart Editions,
edition of 50
Collection of the artist

Candle, 1988 (p.36-37)
Metal gramophone horn and
beeswax cast with wick
Each 30 in. tall and 20 in. diameter
(76.2 cm tall and 50.8 cm diameter)
Henry Art Gallery, University of
Washington, Seattle, gift from
the Collection of Steven Johnson
and Walter Sudol

Chorus II, 1988 (p.120)
Framed black-and-white photographs
56 x 74 in. (142.2 x 188 cm) overall
Collection of the Robert J. Shiffler
Foundation

Door, 1988 (p.35)
Found wooden door with f-hole cutouts
79 ½ x 30 in. (201.9 x 76.2 cm)
On extended loan to the Tang Teaching
Museum at Skidmore College from
a private collector

Endless Column, 1988 (p.22)
Vinyl records, steel cable
122 ½ x 12 x 12 in.
(311.2 x 90.5 x 30.5 cm)
Collection du Fonds d'art
contemporain de la Ville de Genève

Full-color Stereo, 1988 (p.20)
Painted speaker cabinets
22 x 69 ½ x 8 in. (55.9 x 176.5 x 20.3 cm)
The Progressive Corporation,
Cleveland, Ohio

Ghost, 1988
From the Imaginary Records series
Altered record cover
12 ¼ x 12 ¼ in. (31.1 x 31.1 cm)
Collection of Nicolas Collins
and Susan Tallman

1955, 1988 (p.45)
From the Imaginary Records series
Altered record cover
12 ¼ x 12 ¼ in. (31.1 x 31.1 cm)
Collection of David A. Dorsky and
Helaine Posner

Secret, 1988 (p.33)
Metal disc and padlock
Disc; 7 in. (17.8 cm) diameter
Collection of Christian Eckart

The Sound of Silence, 1988 (p.19)
Black-and-white photograph
10 ¾ x 10 ¾ in. (26.8 x 26.8 cm)
Courtesy of the artist and
Paula Cooper Gallery, New York

Yellow, 1988
From the Imaginary Records series
Altered record cover
12 ¼ x 12 ¼ in. (31.1 x 31.1 cm)
Collection of the artist

The Beatles, 1989 (p.34)
Magnetic audio tape
9 x 18 x 12 in. (22.9 x 45.8 x 30.5 cm)
Collection of Deborah Irmas,
Los Angeles

Forever, 1989 (p.47)
From the Imaginary Records series
Altered record cover
12 ¼ x 12 ¼ in. (31.1 x 31.1 cm)
Collection of the artist

Skull, 1989 (p.46)
From the Imaginary Records series
Altered record cover
12 ¼ x 12 ¼ in. (31.1 x 31.1 cm)
Collection of the artist

Tape Fall, 1989 (pp.52-53)
Reel-to-reel player, audio tape, ladder
Dimensions variable
Private Collection, New York

Untitled, 1989 (p.61)
Telephone, adhesive tape
Dimensions variable
Courtesy of the artist and Paula Cooper
Gallery, New York

Untitled, 1989 (p.26)
Melted records
6 in; 5 in., 5 in., 4 in., 3 ½ in; 3 in.,
3 in., 3 in., 2 ½ in. (15.2 cm, 12.7 cm,
12.7 cm, 10.2 cm, 8.9 cm, 7.6 cm,
7.6 cm, 7.6 cm, 6.4 cm) diameters
Collection of the artist

Abstract Music, 1989 – 1990 (p.162-165)
Paint on 16 record covers,
individually framed
Each 12 ¼ x 12 ¼ in. (31.1 x 31.1 cm)
Collection of the artist

Boneyard, 1990 (p.57)
750 hydrostone casts of phone receivers
Dimensions variable
Courtesy of the Dakis Joannou
Collection, Athens

Bouche-Oreille, 1990 (p.136)
Terracotta
Pair, 3 ¼ in. (8 cm) diameter each
Edition of 10
Collection of the artist

Broken Record in Seven Pieces, 1990
Photogram on photographic paper
20 x 24 in. (50.8 x 61 cm)
Collection of the artist

*Broken Record in Seven Pieces
(Ballerina)*, 1990
Photogram on photographic paper
24 x 20 in. (61 x 50.8 cm)
Collection of the artist

Broken Record in Three Pieces, 1990 (p.135)
Photogram on photographic paper
20 x 24 in. (50.8 x 61 cm)
Collection of the artist

Dictators, 1990 (p.176)
Record covers, wood, screws
60 x 60 in. (152.4 x 152.4 cm)
Collection of Martin Z.
Margulies, Miami

Incognita, 1990 (p.177)
Record covers, zippers
72 x 60 in. (182.9 x 152.4 cm)
Private Collection, New York

White Album (No one will be watching us),
1990
Record cover with embossing
12 ¼ x 24 ¾ in. (31.1 x 62.9 cm)
From a series of 17
Courtesy of Blum and Poe, Santa Monica

White Album (So cry baby cry cry cry), 1990
Record cover with embossing
12 ¼ x 24 ¾ in. (31.1 x 62.9 cm)
From a series of 17
Courtesy of Blum and Poe, Santa Monica

*White Album (Look around round
round)*, 1990
Record cover with letterpress
12 ¼ x 24 ¾ in. (31.1 x 62.9 cm)
From a series of 17
Collection of Tina Petra and Ken Wong

White Album (Oh yeah, oh yeah), 1990
Record cover with embossing
12 ¼ x 24 ¾ in. (31.1 x 62.9 cm)
From a series of 17
Courtesy of Blum and Poe, Santa Monica

White Album (Listen for your footsteps), 1990
Record cover with embossing
12 ¼ x 24 ¾ in. (31.1 x 62.9 cm)
From a series of 17
Collection of Jane Hart

White Album (I hear the clock a ticking), 1990
Record cover with embossing
12 ¼ x 24 ¾ in. (31.1 x 62.9 cm)
From a series of 17
Courtesy of Blum and Poe, Santa Monica

Doorsiana, 1991 (p.49)
From the Body Mix series
Record covers and thread
30 x 32 in. (76.2 x 81.3 cm)
Collection of the Robert J.
Shiffler Foundation

Footstompin', 1991 (p.71)
From the Body Mix series
Record covers and thread
17 ¼ x 36 in. (43.8 x 90.4 cm)
Collection of David Hutchinson

Glasses, 1991 (p.113)
Eyeglass frames with telephone
ear and mouth piece
3 x 6 ½ x 7 in. (6.4 x 16.5 x 17.8 cm)
Collection of the artist

Magnetic Fields, 1991 (p.76)
From the Body Mix series
Record covers and thread
27 ¼ x 24 ½ in. (69.2 x 61.6 cm)
Collection of Joan and Gerald
Kimmelman

Remember, 1991 (p.46)
From the Imaginary Records series
Torn record cover
12 ¼ x 12 ¼ in. (31.1 x 31.1 cm)
Collection of the artist

Untitled, 1991 (p.183)
Color surface print
38 ½ x 38 ½ in. (98 x 98 cm)
Published by Solo Impression, Inc.,
edition of 8
Amerada Hess Corporation, New York

Frankfurt, 1992
C-print
14 x 10 ⅜ in. (35.6 x 26.4 cm)
Edition of 5
Collection of the artist

Mort, 1992 (p.47)
From the Imaginary Records series
Torn record cover
12 ¼ x 12 ¼ in. (31.1 x 31.1 cm)
Collection of the artist

Guitar Neck, 1992 (p.178)
Record covers and thread
73 x 19 in. (185.4 x 48.3 cm)
Collection of Peter Norton,
Santa Monica

The Road to Romance, 1992 (p.179)
Record covers and thread
93 ¼ x 19 in. (236.9 x 48.3 cm)
Richard Carpenter Collection

Slide Easy In, 1992 (p.77)
From the Body Mix series
Record covers and thread
27 x 13 ½ in. (68.6 x 34.3 cm)
Collection of Steven Johnson and
Walter Sudol, New York

Stool, 1992 (p.112)
Wooden stool and brass horn
30 x 23 ¼ x 15 in. (76.2 x 59.1 x 38.1 cm)
Property of the Swiss Confederation,
Federal Office of Culture, Bern

Untitled (Large Circle), 1992 (p.23)
Record covers
46 in. (116.8 cm) diameter
Collection of Eileen and Peter Norton,
Santa Monica

Cage, 1993 (p.38)
Bird cage, telephone, and cable
19 ⅝ x 15 ¾ x 15 ¾ in.
(50 x 40 x 40 cm)
Musée de la Communication, Bern

False Advertising, 1994 (p.40)
Posters
16 ¾ x 12 ⅞ in., 13 ¼ x 19 ⅝ in.,
35 ½ x 20 ½ in., 27 ¼ x 20 ⅛ in.,
23 ½ x 11 ⅞ in. (42.5 x 32.7 cm,
33.7 x 49.9 cm, 90.2 x 52.1 cm,
69.2 x 51.1 cm, 59.7 x 30.2 cm)
Signed edition of 50, published
by Art & Public, Geneva
UCLA Hammer Museum, Los Angeles

From Hand to Ear, 1994 (p.39)
Beeswax
42 x 8 x 7 in. (106.7 x 20.3 x 17.8 cm)
Collection of the artist

New Delhi, 1994 (p.184-187)
C-print
10 ³/₈ x 14 in. (26.4 x 35.6 cm)
Edition of 5
Collection of the artist

White Noise, 1994
Found photographs and pins
Dimensions variable
Kunstmuseum Bern/
Stiftung Kunsthalle Bern
Exhibition copy

Geneva, 1995
C-print
14 x 10 ³/₈ in. (35.6 x 26.4 cm)
Edition of 5
Collection of the artist

Marseille, 1995
C-print
10 ³/₈ x 14 in. (26.4 x 35.6 cm)
Edition of 5
Collection of the artist

My Weight in Records, 1995
(inside back cover)
Records in cardboard boxes
13 x 43 x 15 in. (33.1 x 109.2 x
38.1 cm), 165 lbs.
Collection of the artist

Snug Harbor, 1995
C-print
10 ³/₈ x 14 in. (26.4 x 35.6 cm)
Edition of 5
Collection of the artist

Telephones, 1995
Video, 7 minutes, 30 seconds
Private Collection

Bavaria, 1996 (p.196)
C-print
14 x 10 ³/₈ in. (35.6 x 26.4 cm)
Edition of 5
Collection of the artist

Berlin, 1996
C-print
14 x 10 ³/₈ in. (35.6 x 26.4 cm)
Edition of 5
Collection of the artist

New York, 1996 (p.200)
C-print
14 x 10 ³/₈ in. (35.6 x 26.4 cm)
Edition of 5
Collection of the artist

Graffiti Composition, 1996-2002
(Cover and pp.2-7)
Portfolio of 150 images,
indigo prints on cougar stock
Box: 4 x 9 ¹/₂ x 3 in. (35.6 x 24.1 x
7.6 cm); sheets: 13 x 8 ¹/₂ in.
(33 x 21.6 cm) each
Published by Paula Cooper Gallery,
edition of 25 plus 5 performance copies
Courtesy of the artist and
Paula Cooper Gallery,
New York

Blind Faith, 1997
From the Imaginary Records series
Altered record cover
12 ¹/₄ x 12 ¹/₄ in. (31.1 x 31.1 cm)
Collection of BMG Music

Blue Candle, 1997
From the Imaginary Records series
Altered record cover
12 ¹/₄ x 12 ¹/₄ in. (31.1 x 31.1 cm)
Collection of Thurston Moore

Bubbles, 1997 (p.47)
From the Imaginary Records series
Altered record cover
12 ¹/₄ x 12 ¹/₄ in. (31.1 x 31.1 cm)
Courtesy of the artist and Paula Cooper
Gallery, New York

Swiss Savage, 1997
From the Imaginary Records series
Altered record cover
12 ¹/₄ x 12 ¹/₄ in. (31.1 x 31.1 cm)
Collection of the artist

San Antonio, 1999

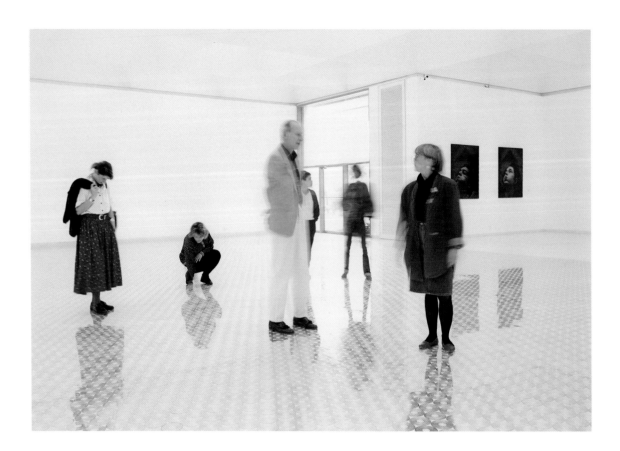

Chicago, 1998
C-print
10 ³/₈ x 14 in. (26.4 x 35.6 cm)
Edition of 5
Collection of the artist

New York, 1998 (p.194)
C-print
14 x 10 ³/₈ in.
(35.6 x 26.4 cm) Edition of 5
Collection of the artist

Vienna, 1998 (p.197)
C-print
14 x 10 ³/₈ in. (35.6 x 26.4 cm)
Edition of 5
Collection of the artist

Drumkit, 1999 (p.115)
Altered drumkit
Drums: 16 x 22 in., 16 x 16 in.,
11 x 13 in., 10 x 12 in., 6 x 14 in.
(40.6 x 55.9 cm, 40.6 x 40.6 cm,
27.9 x 33 cm, 25.4 x 30.5 cm,
15.2 x 35.6 cm); cymbals: 20 x 2 in.
(50.8 x 5.1 cm); stands: 80 x 2 in.
(203.2 x 5.1cm)
Collection of Georgia and
Christopher Erck

Los Angeles, 1999 (p.198-199)
C-print
10 ³/₈ x 14 in. (26.4 x 35.6 cm)
Edition of 5
Collection of the artist

San Antonio, 1999 (p.137)
C-print
10 ³/₈ x 14 in. (26.4 x 35.6 cm)
Edition of 5
Collection of the artist

Smoke Rings, 1999 (p.46)
From the Imaginary Records series
Altered record cover
12 ¼ x 12 ¼ in.
(31.1 x 31.1 cm)
Collection of Burt Minkoff

Boston, 2000
C-print
14 x 10 ³/₈ in. (35.6 x 26.4 cm)
Edition of 5
Collection of the artist

Drumsticks, 2000 (p.42)
Glass
16 in. (40.6 cm) long
Courtesy of the artist and
Paula Cooper Gallery,
New York

Guitar Drag, 2000 (pp.104-109)
DVD projection with sound,
14 minutes
Courtesy of the artist and
Paula Cooper Gallery, New York

Lip Lock, 2000 (p.114)
Tuba and pocket trumpet
34 ½ x 20 x 18 in.
(87.6 x 50.8 x 45.7 cm)
Courtesy of the artist and
Paula Cooper Gallery, New York

London, 2000
C-print
14 x 10 ³/₈ in. (35.6 x 26.4 cm)
Edition of 5
Collection of the artist

Montreal, 2000
C-print
10 ³/₈ x 14 in.
(26.4 x 35.6 cm)
Edition of 5
Collection of the artist

Paris, 2000
C-print
10 ³/₈ x 14 in. (26.4 x 35.6 cm)
Edition of 5
Collection of the artist

Traverse City, 2000
C-print
10 ³/₈ x 14 in. (26.1 x 35.6 cm)
Edition of 5
Collection of the artist

Virtuoso, 2000
Altered accordion
Approximately 25 ft. (762 cm) long
The Israel Museum, Jerusalem.
Gift of the West Coast Aquisitions
Committee of the American Friends
of The Israel Museum.

Valencia, 2001
C-print
10 ³/₈ x 14 in. (26.4 x 35.6 cm)
Edition of 5
Collection of the artist

New York, 2002 (p.195)
C-print
14 x 10 ³/₈ in. (35.6 x 26.4 cm)
Edition of 5
Collection of the artist

Video Quartet, 2002 (p.82-87)
4 DVD screen projections
with sound, 14 minutes, 32 seconds
8 x 40 ft.
Edition of 5
San Francisco Museum of Modern Art:
Gift of the artist and Paula Cooper
Gallery, New York; commissioned
by SFMOMA and the Musée d'art mod-
erne Grand-Duc Jean, Luxembourg

Other Works Reproduced

Dialogue of the Giants, 1988
(version 1) (p.56)
Oil drums and rope
Dimensions variable
Collection of the artist

Live!, 1988 (p.47)
From the Imaginary Records series
Altered record cover
12 ¼ x 12 ¼ in. (31.1 x 31.1 cm)
Collection of the artist

Ring, 1988 (p.27)
Records and bungee cord
7 x 28 in. (17.8 x 71 cm) diameter
Edition of 2
Collection of Sandra and Stephen
Abramson

Untitled, 1988 (p.155)
Guitar case with circular cut-outs
Collection of the artist

Violin, 1988 (p.159)
Violin with magnetic recording tape
Approximately 3 ½ x 28 x 16 in.
(8.9 x 71.1 x 40.6 cm)
Private Collection

5 Cubes, 1989 (p.182)
Melted records
12 x 12 x 12 in.
(30.5 x 30.5 x 30.5 cm) each
Private Collection, New York

Breasts, 1989 (p.32)
Silicone castings and metal clips
16 ¼ x 18 ½ x 2 in. (41.3 x 47 x 5.1 cm)
Private Collection

Footsteps, 1989 (p.99)
3,500 single-sided, 12-inch vinyl records
Dimensions variable
Published by RecRec Music, Zurich

Galatea and Pygmalion, 1989 (p.154)
Records, record covers, and string
Dimensions variable
Collection of the artist

Onomatopoeia (Kraaaaack), 1989 (p.59)
Acrylic paint on comic book page
10 x 6 ½ in.
Collection of the artist

Stereo Volume, 1989 (p.160)
Speaker cabinet and plexiglas
54 x 36 ¼ x 23 in.
(137.2 x 92.1 x 58.4 cm) overall
Collection of the artist

Untitled, 1989 (p.28)
From the Abstract Music series
Record cover
12 ¼ x 12 ¼ in. (31.1 x 31.1 cm)
Collection of the artist

Broken Record in Seven Pieces,
1990 (p.140–141)
Photogram
25 x 29 in. (63.5 x 73.7 cm)
Courtesy of the artist and
Paula Cooper Gallery

Broken Record in Thirteen Pieces, 1990
(pp.140–141)
Photogram
25 x 29 in. (63.5 x 73.7 cm)
Courtesy of the artist and Paula Cooper
Gallery

Ghost Quartet, 1990 (p.140-141)
Four wooden chair frames
and cotton covers
33 ½ x 16 x 17 ¼ in.
(85.1 x 40.6 x 43.8 cm) each
destroyed

Silence, 1990 (p.46)
From the Imaginary Records series
Altered record cover
12 ¼ x 12 ¼ in. (31.1 x 31.1 cm)
Collection of the artist

Soundsheet, 1990 (p.12 and 142-143)
Flexi-discs and thread
81 x 81 in. (206 x 206 cm)
Collection of the artist

Tête à Tête, 1990 (p.142-143)
Wooden table and two speakers
29 ½ x 60 x 24 in. (75 x 152.5 x 61 cm)
Collection of the artist

Untitled, 1990 (p.181)
Photograms
4 works, each 22 ½ x 26 ½ in.
(57.1 x 67.3 cm)
Private Collection

Whisper, 1990 (p.47)
From the Imaginary Records series
Altered record cover
12 ¼ x 12 ¼ in. (31.1 x 31.1 cm)
on long term loan to the Consulate
General of Switzerland, New York,
from the Swiss Government

White Album (Close your eyes and I'll close mine), 1990 (p.31)
Record cover with embossing
12 ¼ x 24 ¾ in. (31.1 x 62.9 cm)
From a series of 17
Private Collection

Net, 1991 (p.157)
Magnetic recording tape
Approximately 16 x 14 ft.
(487.8 x 426.7 cm)
Collection of the artist

Sweathog, 1991 (p.124)
From the Body Mix series
Record covers and thread
30 ¼ x 23 ¾ in. (76.8 x 60.3 cm)
Shogo Yamahata Fine Art, Tokyo, Japan

Black or White, 1992 (p.74)
From the Body Mix series
Record covers and thread
29 ½ x 31 in. (74.9 x 78.7 cm)
Kunstmuseum Bern

Echo and Narcissus, 1992 (pp.138-139)
15,000 compact discs
Dimensions variable
Courtesy of the artist

Furious Pig, 1992 (p.161)
From the Masks series
Record covers
49 ½ x 37 in. (125.7 x 94 cm)
Courtesy of the artist and
Paula Cooper Gallery

If You Can't Lick, 1992 (p.75)
From the Body Mix series
Record covers and thread
22 x 16 ¼ in. (55.9 x 41.3 cm)
Collection of the artist

Untitled (Small Circle), 1992 (p.22)
Record covers
40 ½ in. (102.87 cm) diameter
Private Collection, Beverly Hills

Berlin Mix, 1993 (p.128-133)
Performance at Strassenbahndepot,
Berlin

Birdhouses, 1994 (p.156)
Speaker cabinets and bird food
Dimensions variable
Courtesy of the artist

Extended Phone, 1994 (p.54-55)
Telephone and plastic tubing
Dimensions variable
Fonds Regional d'Art Contemporain
Bourgogne, Dijon

Möbius Loop, 1994 (p.24-25)
Cassette tapes and nylon ties
23 x 79 x 225 in. (58.4 x 200.7 x 571.5 cm)
Collection of the artist

Wheel, 1994 (p.27)
Melted compact discs on carriage wheel
45 in. (114.3 cm) diameter
Collection of the artist

Amplification, 1995 (p.14-17)
Ink-jet prints on cotton scrims
Dimensions variable
Collection of the artist

Interiors (Villa Merkel), 1996 (p.67)
Mixed-media installation at Villa Merkel,
Galerie der Stadt Esslingen am Neckar,
Esslingen, Germany

Musical Chairs, 1996
Chairs, fabric,
Dimensions variable
Collection of the artist

Untitled, 1996 (p.81)
Brown vinyl record with cover
Record: 7 in. (17.8 cm) diameter
Published by Robert Shiffler Collection
and Archive, Greenville, Ohio,
edition of 500

Echoes, 1997 (p.47)
From the Imaginary Records series
Altered record cover
12 ¼ x 12 ¼ in. (31.1 x 31.1 cm)
Collection of the artist

Great Sounds, 1997 (p.46)
From the Imaginary Records series
Altered record cover
12 ¼ x 12 ¼ in. (31.1 x 31.1 cm)
Collection of the artist

Pictures at an Exhibition, 1997 (p.68-69)
Mixed-media installation with works of
art from the collection of the Whitney
Museum of American Art, Whitney
Museum of American Art at Phillip
Morris, New York

Wall of Sound, 1997 (p.64-66)
Mixed-media installation with the
collection of the Kunsthaus Zurich
From the installation *Arranged
and Conducted*, 1997

Empty Cases (In Memoriam Tom Cora), 1998
(p.150−151)
Installation view at OK Centrum für
Gegenwart Kunst, Linz, Austria, with
musical instrument cases from the
collection of Musica Kremsmünster,
Schloß Kremsegg, Kremsmünster,
Austria

Up and Out, 1998 (p.80)
Single-channel color DVD projection
with sound, 110 minutes
Dimensions variable
Courtesy the artist and Paula Cooper
Gallery, New York

Mixed Reviews (American Sign Language),
2001 (p.122)
Color DVD, 30 minutes
Edition of 5
Courtesy the artist and Paula Cooper
Gallery, New York

Accordion, 1999 (p.116-117)
Altered accordion
20 x 9 x 168 in. (50.8 x 22.9 x 426.7 cm)
Collection Linda Pace

Music Boxes (from Crossings), 1999
(p.148-149)
Installation at Galerie Rudolfinum, Prague
30 wooden crates and
music box mechanisms
Various dimensions
Courtesy the artist

Record Without a Cover, 1999
Picture disc
12 in. (30.5 cm) diameter
Reissue of 1985 record
Published by Locus Solus, Japan

The Sounds of Christmas, 1999 (p.100)
Approximately 1,000 records, two
turntables, mixer, sound system,
and six DVDs
Dimensions variable
Collection of the artist

Breathless I, 2000 (p.158)
Altered wooden recorder
12 ½ in. (32 cm) length
destroyed

Keller and Caruso, 2000 (p.121)
Mixed-media installation at the Peabody
Conservatory of Music, Baltimore
Courtesy of The Contemporary, Baltimore

Memory Lane, 2000 (p.123)
Installation at PS1 Contemporary Arts
Center, New York
Records
Dimensions variable
Courtesy the artist

Vertebrate, 2000 (p.118)
Altered acoustic guitar
26 ½ x 15 ½ x 11 in. (67.3 x 39.4 x 27.9 cm)
Courtesy of the artist and Paula Cooper
Gallery, New York

Prosthesis, 2001 (p.119)
Silicone rubber and metal guitar stand
Approximately 44 x 13 x 2 ½ in.
(111.7 x 33 x 6.4 cm)
Edition of 3
Courtesy of the artist and Paula Cooper
Gallery, New York

Mixed Reviews, 1999/2002 (p.152)
Installation at Contemporary Arts
Center, New Orleans
Text on wall
Dimensions variable
Courtesy the artist

Works by Other Artists

Vito Acconci (p.20 bottom)
The Red Tapes, 1976-77
Videotape, black and white, with sound,
140 minutes
Courtesy Acconci Studio, New York

Laurie Anderson (p.51)
Viophonograph, 1975
Photograph
11 x 14 in. (27.9 x 35.6 cm)
Courtesy Canal St. Communications,
New York

Hans Bellmer (p.123)
Die Puppe (The Doll), 1934
Black-and-white vintage gelatin
silver print
5 ¾ x 3 ¾ in. (14.7 x 9.6 cm)
Collection of Turner A. Davis

Bruce Conner (p.98)
A MOVIE, 1958
16-mm film, black and white, sound
Courtesy of Bruce Conner and Canyon
Cinema, San Francisco

Marcel Duchamp (p.32)
A bruit secret (With hidden noise), 1916
Ball of string and unknown object,
secured between two brass plates by
four long screws
4 ½ x 5 x 5 ⅛ in. (11.4 x 12.9 x 13 cm)
Philadelphia Museum of Art: The Louise
and Walter Arensberg Collection

Marcel Duchamp (p.41)
Why Not Sneeze Rose Sélavy?, 1921
152 marble cubes, a thermometer,
a cuttlebone, in a small birdcage
fitted with wooden bars
4 ½ x 12 x 6 ½ in. (11.4 x 33 x 16 cm)
Philadelphia Museum of Art: The Louise
and Walter Arensberg Collection

Marcel Duchamp (p.78)
Door, 11 rue Larrey, 1927 (presumed
destroyed)
Wooden door
86 ⅝ x 24 ⅝ in. (220 x 62.7 cm)

Arthur Køpcke (p.60)
Music while you work, 1972
Record, stamped label, leaf, and glue
7 in. (17.8 cm) diameter
Published by Edition Block, Berlin,
edition of 150

Bruce Nauman (p.41)
From Hand to Mouth, 1967
Wax over cloth
28 x 10 ⅛ x 4 in. (71.1 x 25.7 x 10.2 cm)
Hirshhorn Museum and Sculpture
Garden, Smithsonian Institution, Joesph
H. Hirshhorn Purchase Fund, Holenia
Purchase Fund, In Memory of Joseph H.
Hirshhorn and Museum Purchase, 1993

Claes Oldenburg (p.71)
Giant Soft Drum Set, 1967
Vinyl and canvas filled with polystyrene
chips, metal,
and painted wood parts; wood-and-
Formica base with metal railing;
nine instruments
48 x 72 x 84 in. (121.9 x 182.9 x
253.4 cm) overall
Collection Kimiko and John Powers

Nam June Paik (p.63)
Random Access, 1963 (destroyed)
Strips of audiotape, recording head, and
speakers
Dimensions variable

Mieko Shiomi (p.43)
Water Music, 1964/1969
Glass, plastic, paper
Dimensions variable
Gilbert and Lila Silverman Fluxus
Collection, Detroit

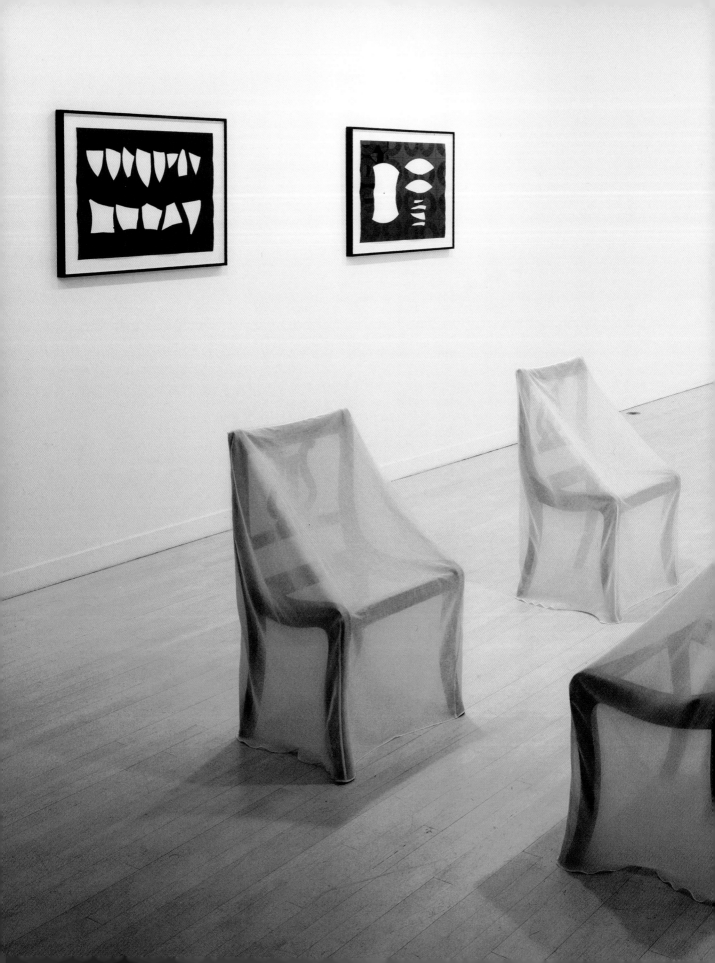

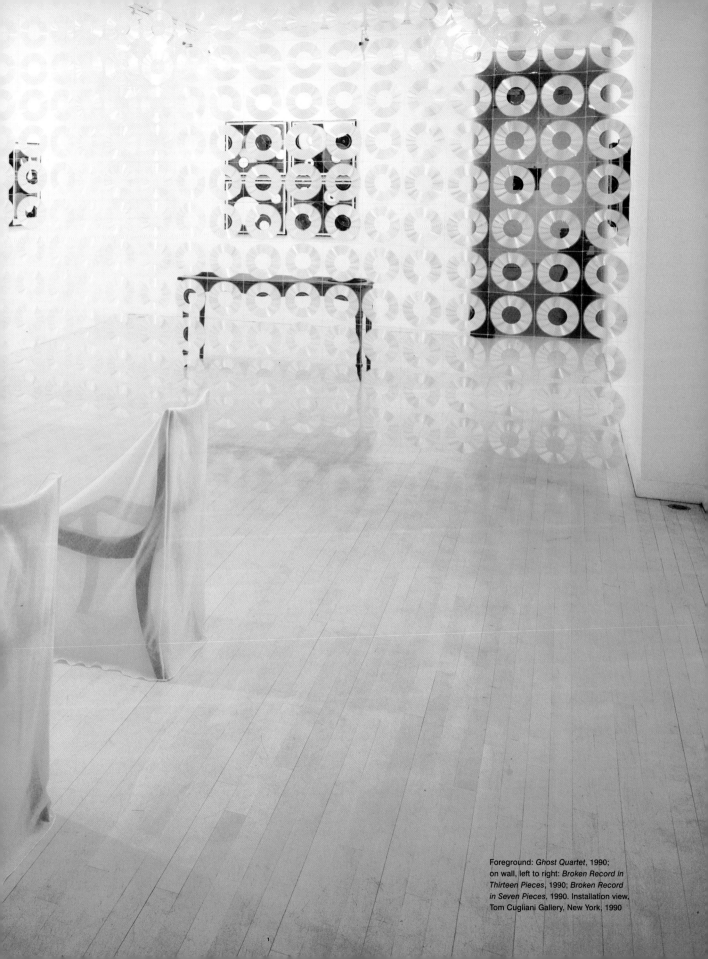

Foreground: *Ghost Quartet*, 1990;
on wall, left to right: *Broken Record in Thirteen Pieces*, 1990; *Broken Record in Seven Pieces*, 1990. Installation view, Tom Cugliani Gallery, New York, 1990

Acknowledgments

An exhibition is always the result of a collaborative process, and it is a pleasant responsibility to thank those who have worked with me to bring this project to fruition.

My heartfelt thanks go to the lenders to the exhibition: the Amerada Hess Corporation; BMG Music; Blum and Poe; Richard Carpenter; Nicolas Collins and Susan Tallman; Paula Cooper Gallery; David A. Dorsky and Helaine Posner; Christian Eckart; Georgia and Christopher Erck; the Fonds d'art contemporain de la Ville de Genève; Jane Hart; the Henry Art Gallery; David Hutchinson; Deborah Irmas; The Israel Museum; Dakis Joannou; Steven Johnson and Walter Sudol; Joan and Gerald Kimmelman; the Kunstmuseum Bern; Martin Z. Margulies; Burt Minkoff; Thurston Moore; the Museé de la Communication, Bern; Eileen Harris Norton; Peter Norton; Tina Petra and Ken Wong; The Progressive Corporation; the San Francisco Museum of Modern Art; the Robert J. Shiffler Foundation; the Art Collection of the Swiss Confederation, Federal Office of Culture, Bern; and the Tang Teaching Museum at Skidmore College, along with those who lent their works anonymously. Their generosity in making available works from their personal and institutional collections was essential to the exhibition.

I am also deeply grateful to the exhibition's funders. Hammer board member Eileen Harris Norton and the Peter Norton Family Foundation offered early and enthusiastic support for the project. Further assistance was provided by the LLWW Foundation; Pro Helvetia, the Arts Council of Switzerland; LEF Foundation; and Art for Arts Sake. Their generous support of the exhibition was crucial to its realization. I am also grateful to the Consulate General of Switzerland in Los Angeles for their assistance.

I would like to thank Douglas Kahn, Miwon Kwon, and Alan Licht for their essays. Their insights and contributions have enriched the project. The book was designed by Georgie Stout and Glen Cummings of 2x4, New York, who have produced a sensitive and elegant context for Marclay's work. Jane Hyun's meticulous attention to detail and skillful editing was an indispensable contribution. The book is co-published with Steidl, and I want to thank Gerhard Steidl for his ready commitment to the project, and for the always superb quality of his printing.

Sincere thanks are also due to Paula Cooper, Steve Henry, Anthony Allen, and Elissa Myerowitz at Paula Cooper Gallery in New York for their invaluable help in preparing the exhibition and catalogue. The entire staff of the gallery could not have been more helpful.

We are delighted to be able to travel the exhibition to a number of other museums, and our thanks go to our collaborators Amada Cruz and Marcia Acita

at the Center for Curatorial Studies Museum, Bard College, Annandale-on-Hudson, New York; Mimi Gates and Lisa Corrin at the Seattle Art Museum; and Madeleine Schuppli at the Kunstmuseum Thun.

We will present a number of concerts at the Hammer Museum in connection with the exhibition, and we are very glad to be able to present, in addition to Christian Marclay himself, Toshio Kajiwara and Tom Recchion; Carlos Niño and Adventure Time, featuring DJs Daedelus and Frosty; Lee Ranaldo; and Stephen Prina. Prina's performance of Marclay's *Graffiti Composition* will be the West Coast premiere of this work, and we are particularly grateful to him for undertaking this major commitment on our behalf. All of these performances were made possible by generous support from the American Center Foundation.

I am deeply appreciative of my colleagues at the Hammer Museum. The museum's director, Ann Philbin, has known Marclay's work for many years, and she was immediately and consistently supportive of the idea of a survey exhibition. Curatorial assistant Aimee Chang worked tirelessly on every aspect of this project, and it is no exaggeration to say that the exhibition would not have been possible without her. Sarah Stifler organized the impressive array of lectures and performances that accompany the exhibition. My other colleagues in the curatorial departments of the Hammer Museum and the Grunwald Center—Cindy Burlingham, James Elaine, Claudine Dixon, Claudine Isé, and Carolyn Peter—were also supportive of the project from the beginning. Gloria Gerace, deputy director of administration, and Lisa Whitney, director of finance, took care of countless administrative and financial issues. Jennifer Wells and Sarah Sullivan energetically spearheaded the museum's fundraising for this ambitious project. Our wonderful registrars, Susan Lockhart and Grace Murakami, skillfully managed a series of complex national and international loans. Mitch Browning and Chris McLaughlin were responsible for the major undertaking of the show's installation. Steffen Böddeker, along with Cynthia Wornham and Domenic Morea of Ruder Finn, expertly handled press and publicity. In addition, I would also like to thank staff members Lynne Blaikie, Paul Butler, Andrea Gomez, Jeanne Hoel, Andrew Kaiser, Jennifer Katell, Paulette Parker, Judith Quinones, David Rodes, Mary Ann Sears, Dana Turkovic, Ellen Wirth, and Heidi Zeller.

In addition to all those named above, I would like to thank the following individuals for all their help in innumerable ways: Herb Alpert, Elizabeth Armstrong, Julie Ault, Martin Beck, Ian Berry, Liz Brown, Eileen and Michael Cohen, Marc

Fehlmann, Matthias Frehner, Karin Higa, Franz Rene Hunkeler, Mami Kataoka, David Katznelson, Karl Kronig, Kris Kuramitsu, Tom Lawson, Toby Lewis, Pierre Andre Lienhard, Eugenio Lopez, Jenée Misraje, Isabelle Naef Galuba, Linda Pace, Ben Portis, Judith Solodkin, Rochelle Steiner, Toni Stooss, Urs V. Strausak, Benjamin Weil, Werner Wolfen, and Lydia Yee.

In conclusion, my deepest thanks go to Christian Marclay, not only for making the outstanding body of work presented here, but for the extraordinary commitment he has given to every aspect of this project. It has been my privilege, and my pleasure, to work with him.

—Russell Ferguson

You beat me to it Russell! Thank you for thanking all these wonderful people who I wanted to thank as well. Their collaboration was indeed invaluable. But above all you deserve my deepest appreciation. You did a tremendous job. I am so grateful for your friendship and your commitment to my work.

Thank you Paula and everybody at the gallery for being so generous and kind while taking care of business.

Thank you Terry, Rachel, and John-Erik for sorting out the mess in my archives.

Thank you, dear family, for your unconditional love and support.

And thank you Lydia for always being there and making everything worthwhile.

—Christian

Opposite and above: *Music Boxes*
(from Crossings), 1999. Installation view,
at the Galerie Rudolfinum, Prague

149

Above and opposite: *Empty Cases*
(In Memoriam Tom Cora), 1998.
Installation views, at O.K Centrum für
Gegenwartskunst, Linz, Austria, 1998

Exhibition History

Born 1955, San Rafael, California

Lives and works in New York City

Mixed Reviews, 1999/2002.
Installation view at Contemporary Arts
Center, New Orleans, 2002

Solo Exhibitions

2003

"Christian Marclay: Video Quartet," Kunsthalle Fridericianum, Kassel, Germany, 19 January–16 March

2002

"Video Quartet," Paula Cooper Gallery, New York, 12 December–1 February 2003

"The Sounds of Christmas," Museum of Contemporary Art, North Miami, 3–31 December

"Christian Marclay," November Music 2002, s-Hertogenbosch, The Netherlands, 6–10 November

"Look at the Music/SeeSound: Christian Marclay," Ystad Art Museum, Ystad, Sweden, 12 October–1 December, exh. brochure

"Three Compositions," Contemporary Arts Center, New Orleans, 5 October–15 December, exh. brochure

"Sampling," San Francisco Museum of Modern Art, San Francisco, 11 April–28 July, exh. brochure

2001

"Christian Marclay: The Sounds of Christmas," Yerba Buena Center for the Arts, San Francisco, 6–27 December

"Telephones," Delaware Center for Contemporary Art, Wilmington, 1 July–20 September

Museum of Contemporary Art, Chicago, 5 May–2 September, exh. brochure

"Currents 84: Christian Marclay," Saint Louis Art Museum, Saint Louis, 20 April–24 June, exh. brochure

"Guitar Drag," Gallery Koyanagi, Tokyo, 27 March–10 April

"New Works," Paula Cooper Gallery, New York, 24 January–17 February

2000

"Christian Marclay: The Sounds of Christmas," The New Museum of Contemporary Art / Media Z Lounge, New York, 14–31 December

"Christian Marclay: Cinema," Oakville Galleries, Oakville, Canada, 9 December–4 February 2001, exh. cat.

"Telephones," Presentation House Gallery, North Vancouver, Canada, 2 September–28 October

Musical Chairs, 1996.
Installation view at Villa Merkel,
Galerie der Stadt Esslingen am
Neckar, Esslingen, Germany

"Christian Marclay: Video & Fotografi," Museet for
Samtidskunst, Roskilde, Denmark, 23 March – 14 May,
exh. brochure

1999
"Telephones," Paula Cooper Gallery, New York,
11 December – 29 January 2000

ArtPace, A Foundation for Contemporary Art, San Antonio,
Texas, 10 December – 16 January 2000, exh. brochure

1997
"Pictures at an Exhibition," Whitney Museum of American
Art at Phillip Morris, New York, 24 October – 25 January 1998,
exh. brochure

"Arranged and Conducted," Kunsthaus, Zurich,
5 September – 26 October, exh. cat.

1995
"Accompagnement Musical," Musée d'art et d'histoire,
Geneva, 8 December – 25 February 1996

"Amplification," Venice Bienniale, Chiesa di San Staë,
2 February – 16 March, exh. cat. Traveled to Temple
de la Fusterie, Geneva

1994
Fawbush Gallery, New York, 19 November – 22 December

daadgalerie, Berlin, 21 January – 27 February. Traveled to
Fri-Art Centre d'Art Contemporain Kunsthalle, Fribourg,
Switzerland, 30 January – 13 March, exh. cat.

1993
Margo Leavin Gallery, Los Angeles,
10 March – 17 April

1992
"The Wind Section." Galerie Jennifer Flay, Paris,
24 October – 28 November

"Christian Marclay: Sewn Record Jackets,"
Nancy Drysdale Gallery, Washington, D.C.,
15 April – 30 May

"Masks," Galleria Valentina Moncada, Rome,
20 March – 30 June, exh. cat.

1991
Tom Cugliani Gallery, New York,
9 November – 1 January 1992

"Abstract Music," Trans Avant-Garde Gallery, San Francisco,
22 March – 17 April

Maureen Paley Interim Art, London, 24 February – 31 March

Galerie Isabella Kacprzak, Cologne, 11 January – 28 February

1990
"The White Album," Solo Press Gallery, New York,
29 November – 29 December

"Directions: Christian Marclay," Hirshhorn Museum &
Sculpture Garden, Washington, D.C., 26 June – 30 September,
exh. brochure

Tom Cugliani Gallery, New York, 2 – 31 March

1989
"Footsteps," Shedhalle, Zurich, 4 June – 16 July, exh. cat.

Tom Cugliani Gallery, New York, 21 April – 20 May

"Christian Marclay: Pochettes de Disques,"
Galerie Rivolta, Lausanne

1988
"One Thousand Records," Gelbe Musik, Berlin,
13 August – 1 October

Tom Cugliani Gallery, New York, 22 April – 21 May

1987
"850 Records," The Clocktower, P.S.1 Contemporary
Art Center, New York, 28 May – 28 June

1981
Apartment, Geneva, 17 – 27 June

Galatea and Pygmalion, 1989

Selected Group Exhibitions

2003

"Not Exactly Photographs," Fraenkel Gallery, San Francisco,
6 March–26 April

"Harlem Postcards II," The Studio Museum in Harlem,
New York, 23 January–30 March

2002

"Christmas Tree Festival," Fondation Art Project,
Geneva, 1 December–5 January 2003, exh. cat.

"Zero Visibility," Vilnius, Ljubljana, and Genazzano,
22 November–2 December

"Re:Direct," Künstlerhaus, Stuttgart, Germany,
16 November–2 December

"Remapping the City, New Ears Festival," Kortrijk,
Belgium, and Lille, France, 2–11 November

"Electric Body: Le corps en scène," Cité de la musique–
Musée de la musique, Paris, 19 October–3 July 2003, exh. cat.

"Mirror, Mirror," Mass MOCA, North Adams, Massachusetts,
5 October–2 January 2003

"Some Assembly Required: Collage Culture in Post-War
America," Everson Museum of Art, Syracuse, New York,
28 September–26 January 2002

"Unexpected Selections From the Martin Z. Margulies
Collection: Art from 1985 to the Present," The Art Museum
at Florida International University, Miami,
20 September–8 December, exh. brochure

"The Passing," Galeria Helga de Alvear, Madrid,
19 September–11 February 2003

"Fluxus und die Folgen," Kunstsommer Wiesbaden, Germany,
1 September–13 October, exh. brochure

"Air Guitar: Art Reconsidering Rock Music," Milton Keynes
Gallery, Milton Keynes, England, 13 July–26 August. Traveled
to Turnpike Gallery, Leigh, 21 September–9 November;
Angel Row Gallery, Nottingham, 18 January–1 March 2003;
and Tullie House, Carlisle, 22 March–18 May 2003

"Something, Anything," Matthew Marks Gallery, New York,
2 July–15 August. Curated by Nayland Blake

"Expo 2002," Yverdon-les-Bains, Switzerland, 15 May–20 October. Sound installation (*Nebula*) for *Blur* by Diller & Scofidio

"Das zweite Gesicht: Metamorphosen des fotografischen Porträts" (The Other Face: Metamorphoses of the Photographic Portrait), Deutsches Museum, Munich, 8 May–11 August, exh. cat.

"Media Field: Old New Technologies," Williams College Museum of Art, Williamstown, Massachusetts, 20 April–21 July

"Rock My World: Recent Art and the Memory of Rock 'n' Roll," CCAC Wattis Institute for Contemporary Arts, San Francisco, 23 March–11 May, exh. cat.

"Whitney Biennial," Whitney Museum of Art, New York, 7 March–26 May, exh. cat.

"Shoot the Singer: Music on Video," Institute of Contemporary Art, Philadelphia, 2 March–21 April, exh. brochure

"Mirror Image," UCLA Hammer Museum, Los Angeles, 9 February–5 May, exh. brochure.

"Stutter, Stutter," Shaheen Gallery, Cleveland, 25 January–1 March

"Telephones," Anthony Wilkinson Gallery, London, 24–27 January

2001
"Feature: Art, Life & Cinema," Govett-Brewster Art Gallery, New Plymouth, New Zealand, 8 December–28 January 2002, exh. cat.

"Record All-Over, 9th Biennial of Moving Images," Centre pour l'image contemporaine, Saint-Gervais, Geneva, 3 November–30 December, exh. cat.

Untitled, 1988

"Audible Imagery: Sound and Photography," The Museum of Contemporary Photography, Columbia College, Chicago, 26 October–21 December, exh. brochure

"E/Motion Studies," Video Café, Queens Museum of Art, Long Island City, New York, 21 October–7 February 2002

"Wiederaufnahme" (Retake), NAK—Neuer Aachener Kunstverein, Germany, 14 October–12 December

"Best of the Season," The Aldrich Museum of Contemporary Art, Ridgefield, Connecticut, 23 September–30 December, exh. brochure

"Recasting the Past: Beneath the Hollywood Tinsel," Main Art Gallery, California State University, Fullerton, California, 8 September–11 October

"Looking at You," Kunsthalle Fridericianum, Kassel, Germany, 12 August–16 September, exh. cat.

"The LP Show," Exit Art, New York, 1 June–17 August. Traveled to The Andy Warhol Museum, Pittsburgh, 23 June–1 September 2002

"In Sync, Cinema and Sound in the Work of Julie Becker and Christian Marclay," Whitney Museum of American Art, New York, 10 April–1 July, exh. brochure

"Body & Sin," Valencia Biennial, Valencia, Spain, 13 June–20 October, exh. cat.

"Collaborations with Parkett: 1984 to Now," The Museum of Modern Art, New York, 5 April–5 June, exh. brochure

"art>music," Museum of Contemporary Art, Sydney, Australia, 21 March–24 June, exh. cat.

"Patents, Monkeys, and More... On Collecting," Independent Curators International, New York, exh. cat. Traveled to Western Gallery, Western Washington University, Bellingham, Washington, 19 January–10 March; John Michael Kohler Arts Center, Sheboygan, Wisconsin, 12 August–21 October; Akron Art Museum, Akron, Ohio, 17 November–24 February 2002; Fuller Museum of Art, Brockton, Massachusetts, 1 June–18 August 2002; Institute of Contemporary Art, University of Pennsylvania, Philadelphia, 15 September–10 November; Pittsburgh Center for the Arts, Pittsburgh, Pennsylvania, 18 January–16 March 2003

"Now Playing: Audio in Art," Susan Inglett Gallery, New York, 11 January–17 February

2000

"Art On Paper 2000," Weatherspoon Art Gallery, The University of North Carolina, Greensboro, 19 November–14 January 2001, exh. cat.

"Monter/Sampler: L'Échantillonnage généralisé," Pompidou Center, Paris, 15 November–21 December, exh. cat.

"To Infinity and Beyond: Editions for the Year 2000," Brooke Alexander Gallery, New York, 3 November–23 December

"Hard Pressed: 600 Years of Prints and Process," AXA Gallery, New York, 2 November–31 January 2001, exh. cat.

"S.O.S.: Scenes of Sounds," The Tang Teaching Museum and Art Gallery, Skidmore College, Saratoga Springs, New York, 27 October–28 January 2001, exh. cat.

"Print Publishers' Spotlight," Barbara Krakow Gallery, Boston, 21 October–29 November

"Berlin Open," Trafo Galeria, Budapest, 16–26 October

"Off the Record: Music in Art," Center Gallery, Bucknell University, Lewisburg, Pennsylvania, 13 October–10 December

"La Biennale de Montreal," Centre international d'art contemporain, Montreal, 28 September–29 October, exh. cat.

"Volume: Bed of Sound," P.S.1 Contemporary Art Center, Long Island City, New York, 14 July–30 September

"Umedalen Skulptur 2000," Galleri Stefan Andersson, Umea, Sweden, 10 June–3 September

"Group Show," Paula Cooper Gallery, New York, 9 June–21 July

"Making Sense: Ellen Gallagher, Christian Marclay and Liliana Porter," Contemporary Museum, Baltimore, Maryland, 4 May–20 August, exh. cat.

"Sonic Boom: The Art of Sound," Hayward Gallery, London, 27 April–18 June, exh. cat.

"Der anagrammatische Körper: Der Körper und seine mediale Konstruktion," Zentrum für Kunst und Medientechnologie, Karlsruhe, Germany, 8 April–18 June

"Human Gender and Being," Kwangju Biennale, South Korea, 23 March–7 June

"Multiple Visions: Works by Master Printers," The Print Center, Philadelphia, 22 January–11 March

"Le temps, vite!," Centre Georges Pompidou, Paris, 13 January–17 April, exh. cat. Traveled to Palazzo delle Exposizioni, Rome, 27 July–23 October; and Centre de Cultura Contemporània, Barcelona, 28 November–25 February 25

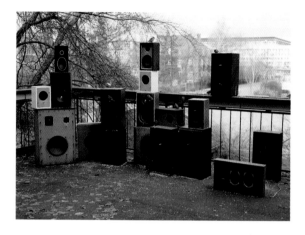

Birdhouses, 1994
Installation view at daadgalerie, Berlin, 1994

1999

"Videodrome," The New Museum of Contemporary Art, New York, 22 October–11 November

"Releasing Senses," Tokyo Opera City Art Gallery, Tokyo, 9 September–21 November, exh. cat.

"Missing Link," Kunstmuseum Bern, 3 September–14 November, exh. cat.

"Works on Paper," D'Amelio Terras Gallery, New York, 1 September–2 October

"A Sense of Risk: Art of the 90's, Selections from the Robert J. Shiffler Foundation," Miami University Art Museum, Miami, Ohio, 20 August–17 October

"Video — Aus der Sammlung," Kunsthaus, Zurich, 30 July–24 October

"Notorious: Alfred Hitchcock and Contemporary Art," Museum of Modern Art, Oxford, 11 July–3 October, exh. cat. Traveled to Museum of Contemporary Art, Sydney, 15 December–24 April 2000; Tokyo Opera City Art Gallery, Tokyo, 4 April–17 June 2001; Museet For Fotokunst, Brandts Klædefabrik, Odense, Denmark, 26 August–12 November; and Centro Cultural de la Fundación, Lleida, Spain, 22 September–11 November 2001

"DAPERtuto," Venice Biennial, Venice, 13 June–7 November

"Serien und Konzepte: In der Photound Videokunst," Museum Ludwig, Cologne, 5 May–25 July

"Talk Show," Von der Heydt Museum, Wuppertal, Germany, 28 March–24 May, exh. cat. Traveled to Haus der Kunst, Munich, 10 August–1 September 2000

"Sound Foundations: Audio in Video," The Center for Curatorial Studies, Bard College, Annandale-on-Hudson, New York, 14–28 March

"Oh cet écho! (duchampiana)," Fondation Mamco and Centre d'art contemporain, Geneva, February

"Musique en Scène," Musée d'art contemporain, Lyon, 12 February–11 April, exh. cat.

"20 Ans de Mécénat à la Banque Cantonale de Genève," Musée Rath, Geneva, 12 February–11 April

1998
"Bowie," Rupert Goldsworthy Gallery, New York, 18 November–9 January 1999

"I Love New York," Museum Ludwig, Cologne, 6 November–31 January 1999, exh. cat.

"In vitro e altro: affiches d'artistes," Cabinet des estampes du musée d'art d'histoire, Geneva, 17 September–25 October

"Dust Breeding: Photographs, Sculpture & Film," Fraenkel Gallery, San Francisco, 10 September–31 October, exh. cat.

"Freie Sicht aufs Mittelmeer," Kunsthaus Zurich, 5 June–30 August, exh. cat. Traveled to Schirn Kunsthalle, Frankfurt, 6 October–22 November

"Crossings: Art to Hear and to See," Kunsthalle, Vienna, 29 May–13 September, exh. cat. Traveled to Rudolfinum, Prague

"White Noise," Kunsthalle Bern, 21 May–28 June, exh. cat.

"Intérieur/Extérieur," Villa Bernasconi, Service Culturel de la Ville de Lancy, Geneva, 16 May–27 June

"Archiv X," Offenes Kulturhaus Centrum für Gegenwartskunst, Linz, Austria, 24 April–17 July, exh. cat.

"Technoculture (Computer World)," Fri-Art Centre d'art contemporain, Fribourg, 5 April–23 May

"Composed," Angles Gallery, Santa Monica, California, 13 March–11 April

"Parasite," Drawing Room at The Drawing Center, New York, 21 February–24 April

"Technosophia I: Overpromised," The Swiss Institute, New York, 8 January–1 March

"Foto Relations," Kunsthaus der Stadt Brünn, Brno, Czech Republic, 13 January–1 March, exh. cat.

1997
"Alpenblick," Kunsthalle Wein, Vienna, 31 October–February 1998

"Nonchalance," Centre PasquART, Bienne, Switzerland, 31 August–26 October, exh. cat. Traveled to Akademie der Kunste, Berlin, 29 August–4 October 1998

"projects.doc: Selections from the Robert J. Shiffler Collection and Archive," Cincinnati Arts Association, Aronoff Center, Cincinnati, Ohio, 14 June–24 August, exh. cat.

"Extended Play: Between Rock and an Art Space," The Photographic Resource Center, Boston, 9 May–17 August, exh. brochure

"Rrose Is a Rrose Is a Rrose: Gender Performance in Photography," Guggenheim Museum, New York, 17 January–27 April, exh. cat. Traveled to The Andy Warhol Museum, Pittsburgh, 13 September–30 November

1996
"Helvetia Sounds," Galerien der Stadt, Villa Merkel, Esslingen, Germany, 21 July–15 September, exh. cat.

"Transformers: A Moving Experience," Auekland Art Gallery, New Zealand, 25 April–28 July 28, exh. cat.

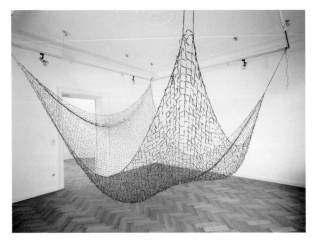

Net, 1991

"Art and Film Since 1945: Hall of Mirrors," The Museum of Contemporary Art, Los Angeles, 17 March–July 28, exh. cat. Traveled to The Wexner Center for the Arts, Columbus, Ohio, 21 September 1996–5 January 1997; Palazzo delle Esposizioni, Rome, June–September 1997; and Museum of Contemporary Art, Chicago, 11 October 1997–21 January 1998

"Model Home," Clocktower Gallery, P.S.1 Contemporary Center, New York, 8 February–31 March

"Everything That's Interesting Is New: The Dakis Joannou Collection," The Deste Foundation for Contemporary Art, exh. cat. Traveled to Athens School of Fine Arts "the factory," Athens; Museum of Modern Art, Copenhagen; and Guggenheim Museum, New York

1995
"Tekeningen & Tekeningen" (Drawings & Drawings), Galerie Van Gelder, Amsterdam, 19 November–18 January 1996

"It's Only Rock & Roll: Rock & Roll Currents in Contemporary Art," Contemporary Art Center, Cincinnati, 17 November–21 January 1996, exh. cat. Traveled to Lakeview Museum of Arts and Sciences, Peoria, Illinois, 17 February–14 April 1996; Virginia Beach Center for the Arts, Virginia, 12 May–30 June 1996; Tacoma Art Museum, Tacoma, Washington, 12 July–8 September; Jacksonville Museum of Contemporary Art, Jacksonville, Florida, 26 September–20 November 1996) Dean Lesher Regional Center for the Arts, Walnut Creek, California, 17 December–16 February 1997; Phoenix Art Museum, Phoenix, 22 March–15 June 1997; Lowe Art Museum, Coral Gables, Florida, 11 December 1997–8 February 1998; Milwaukee Art Museum, Milwaukee, 20 March–24 May 1998; and Arkansas Art Center, Little Rock, 1 July–1 September 1998

"Temporarily Possessed: The Semi-Permanent Collection," The New Museum of Contemporary Art, New York, 15 September–17 December, exh. cat.

Breathless I, 2000

"Group Exhibition," Fawbush, New York, 9 September–11 October

"Back Beat: Art Influenced by Rock & Roll," Cleveland Center for the Arts, Cleveland, 25 August–24 September

"Material Matters, Art in the Anchorage," Creative Time, New York, 13 July–14 September, exh. cat.

"Klangskulpturen–Augenmusik," Ludwig Museum im Deutschherrenhaus, Koblenz, Germany, 2 July–24 September, exh. cat.

"Venice Biennial," Venice, 11 June–15 October, exh. cat.

"Exposition Suisse de sculpture Môtiers 1995," Môtiers, Switzerland, summer, exh. cat.

"Prints from the Judith Solodkin NYC Workshop," Gallery 72, Omaha, 7 April–1 May, exh. cat.

"Commercial Art," Gallery Paule Anglim, San Francisco, 4 October–11 November

1994
"The Music Box Project," The Equitable Gallery, New York, 10 November–7 January 1995, exh. cat. Traveled to Center for the Fine Arts, Miami, 26 January–17 March 1995; and Long Beach Museum of Art, Long Beach, California, 3 March–21 May

"Transformers: The Art of Multiphrenia," Center for Curatorial Studies, Bard College, Annandale-on-Hudson, New York, 21 September–13 November, exh. cat.

"Synesthesia: Sound & Vision in Contemporary Art," San Antonio Museum of Art, San Antonio, 27 August–4 December, exh. cat.

"Solo Impressions," The College of Wooster Art Musuem, Wooster, Ohio, 24 August–9 October

"Playoff," Art & Public, Geneva, 30 May–25 June

"Outside the Frame: Performance and the Object," Cleveland Center for Contemporary Art, 11 February–1 May, exh. cat. Traveled to Snug Harbor Cultural Center, Staten Island, New York, 26 February–18 June 1995

"New Delhi Triennial," New Delhi, 17 February–15 March, exh. cat.

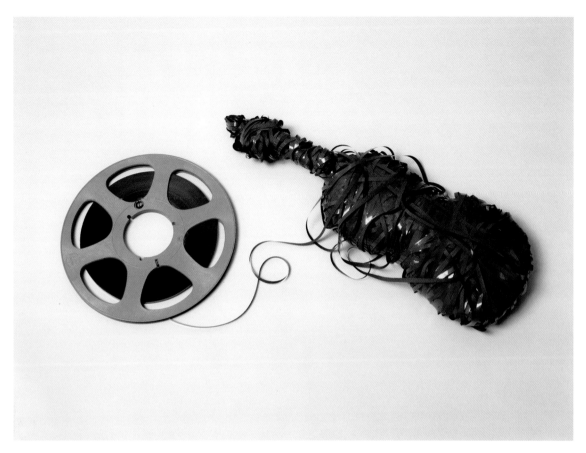

1993

"Nine Sculptors and Their Printer: A Tribute to Judith Solodkin," Bernard Toale Gallery, Boston, 6 December – 22 January 1994

"The Return of the Cadavre Exquis," The Drawing Center, New York, 6 November – 18 December, exh. cat. Traveled to The Corcoran Gallery of Art, Washington, D.C., 5 February – 10 April 1994; Santa Monica Museum of Art, 7 July – 5 September 1994; Forum for Contemporary Art, St. Louis, 30 September – 12 November 1994; American Center, Paris, December 1994 – January 1995

"My Home Is Your Home," Artists' Museum, Lodz, Poland, 1 – 7 October, exh. cat. Traveled to Stadsgalerij, Heerlen, Holland, 20 November – 23 January 1994

"Money/Politics/Sex," Nancy Drysdale Gallery, Washington, D.C., 18 September – 16 October, exh. brochure

"Ecart," Galerie Susanna Kulli, St. Gallen, Switzerland, 12 February – 16 April

"Mettlesome & Meddlesome: Selections from the Collection of Robert J. Shiffler," The Contemporary Arts Center, Cincinnati, 6 February – 20 March, exh. cat.

"At the Edge of Chaos — New Images of the World," Louisiana Museum of Modern Art, Humlebaeck, Denmark, 5 February – 9 May

1992

"Tattoo Collection," Andrea Rosen Gallery, New York, 23 October – 28 November

"Hollywood, Hollywood: Identity under the Guise of Celebrity," Art Center College of Design, Pasadena, California, 20 October – 20 December, exh. cat.

"Trans-Voices," American Center, Paris, 26 September – 18 October

"Cross Section," Battery Park City and the World Financial Center, New York, 9 July – 20 September

"The Speaker Project," Molteplici Culture, Convento di S. Egidio, Rome, 19 May – 19 June

"Post Human," FAE Musée d'art contemporain, Pully/ Lausanne, 14 June – 13 September, exh. cat. Traveled to Castello di Rivoli, Museo d'arte contemporanea, Turin, 1 October – 22 November; Deste Foundation for Contemporary Art, Athens, 3 December – 14 February 1993; Deichtorhallen, Hamburg, 12 March – 9 May 1993; The Israel Museum, Jerusalem, 21 June – 10 October 1993

"Hidden Reflections," The Israel Museum, Jerusalem, April – May, exh. cat.

Stereo Volume, 1989

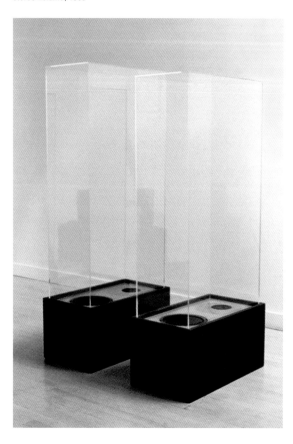

"Not Quiet: Felix Gonzalez-Torres, Liz Larner, Christian Marclay, Matthew McCaslin," Galerie Jennifer Flay, Paris, 21 March–18 April, exh. cat.

"Nicolas Collins, Alvin Lucier, Christian Marclay, Ron Kuivila," Sous-sol, Ecole Superieure d'Art Visuel, Geneva, 10 March–10 April, exh. cat.

"Notes from the Material World," John Michael Kohler Arts Center, Sheboygan, Wisconsin, 1 March–10 May 1992

"Doubletake: Collective Memory & Current Art," Hayward Gallery, London, 20 February–20 April, exh. cat. Travelled to Kunsthalle Wien, Vienna, 8 January–28 February 1993

1991
"Residue Politics," Beaver College Art Gallery, Glenside, Pennsylvania, 14 November–20 December, exh. cat.

"Just What Is It That Makes Today's Homes So Different, So Appealing?," The Hyde Collection's Charles R. Wood Gallery, Glens Falls, New York, 8 September–17 November, exh. cat.

"They See the Light," Galerie Van Gelder, Amsterdam, 11–27 August

Jay Gorney Modern Art, New York, 8 June–26 July

"Ex Aequo: 24 artistes suisses à St Imier," St. Imier Switzerland, 26 May–29 September, exh. cat.

"Whitney Biennial," Whitney Museum of American Art, New York, 9 April–23 June, exh. cat.

"FluxAttitudes," Hallwalls, Buffalo, New York, 23 February–27 March, exh. cat. Traveled to The New Museum, New York, 27 September 1992–3 January 1993

"The Savage Garden," Fundacion Caja de Pensiones, Madrid, 22 January–10 March, exh. cat.

"Mute: Pictures of Sound," Solo Gallery/Solo Press, New York, 3 January–9 February

1990
"New Works for New Spaces: Into the Nineties," Wexner Art Center, Columbus, Ohio, 6 October–6 January 1991, exh. cat.

"The Thing Itself," Feature Gallery, New York, 10 July–10 August

"Drawings," Althea Viafora Gallery, New York, 9 June–21 July

"Loving Correspondence," Massimo Audiello Gallery, New York, 1–30 June

"Stendhal Syndrome: The Cure," Andrea Rosen Gallery, New York, 29 June–4 August, exh. cat.

Laurie Rubin Gallery, New York, 28 April–26 May

"Status of Sculpture," Espace Lyonnais d'art contemporain, Lyon, 23 March–20 May, exh. cat. Traveled to Institute of Contemporary Arts, London, 14 September–28 October; Provincial Museum, Hasselt, Belgium, 24 November–24 February 1991; Lion's Palais, Stiftung Starke, Berlin

"Assembled," University Art Galleries, Wright State University, Dayton, Ohio, 8 April–13 May

1989
"The Second Second (or the discomfort of recent history)," Althea Viafora Gallery, New York, 2–23 December

"Strange Attractors: Signs of Chaos," The New Museum of Contemporary Art, New York, 14 September–26 November, exh. cat.

"Exposition Suisse de Sculpture," Môtiers, Switzerland, 24 June–24 September, exh. cat.

"Miroir 89: Balthasar Burkhard, Philippe Deléglise, Michel Huelin, Pierre Keller, Christian Marclay, Olivier Mosset, Jean Tinguely," Musée de Carouge, Carouge-Geneva, 1 June–2 July, exh. brochure

1988
"Group Material: Politics and Election," Dia Center for the Arts, New York, 15 October–12 November

"Broken Music: Artists' Recordworks," daadgalerie, Berlin, 1 October–26 November, exh. cat. Traveled to Gemeentemuseum, The Hague; Le Magasin, Grenoble, France; Musée d'Art Moderne, Montreal, 4 November 1990–10 February 1991

Furious Pig, 1992

Paul Kasmin Gallery, New York, September–October

Kunstverein, Freiburg, Germany, 18 August–11 September

Tom Cugliani Gallery, New York, April–May

"Extended Play," Emily Harvey Gallery, New York, 12 February–12 March, exh. cat. Curated by Ursula Block and Christian Marclay

John Gibson Gallery, New York, 9–30 January

"ReDefining the Object," University Art Galleries, Wright State University, Dayton, 21 February–3 April, exh. brochure

1987
"Inaugural Exhibition," Tom Cugliani Gallery, New York, 30 October–28 November

1986
"Sound Wave NYC," City Gallery, New York, 9 June–12 July, exh. cat.

"5 Ans," Palud No 1, Lausanne, Switzerland, 18 April–17 May

"Künstlerschallplatten," Gelbe Musik, Berlin, 1 February–15 March. Traveled to Galerie Vorsetzen, Hamburg, 14 March–4 April 1987

1985
"On the Wall/On the Air: Artists Make Noise," Hayden Corridor Gallery, Massachusetts Institute of Technology, Cambridge, Mass., 15 December–27 January, exh. brochure

"Visual Sound," Brattleboro Museum, Brattleboro, Vermont, 16 August–12 October

1984
"Réf. 84," Palud No 1, Lausanne, Switzerland, 24 March–14 April, exh. cat.

1983
"Sound Seen," New Music America, Washington Project for the Arts, Washington, D.C.

1980
"Invitational Show," The Bachelors, even, Gallery Naga, Boston, 21 June–30 August

Abstract Music, 1989-90

Abstract Music, 1989-90

Selected Bibliography

Books and Catalogues

Anastas, Rhea. *Christian Marclay: Video & Fotografi.* Exh. brochure. Roskilde, Denmark: Museet for Samtisdskunst, 2000.

Arteau, Gilles, and Louis Ouellet. *Obscure 1982–1988.* Quebec City: The Canada Council, 1988.

Armstrong, Richard, et al. *1991 Whitney Biennial.* Exh. cat. New York: Whitney Museum of American Art, 1991.

Beauvais, Yann, and Jean-Michel Bouhours, eds. *Monter/Sampler: L'échantillonnage généralisé.* Paris: Scratch Projection/Centre Pompidou, 2000.

Beil, Ralf, and Marc Fehlmann. *Eiszeit: Kunst der Gegenwart aus Berner Sammlungen.* Exh. cat. Bern: Kunstmuseum, 2000.

Bezzola, Tobia, Dan Cameron, Simon Maurer, et al. *Arranged and Conducted.* Exh. cat. Zurich: Kunsthaus, 1997.

Blessing, Jennifer. *Rrose Is a Rrose Is a Rrose: Gender Performance in Photography.* Exh. cat. New York: Solomon R. Guggenheim Museum, 1997.

Block, Ursula, and Michael Glasmeier. *Broken Music: Artists' Recordworks.* Exh. cat. Berlin: daadgalerie, 1989.

Block, Ursula, Peter Frank, Christian Marclay, et al. *Extended Play.* Exh. cat. New York: Emily Harvey Gallery, 1988.

Bogle, Andrew. *Transformers: A Moving Experience.* Exh. cat. Auckland, New Zealand: Auckland Art Gallery, 1996.

Bourriaud, Nicolas. *Not Quiet.* Exh. cat. Paris: Galerie Jennifer Flay, 1992.

Bradley, Fiona. *Sonic Boom: The Art of Sound.* Exh. cat. London: Hayward Gallery, 2000.

Brentano, Robyn, Olivia Georgia, et al. *Outside the Frame: Performance and the Object.* Exh. cat. Cleveland: Cleveland Center for Contemporary Art, 1994.

Brougher, Kerry. *Art and Film Since 1945: Hall of Mirrors.* Exh. cat. Los Angeles: The Museum of Contemporary Art, 1996.

——— and Michael Tarantino. *Notorious: Alfred Hitchcock and Contemporary Art.* Exh. cat. Oxford, England: Museum of Modern Art, 1999.

Brunon, Bernard. *Status of Sculpture.* Exh. cat. Lyon, France: Espace Lyonnais d'art contemporain, 1990.

Burke, Gregory, and Hanna Scott, eds. *Feature: Art, Life & Cinema.* Exh. cat. New Plymouth, New Zealand: Govett-Brewster Art Gallery, 2001.

Cameron, Dan. *The Savage Garden.* Exh. cat. Madrid: Fundacion Caja de Pensiones, 1991.

———. *Just What Is It That Makes Today's Homes So Different, So Appealing?.* Exh. cat. Glens Falls, New York: The Hyde Collection's Charles R. Wood Gallery, 1991.

———. *Redefining the Object.* Exh. cat. Dayton, Ohio: University Art Galleries, Wright State University, 1988.

Celant, Germano, and Paula Marincola. *Residue Politics.* Exh. cat. Glenside, Pennsylvania: Beaver College Art Gallery, 1991.

Christov-Bakargiev, Carolyn. *Storie.* Exh. cat. Rome: Galleria Campo, 1991.

Cooke, Lynne, Bice Curiger, and Greg Hilty. *Doubletake: Collective Memory and Current Art.* Exh. cat. London: Parkett, The South Bank Centre, 1992.

Cooper, Dennis, and Harm Lux. *Christian Marclay*. Exh. cat. Zurich: Shedhalle, 1989.

Cramer, Sue. *Art>Music: Rock, Pop, Techno*. Exh. cat. Sydney: Museum of Contemporary Art, 2001.

Criqui, Jean-Pierre, and Daniel Soutif. *Le Temps, vite!*. Exh. cat. Paris: Centre Georges Pompidou, 2000. Also translated into Spanish and Italian.

Cruz, Amada. *Christian Marclay*. Exh. brochure. Washington, D.C.: Hirshhorn Museum and Sculpture Garden, Smithsonian Institution, 1990.

Curiger, Bice, et al. *Freie Sicht aufs Mittelmeer*. Exh. cat. Zurich: Kunsthaus, 1998.

Damsch-Wiehager, Renate. *Helvetia Sounds*. Exh. cat. Esslingen, Germany: Villa Merkel, Galerie der Stadt, 1996.

Deitch, Jeffrey. *Post Human*. Exh. cat. Pully/Lausanne: FAE Musée d'art contemporain, 1992.

Doswald, Christoph, and Andreas Meyer. *Nonchalance*. Exh. cat. Bienne/Biel, Switzerland: Centre PasquART, 1997.

Doswald, Christoph. *Missing Link: Menschen-Bilder in der Fotografie*. Exh. cat. Bern: Kunstmuseum, 1999.

Exposition Suisse de Sculpture Môtiers 1989. Exh. cat. Môtiers: La Chaux-de-Fonds, 1989.

Exposition Suisse de Sculpture Môtiers 1995. Exh. cat. Lausanne: Editions Acatos, 1995.

Ferguson, Russell. *Christian Marclay: Amplification*. exh. catalogue, Chiesa San Stae, Venice Biennale 1995. Bern: Lars Müller, 1995.

Fibicher, Bernhard. *White Noise*. Exh. cat. Bern: Kunsthalle, 1998.

Frank, Peter, et al. *Fri-Art: Made in Switzerland*. Exh. cat. Fribourg, Switzerland: Fri-Art, 1985.

Frankel, David. *Christian Marclay*. Exh. brochure. San Antonio: ArtPace, A Foundation for Contemporary Art, San Antonio, 1999.

Gale, Peggy. *Tout le temps: Every Time, Biennale de Montréal*. Exh. cat. Montréal: CIAC, 2000.

Glasmeier, Michael, and Douglas Kahn. *Christian Marclay*. Exh. cat. Berlin: daadgalerie; and Fribourg, Switzerland: Fri-Art, Centre d'art contemporain, 1994.

Godfrey, Tony. *Conceptual Art*. London: Phaidon Press, 1998.

Goldberg, RoseLee. *Performance: Live Art Since 1960*. New York: Harry N. Abrams, 1998.

Groos, Ulrike, and Suzanne Titz. *Wiederaufnahme (Retake)*. Exh. cat. Aachen: NAK—Neuer Aachener Kunstverein, 2001.

Higgs, Matthew, Ann Powers, and Ralph Rugoff. *Rock My World: Recent Art and the Memory of Rock 'n' Roll*. Exh. cat. Oakland: California College of Arts and Crafts, 2002.

Hosokawa, Shuhei. *Aesthetics of Records*. Japan: Keisoushobou, 1990.

Jaguer, Edouard, and Jean-Jacques Lebel. *After Duchamp*. Exh. cat. Paris: Marcel Fleiss Galerie 1900–2000, 1991.

Kataoka, Mami, ed. *Releasing Senses*. Tokyo: Tokyo Opera City Cultural Foundation, 1999.

Kemp, Cornelia, and Susanne Witzgall, eds. *Das zweite Gesicht: Metamorphosen des fotografischen Porträts* (The Other Face: Metamorphoses of the Photographic Portrait). Exh. cat. Munich: Prestel/Deutsches Museum, 2002.

Koestenbaum, Wayne. *Masks*. Exh. cat. Rome: Galleria Valentina Moncada, 1992.

Klangkunst. Exh. cat. Berlin: Prestel & Akademie der Künste, 1996.

Klangskulpturen—Augenmusik. Exh. cat. Koblenz, Germany: Ludwig Museum im Deutschherrenhaus, 1995.

Landau, Suzanne, and Jim Lewis. *Réflexions Voilées*. Exh. cat. Jerusalem: The Israel Museum, 1992.

Lander, Dan, and Micah Lexier, eds. *Sound by Artists*. Toronto: Art Metropole, 1990. Insert by Marclay.

Lauf, Cornelia, and Susan Hapgood, eds. *FluxAttitudes*. Exh. cat. New York: Hallwalls Center & The New Museum, 1991.

Lavigne, Emma, et al. *Electric Body: Le corps en scène*. Exh. cat. Paris: Beaux Arts Magazine/Cité de la musique, 2003.

Lieberman, Rhonda, Catherine Liu, and Lawrence Rickels. *Stendhal Syndrome: The Cure*. Exh. cat. New York: Andrea Rosen Gallery, 1990.

Marclay, Christian. "Le son en images." In *L'écoute*, ed. Peter Szendy. Paris: L'Harmattan, Ircam-Centre Pompidou, 2000.

Marcoci, Roxana, Diana Murphy, Eve Sinaiko, eds. *New Art*. New York: Harry N. Abrams, 1997.

Macioce, Michael. *Light & Dark*. New York: Shimmy Disc Publication, 1992.

Mahony, Emma. *Air Guitar: Art Reconsidering Rock Music*. Exh. cat. Milton Keynes, England: Milton Keynes Gallery, 2002.

Meyer-Bueser, Susanne, and Bernhart Schwenk. *Talk Show: Die Kunst der Kommunikation in den 90er Jahren*. Exh. cat. Munich: Haus der Kunst, 1999.

Obrist, Hans Ulrich, and Guy Tortosa. *Unbuilt Roads: 107 Unrealized Projects.* Stuttgart: Hatje Cantz, 1997.

Pichler, Cathrin, et al. *Crossings: Kunst zum Hören und Sehen*. Exh. cat. Vienna: Kunsthalle wien, 1998.

Platzker, David, and Elizabeth Wyckoff. *Hard Pressed: 600 Years of Prints and Process*. New York: Hudson Hills Press, in association with International Print Center New York, 2000.

Poetter, Jochen. *I Love New York: Crossover der aktuellen Kunst*. Exh. cat. Cologne, Germany: Ludwig Museum, 1998.

Ritter, Michel. *Fri-Art Centre d'art contemporain Kunsthalle* (annual catalogue). Fribourg, Switzerland: Fri-Art, 1992, 1994, 1995, 1996, 1998.

Rubin, David S. *It's Only Rock & Roll: Rock and Roll Currents in Contemporary Art*. Exh. cat. New York: Prestel, 1995.

Rugoff, Ralph. *Transformers*. Exh. cat. New York: Independent Curators Incorporated, 1994.

Schaffner, Ingrid, Fred Wilson, and Werner Muensterberger. *Pictures, Patents, Monkeys, and More... On Collecting*. Exh. cat. New York: Independent Curators International, 2001.

Schwartz, Dieter. *Kunstverein Freiburg*. Exh. brochure. Freiburg: Kunstverein, 1988.

Soejima, Teruto. *The Stream of Contemporary Jazz*. Tokyo: Maruzen Books, 1994.

Smolenicka, Maria. *Foto Relations*. Exh. cat. Brno, Czech Republic: Kunsthaus, 1998.

Steiner, Rochelle. *Currents 84: Christian Marclay*. Exh. brochure. Saint Louis: Saint Louis Art Museum, 2001.

Toop, David. "Christian Marclay." In *Look at the Music/SeeSound Anthology*. Exh. cat. Ystad, Sweden: Ystad Art Museum, 2002.

Trippi, Laura. *Strange Attractors: Signs of Chaos*. Exh. cat. New York: The New Museum of Contemporary Art, 1989.

Tsai, Eugenie. *Pictures at an Exhibition*. Exh. brochure. New York: Whitney Museum of American Art at Philip Morris, 1997.

Veenstra, Irene. *My Home Is Your Home*. Exh. cat. Eindhoven: Het Apollohuis and Heerlen: Stadsgalerij 1993.

Interviews and Conversations

"A Conversation between Christian Marclay and Michael Snow," ed. Benjamin Portis. *Christian Marclay: Cinema*. Exh. brochure. Oakville, Canada: Oakville Galleries, 2000.

"Christian Marclay." *Speed Kills* (Chicago) 3, no. 5 (1993): 21–29. Interview.

"Christian Marclay im Gespräch mit Lawrence 'Butch' Morris." *Inventionen '94* (Berlin) (1994): 44–48.

"Die Ohren der Leute werden an unserer Musik wachsen...Ein Willisauer Gespräch mit John Zorn, Arto Lindsay, Christian Marclay." *Jazz* (Basel) 5 (1984).

Adler, Sabine. "Was macht die Wuirst im Bierglas?" *TZ München* (26 April 1996): 20.

Burk, Craig. "Entretien avec Christian Marclay." *Intra Musiques* (France) 12 (1985): 9–12.

Curiger, Bice. "Das Medium ist die Message." *Kunst Expansiv: Zwischen Gegenkultur und Museum*. Regensburg, Germany: Lindinger + Schmid 2002. Interview. Translated into German from *Arranged and Conducted*. Exh. cat. Zurich: Kunsthaus, 1997.

Dyment, Dave. "Up and Out." *Lola* (Toronto) 8 (winter 2000–01): 37.

Erfle, Anne. "(Un-)Ordnung der Dinge." *Zyma Art Today* (Munich) 2 (June/July 1996): 37–38.

Estep, Jan. "Words and Music: Interview with Christian Marclay." *New Art Examiner* (September/October 2001): 78–83.

Groos, Ulrike, and Markus Müller. "Interview mit Christian Marclay," 180–189. In *Make it Funky: Crossover zwischen Musik, Pop, Avantgarde und Kunst*. Cologne: Oktagon Press, 1998. Translated into French, ed. Vincent Pécoil, *Prières américaines*. Dijon-Quetigny: Les Presses du Réel, 2002.

Henritzi, Michel. "Christian Marclay." *Revue et Corrigée* (Grenoble) 41 (September 1999): 9–14.

——. "Christian Marclay 'Scratchh...'" *Supersonic Jazz* 15F (April 1997): 4–9.

Hill, Gary, and Christian Marclay. "Conversation." *Annandale* (Bard College) (spring 2000): 2–9.

Hosokawa, Shuhei. "The Abuse of Record: An Interview with Christian Marclay." *Music Today* (Japan) 8 (spring 1990): 42–46.

Howard, Carl. "Interview: Christian Marclay." *Artitude/The Audiofile Magazine* 3 (December/January 1985): 4–5.

Katz, Vincent. "Interview with Christian Marclay." *The Print Collector's Newsletter* 22, no. 1 (March/April 1991): 5–9.

Kawauchi, Taka. "Bad Interview: Christian Marclay." *Studio Voice* (Tokyo) 286 (October 1999): 142–44.

Kitahara, Kay. "Christian Marclay: New Music." *UR* (Japan) 11 (30 November 1995): 64–87.

Landolt, Patrick. "Christian Marclay über die Katastrophe und die Bilder: Splitscreen der Realität." *Die Wochenzeitung* (Zurich) 38 (20 September 2001): 18–19.

Lista, Marcella. "L'Oeil de Christian Marclay." *L'Oeil* (Paris) 539 (September 2002): 26–27.

Macaulay, Scott. "Interview with Christian Marclay," 65–69. In Lee Morrissey, ed., *The Kitchen Turns Twenty: A Retrospective Anthology*. New York: Kitchen, 1992.

Marclay, Christian, and Yasunao Tone. *Music* (New York) 1 (1997): 38–46.

McDonald, Cameron. "Christian Marclay." *Punk Planet* (San Francisco) 52 (November/December 2002): 27–28.

Noetinger, Jerôme, and Andrea Petrini. "Christian Marclay Interview." *Revue & Corrigée* (Grenoble) 14 (autumn 1992): 10–11.

Queloz, Catherine. "Questions à Christian Marclay." In *Nicolas Collins, Ron Quivela, Alvin Lucier, Christian Marclay*. Exh. cat. Geneva: Sous-Sol, ESAV, 1992.

Ranaldo, Lee, and Christian Marclay. "A Conversation." *Paletten* (Götberg, Sweden) 245–246 (April/May 2001): 46–49. Translated into English in *BB GUN Magazine* 6 (Hoboken, New Jersey) (October 2003): 18–23.

Seliger, Jonathan. "An Interview with Christian Marclay." *Journal of Contemporary Art* 5, no. 1 (spring 1992): 64–76.

Söderkvist, Lars, and Philip von Zweck. "Turning the Tables on Music and Art: A Conversation with Christian Marclay." *Ten by Ten* (Chicago) 1, no. 3 (2001): 10–13.

Tobler, Konrad. "Grenzganger zwischen ton und Bild." *Berner Zeitung*, 4 June 1998, 31.

Tolentino, Noël. "Marclay." *Bunnyhop* 9, B&H Publications (1998): 65–67.

Troncy, Éric. "Christian Marclay." *Documents* (Paris) 2 (February 1993): 28–30.

Vogel, Sabine B. "Christian Marclay: 'Das Cover ist das einzig Visuelle wahrend des Zuhorens–eine Art Haut.'" *Kunstforum* 134 (May/September 1996): 235–241.

Watanabe, Yuya. "Christian Marclay Interview." *Musée* 22 (November 1999): 65.

Journals, Magazines, and Newspapers

"The Bachelors, even." *RE/SEARCH* (San Francisco) 2 (1981): 32–33.

"David Moss and Christian Marclay from New York." *Friday Magazine* (Tokyo) 48 (1986): 52–53.

"Off Center for the Off Season." *LIFE* (July 1985): 96.

"The Art of Christian Marclay." *Blueboy* 3, no. 6 (June 1992): 60–61.

"Variantenreiche Platten-Spielereien." *Neue Zürcher Zeitung* (Zurich) 154 (6 July 1989): 50.

Asakuaa, Mario. "Noise Music." *Brutus* (Tokyo) (15 November 1986): 28.

Adler, Scott. "What Not to Miss Around Town this Month: Up & Out." *San Francisco Magazine* (April 2002): 111.

Affentranger-Kirchrath, Angelika. "Musik zum Anfassen—Christian Marclay im Kunsthaus Zürich." *Neue Zürcher Zeitung*, 10 August 1997.

Ammicht, Marion. "Les Sortilèges." *Süddeutsche Zeitung* (Münchner Kultur), 29 April 1996, 14.

Amy, Michaël. "Christian Marclay at the Whitney Museum at Phillip Morris." *Art in America* (March 1998): 100–01.

Andrews, Max. "Christian Marclay." *Contemporary Visual Arts* 34 (May 2001): 83.

Archer, Michael. "Christian Marclay." *Art Monthly* (April 1991).

Ashley, Beth. "A New Vision of Music." *Marin Independent Journal* (23 April 2002): 1-C2.

Aukeman, Anastasia, "Christian Marclay at Paula Cooper." *Art in America* (September 2001): 147.

Avgikos, Jan. "Christian Marclay: Der bedeutende Klang von Schritten." *Du* 6 (June 1991): 66–67.

Azumaya, Takashi. "Christian Marclay." *Salon: Cross Media Magazine*, no. 1 (20 September 1999): 25–26.

Baker, Kenneth. "Dust Breeding:' Fraenkel." *ARTnews* (November 1998): 169.

Baudevin, Francis. "Pops and Scratches." *FACES* (Geneva) 38 (spring 1996): 36–40.

Beckman, Janette. "Other Voices." *New Musical Express* (London), 4 June 1988.

Bernard, Jean-Philippe. "Christian Marclay organise au Belluard le télescopage de toute la musique Suisse." *V Magazine, Le Nouveau Quotidien* (Lausanne) (28 June – 4 July 1996): 43.

Bernays, Ueli. "Ausklang einer Ausstellung—Christian Marclay im Kunsthaus." *Neue Zürcher Zeitung* (28 October 1997): 50.

Bernier, Alexis. "Scratch Suisse." *Liberation* (Paris) (11 February 2000): 41.

Berwick, Carly. "Here We Go A-Mixing." *ARTnews* (December 2000): 42.

Blackford, Chris. "Günter Müller and Christian Marclay." *The Wire* (March 1995).

Blase, Christoph. "Im Netz der Unsichtbaren Töne." *Kunstbulletin* 3 (March 1991): 11.

Bonetti, David. "A New Spin on Sound Collage." *San Francisco Examiner*, 5 April 1991, C2.

Bonniol, Marie-Pierre. "Christian Marclay: More Encores." *Nouvelle Vague* (February 1999).

Bonvin, Stéphane. "Le Belluard retrouve le nord en cherchant la Suisse." *Le Nouveau Quotidien*, 20 June 1996.

Bratschi, Isabelle. "La Symphonie du silence de C. Marclay." *Le Courrier* (Geneva), 12 July 1995.

——. "De bruit et de silence." *Scenes Magazine* (Geneva) (December 1995).

Busti, Massimiliano. "Christian Marclay." *Blow Up* (September/October 1998): 64–66.

Cadet, Nancy R. "Christian Marclay." *High Performance* 38 (1987): 73–74.

Cameron, Dan. "Pop 'n Rock." *Art Issues* (November 1989): 9–12.

Campbell, Karen, Lona Foote, Howard Mandel, Spencer Rumsey, and Daryl-Ann Saunders. "New Faces." *EAR Magazine* 2, no. 2 (October 1986): 21.

——. "The Changing Tide." *Art & Auction* (January 1992).

Castant, Alexandre. "Musiques en scène/la voix." *Art Press* (May 1999): 78–79.

Cérésole, Catherine and Nicolas. "Hors Piste: Christian Marclay" *Vibrations* (Lausanne) 7 (May/June 1995): 46.

Chacon, Chema. "Christian Marclay." *Oro Molido* (Madrid) 6 (September 2002): 50–54.

Chiara, Federico, and Olivier Rohrbach. "Musica e design... musica/arte." *Vogue Italia* (September 2001): 252–259.

Christov-Bakargiev, Carolyn. "Christian Marclay: Valentina Moncada." *Flash Art*, no. 169 (summer 1992): 106–107.

——. "La Griffure de Marclay." *L'Hebdo* (Lausanne) 27 (3 July 1986).

Collins, Robert. "'Dead Stories: An Aural Collage." *St. Paul Pioneer Press & Dispatch*, 7 April 1986.

Colpitt, Frances. "Jewel in the Rough: Report from San Antonio." *Art in America* (February 2002): 59–65.

Corbett, John. "Critic's Choice: Christian Marclay." *Chicago Reader* (4 May 2001): sec. 3, 44.

Cornwell, Regina. "Christian Marclay/Perry Hoberman: The Kitchen." *Artscribe* 80 (March/April 1990): 77–78.

Coulter, Tony. "Viva Vinyl: The Record as Art." *EAR Magazine* 15, no. 3 (May 1990): 16.

Cragin, Sally. "Cellars by Starlight." *The Boston Phoenix*, 22 January 1985.

Criqui, Jean-Pierre. "Best of Show." *Artforum* (September 1995): 35–36.

Crittin, Pierre-Jean. "Christian Marclay." *Vibrations* (Lausanne) (March 2001): 32–32.

——. "Christian Marclay & Otomo Yoshihide, Christian Marclay & Elliott Sharp." *Vibrations* (Lausanne) 28 (October 2000).

——. "Noir et Blanc." *Vibrations* (Lausanne) 19 (November 1999): 11.

——. "Scratch! Fade! Cut! Loop!" *Vibrations* (Lausanne) 10 (December 1998/January, 1999): 36–39.

——. "L'avant-garde ne se rend pas." *L'Hebdo* (Lausanne), 16 April 1987.

——. "L'Art du Cut-Up Revisité." *Gazette de Lausanne* (23 December 1985): 2.

Cutler, Chris. "Plunderphonia." *Musicworks* 60 (fall 1994): 6–19.

Dery, Mark. "Spin Doctors." *Keyboard* (October 1992): 55–57.

——. "Notes from the Underground." *Keyboard* (August 1990): 29.

——. "Deejay of Sculpted Sound." *Elle* 4, no. 10 (June 1989): 38.

——. "From Hugo Ball to Hugo Largo: 75 Years of Art and Music." *High Performance* 44 (winter 1988): 54–57.

————. "Christian Marclay: Confessions of a Vinyl Fetishist." *International Musician and Recording World* 8 (April 1986): 16.

Descombes, Mireille. "Christian Marclay, Plasticien sans étiquette." *L'Hebdo* (Lausanne) 51 (21 December 1995): 71.

Dick, Terence. "Sightgags and Soundtricks." *BorderCrossings* 78 (2001): 125–126.

Diederichsen, Diedrich. "Verbrannte CD's sind geruchslos." *Kunst-Bulletin* 6 (June 1995): 18–25.

Diehl, Carol. "Christian Marclay at Paula Cooper." *Art in America* (June 2000): 128.

Diers, Von Michael. "Musik für die Augen, Bilder für die Ohren: Christian Marclay's Installation in Venedig." *Neue Züricher Zeitung* (Zurich), 2–3 September 1995.

Dijksterhuis, Edo. "Een tik of een kraak is net zo goed muziek." *NRC Handelsblad* (4 November 2001): 8.

Doherty, Mike. "The Magic Christian." *Eye* (Toronto) (30 November 2000): 29.

Dollar, Steve. "Art Performer Christian Marclay Brings 'Mad Mad World' to Town." *Times-Union* (Rochester, New York) (10 April 1986: 12C.

Dössel, Christine. "Der Herr der Dinge." *Süddeutsche Zeitung*, 26 April 1996, 15.

Duguid, Brian. "Christian Marclay: Records, More Encores." *The Wire* 166 (December 1997): 54.

Duller, Chris. "Musik: Captured Music." *Falter* (20–26 February 1987): 1, 19.

Eden, Xandra. "Christian Marclay: Cinema." *para-para* (Toronto) (2001): 3.

El Beblawi, Nadia. "Christian Marclay connait la musique." *Le Journal des Arts* 22 (February 1996).

Elms, Anthony. "Audible Imagery." *New Art Examiner* (March/April 2002): 70.

——. "Christian Marclay, MCA Chicago." *New Art Examiner* (September/October 2001): 93.

Ermen, Reinhard. "Helvetia Sounds: Christian Marclay, Roman Signer, Jean Tinguely, Villa Merkel." *Kunstforum* 135 (October 1996/January 1997): 424.

Evelev, Yale. "Extended Play." *EAR Magazine* (October 1988): 26–27.

Faust, Gretchen. "Christian Marclay." *Arts Magazine* (March 1991).

Feldman, Mitchell. "Christian Marclay: Tape Fall." *EAR Magazine* (February 1990): 40–41.

Ferguson, Russell. "The Audience for a Piece of Silent Music." *Art & Design* (London) (January 1996).

Ferguson, Sarah. "Season's Bleepings." *The Village Voice* (2 January 2001): 99.

Fleury, Jean-Damien. "Christian Marclay met le son en image et joue avec le bruit." *La Liberté* (Fribourg) (31 January 1994): 11.

Freund, Michael. "Musikspiele aus dem Müll." *Falter* (Vienna) (November 1985).

Gaddis, Anicée. "Kid Marclay–Master of Scratch Art." *Oculus Magazine* 64 (August/September 1997): 18–19.

Gangadharan, Seeta Peña. "Sampling/Christian Marclay." *The Wire* (July 2002): 79.

Gardner, Lee. "Sense and Sensibility: The Contemporary Explores the Meaning of Meaning." *Baltimore City Paper* (5 May 2000): 29–30.

Geisenhanslüke, Ralph. "Die Weltempfänger: Christian Marclay und Shelley Hirsch in der Akademie der Künste." *Tagesspiegel* (Berlin), 31 August 1998.

Gertich, Frank. "Klang: Prasenziabsenz, Bemerkungen zu Christian Marclay." *Neue Zeitschrift für Musik* (May/June 1997): 14–17.

Gianadda, Jef. "Symphonie cacophonique." *Le Matin* (Lausanne) (30 June 1996): 47.

Gilardino, Fabrizio. "New Music America: 10th Anniversary." *Musiche* 7 (spring 1990): 48–49.

Glueck, Grace. "Christian Marclay 'Pictures at an Exhibition.'" *The New York Times*, 7 November 1997, E-37.

Goldberg, Roselee. "Christian Marclay at Paula Cooper Gallery." *Artforum* (April 2001): 138.

Gottschalk, Kurt. "Christian Marclay: Sounding More Like Records Than Music." *The Tribeca Tribune* (November 1996): 27.

Griffin, Tim. "Christian Marclay, Paula Cooper Gallery," *Time Out* (New York) 282 (15–22 February 2001): 55.

Groome, Carl VP. "The Curious Mixology of Turntable Artist Christian Marclay." *Ray Gun* 52 (December/January 1998).

Haagsma, Jacob. "Klankcollages met platenspelers." *Leeuwarder Courant* (Holland), 3 January 1986.

Haglund, Magnus. "Look at the Music/SeeSound: Ystad." *The Wire* 226 (December 2002): 85.

Harris, Jane. "Christian Marclay." *Artpress* (April 2001): 66.

Heidkamp, Konrad. "Marclay's Recordsaw Massacre." *Taz* (Berlin) (5 September 1988): 15.

——. "Eine Liebsaffare." *Taz* (Berlin), 16 August 1988.

Helfand, Glen. "San Francisco: Christian Marclay, Museum of Modern Art." *Artforum* (October 2002): 159.

——. "Pop-Pop-Pop-Pop-Culture Video." *Wired News* (wired.com), 10 May 2002.

——. "Sound Effects." *San Francisco Bay Guardian* (8 May 2002): 43.

Higgs, Matthew. "Best of 2002." *Artforum* (December 2002): 110.

Holden, Stephen. "Video Artistry Sparks a New Series." *The New York Times*, 30 June 1985.

Holoch, Annette. "Marclay im Kunstgebäude: Anarchische Manipulationen." *Stuttgarter Nachrichten*, August 1988.

Holt, Richard. "3-Chord Art." *World Art* 19 (1998): 42–45.

Honigman, Ana. "The Whitney Biennial." *Contemporary* (May 2002): 100–101.

Howard, Carl. "Christian Marclay and the Scratches of Time." *Unsound* 2, no. 1 (February 1985): 17–20.

Huber, Gauthier. "9e biennale de l'image en mouvement." *Art Press* (January 2002): 70.

Hughes, Jeffrey. "Reviews: Saint Louis." *Art Papers Magazine 25th Anniversary Edition* (November/December 2001): 78.

Ilic, David. "Christian Marclay: Record Without a Cover." *The Wire* 38 (April 1987): 53.

——. "Christian Carvings." *City Limits: London's Guide* (11–18 January 1990).

Jaunin, Françoise. "Christian Marclay, l'agent double, primé et exposé à Zurich." *24 Heures* (Lausanne), 7 October 1997, 41.

——. "Christian Marclay joue son concerto pour instruments muets et images sonores." *24 Heures* (Lausanne), 1 June 1996.

Johnson, Martin. "Solo Symphonies Downtown: Cooper's Percussion; Marclay's Turntables." *Villager Downtown* (New York), 9 March 1985.

Kahn, Douglas. "Christian Marclay's Lucretian Acoustics." *Parachute* 74 (April/June 1994): 18–23.

Kandel, Susan. "Marclay in Tune with his Gallery Showing." *Los Angeles Times*, 30 March 1993.

Katz, Vincent. "Christian Marclay at Fawbush." *Art in America* (April 1995): 106–107.

Kawachi, Taka. "Pipeline." *Mr. High Fashion* (December 1999): 233.

Kawakami, Genichiro. "Christian Marclay." *Fools' Mate* (August 1991): 88.

Kawaski, Katsumi. "Revelation or End of the Century," *MJ* (August 1991): 94.

Khazam, Rahma. "Christian Marclay: Jumpcut Jockey." *The Wire* 195 (May 2000): 28–32.

Kimmelman, Michael. "Searching for Some Order in a Show Based on Chaos." *The New York Times*, 15 September 1989, C-20.

——. "The Art of the Moment." *The New York Times*, 1 August 1999, sec. 2, 1, 34.

Kimura, Kimihiko. "Releasing Senses." *DICE* 31 (November 1999): 14–17.

Kitazato, Yoshiyuki. "Christian Marclay." *Jazz Critique* 5, no. 56 (1986): 342.

——. "Concert Review." *Jazz Critique* 1, no. 57 (1987): 9–10.

Kramar, Thomas. "Schallplatten sind Skupturen des Klanges." *Die Presse* (Vienna), 9 July 1998, 25.

Krasnow, David. "Spin Doctor." *Artforum* (November 1998): 42.

Krause, Anna-Bianca. "Der Rillenbrecher." *Tip* (Berlin) 15 (15–28 July 1993): 145–46.

——. "Christian Marclay: Die zerbrochen Illusion." *Positionen* (Berlin) 30 (February 1997).

Kronick, Ilana. "Christian Marclay: On Top of His Vinyl." *Hour* (Montreal) (20–26 May 1999): 12.

Kuipers, Dean. "Spinning in the Vinyl Boneyard." *EAR Magazine* 12, no. 8 (November 1987): 20-22.

——. "Wax Works." *Downtown* (23 March 1988): 24–26.

La Barbara, Joan. "Recordings on the Cutting Edge." *High Fidelity* (Musical America Edition) 36, no. 4 (April 1986): 12, 32.

Lachner, Harry. "Shelley Hirsch und Christian Marclay: Schall und Rausch." *Süddeutsche Zeitung*, 28 April 1997.

Lee, Stewart. "On Record: William Hooker, Christian Marclay, Lee Ranaldo." *Sunday Times* (London), 21 January 2001, 22.

Legrange, Al. "Bring the Noise: Christian Marclay." *The Village Voice* (14 November 1989): 93.

Levin, Thomas Y. "Indexicality Concrète: The Aesthetic Politics of Christian Marclay's Gramophonia." *Parkett*, no. 56 (1999): 162–177.

Liebmann, Lisa. "People and Ideas: Rrose Is a Rrose Is a Rrose." *Aperture* 148 (summer 1997): 72–75.

Lienhard, Pierre-André. "Bidouiller l'univers des sons." *Journal de Genève* (9 February 1994): 23.

Loktev, Julia. "Injury to Insult: If Vinyl's Not Dead Yet, Christian Marclay Isn't Helping Any." *Option* 32 (May/June 1990): 50–53.

Lorenz, Gabriella. "Wenn gegenstände Tanzen." *AZ München* (24 April 1996): 7.

Mahoney, Robert. "Christian Marclay." *Art International* 4, no. 2 (spring 2001): 42.

——. Review. *Arts Magazine* (October 1991).

——. Review. *Arts Magazine* (February 1992).

Masserey, Michel. "Vinyle Attitude." . *Le Temps: Le Samedi Culturel* (Geneva) (25 March 2000): 1–4.

——. "A New York, l'artiste Christian Marclay manipule les musiques. Silence." *Le Nouveau Quotidien* (Lausanne) (7 December 1996): 27.

Mathonnet, Philippe. "Christian Marclay: L'artiste qui donne à voir la musique." *Journal de Genève* (28 December 1995).

Mathur, Paul. "Plow: Organik." *Melody Maker* (11 May 1985): 27.

McCormick, Carlo. "Christian Marclay: Tom Cugliani Gallery." *Artforum* 27 (October 1988): 144–45.

——. "The Sounds of 'Christmas.'" *papermag.com,* 14 December 2000.

Melrod, George. "Reviews: New York." *Sculpture* (March/April 1995).

Mendenhall, Lauri. "Transparent Tinsel: Recasting the Art of Hollywood." *Coast* (October 2001): 104.

Milkowski, Bill. "The Downtown New York Scene." *New Music America '89* (1989): 8–10.

Mirolla, Miriam. "Volti e Figure. Segni, Visioni. L'Umanità Secondo la Biennale." *Vogue Italia* (June 1995): 98–101.

Morgan, Robert C. "Christian Marclay 'Record Without a Cover'; 'The Mad Mad World of Composer/Performer Christian Marclay." *High Performance* 34 (1986).

Müller-Grimmel, Werner. "Skulpturen für die Ohren." *Stuttgarter Zeitung* 191 (19 August 1988): 27.

Myles, Eileen. "Prints of Words." *Print Collector's Newsletter* 24, no. 4 (September/October 1993): 132–35.

Nesbitt, Lois E. "Christian Marclay: Tom Cugliani Gallery." *Artforum* 28 (September 1989): 146.

Newhall, Edith. "Instruments of Change." *New York Magazine* (12 February 2001): 92.

Nickas, Bob. "Mutiple Voice." *Artforum* (May 2002): 163–64.

Nielsen, Tone. "Christian Marclay." *Louisiana Revy* 33, no. 2 (February 1993): 30–31.

Nordell, John. "'Artists Make Noise' Christian Marclay/Bill Buchen." *Boston Rock* (February 1985).

Ogura, Masashi. "From Exhibition 2 Tokyo Opera City Art Gallery." *BT* (Tokyo) 51, no. 779 (November 1999): 120–122.

Otomo, Yoshihide. "New York Contemporary Music." *Jazz Critique* (Tokyo) 2, no. 61 (1988): 220–23.

——. "David Moss and Christian Marclay." *Jazz Life* (November 1986): 70–71.

——. "Record Without a Cover/Christian Marclay." *HOLIC* (Japan) (March 1986).

——. "Improvisation Music of N.Y. 2– C. Marclay/B. Ostertag." *HOLIC* (Japan) (July 1985).

Pagel, David. "Christian Marclay at Margo Leavin." *Art Issues* (May/June 1993).

Pareles, Jon. "Music: 'Festival of Voices.'" *The New York Times*, 30 April 1984.

——. "Music: A Night of Odd Noises.'" *The New York Times*, 14 February 1987.

Perra, Daniele. "Biennale de l'image en mouvement 2001." *Tema Celeste* (January/February 2002): 105.

Pesch, Martin. "Versteht sich als Dirigent." *Die Tageszeitung* (Berlin), 1 October 1997, 16.

Petrini, Andrea. "Christian Marclay: Le vinyl récupéré." *Libération* (Paris) (17–18 September 1992).

Pollack, Barbara. "Christian Marclay, 'Video Quartet.'" *Time Out* (New York) (9–16 January 2003): 50.

——. "Art Rocks." *ARTnews* (December 2002): 98–101.

Queloz, Catherine. "A un autre tempo." *FACES* (Geneva) (spring 1996): 36–40.

Rechler, Glenn. "On the B-Side." *New York Press* 1 (29 April 1988): 1, 4–7.

Reighley, Kurt B. "Revolutionary R.P.M.s." *Warp* 4, no. 6 (February 1996): 64–65.

Rentsch, Christian. "Moss, Marclay & Co.: New York Underground." *Züritip* (Zurich) (24 May 1985): 11.

Rentsch, Christian. "Weltmusik ohne jeden Kompromiss." *Tages-Anzeiger* (Zurich), 3 July 1989, 11.

Ress, Simon. "Art Music MCA Sydney." *Flash Art* (May/June 2001): 96.

Reust, Hans Rudolf. "Christian Marclay, Christoph Rütimann/Shedhalle." *Artscribe* 79 (January/February 1990): 87.

Risatti, Howard. "Christian Marclay, Hirshhorn Museum." *Artforum* (December 1990).

Ritschard, Claude. "'Amplification' de Christian Marclay au Temple de la Fusterie." *Le Protestant* (Geneva) (5 May 1996).

Robecchi, Michele. "The 1st Valencia Biennial." *Flash Art* (November/December 2001): 58.

Robinson, Walter. "Christian Marclay at Tom Cugliani." *Art in America* (September 1992).

Rockwell, John. "Marclay, Hoberman, Sound and Fury." *The New York Times*, 22 October 1989, sec. 2, 64.

——. "Performance Art: 'Dead Stories.'" *The New York Times*, 23 March 1986.

Rovere, Walter. "Macrosolco." *La Dolce Vita Magazine* (Milan) 22, no. 14 (November 1988): 22.

Rubinstein, Meyer Raphael, and Daniel Wiener. "Christian Marclay at Tom Cugliani." *Flash Art*, no. 147 (summer 1989): 149.

Saltz, Jerry. "Beautiful Dreamer: Christian Marclay's 'The Beatles.'" *Arts Magazine* 64 (December 1989): 21–22.

Samuelson, Grant. "Christian Marclay." *New Art Examiner* (December 1997/January 1998): 62.

Sanders, Linda. "Soundings: Causerie." *The Village Voice* (17 December 1985): 104.

Sandow, Gregory. "Artists Meet at Bowery and Grand." *The Village Voice* (15 March 1983).

Sasaki, Atsushi. "Christian Marclay: Memory Serves." *BT* (Tokyo) 48, no. 734 (December 1996): 18–35.

Sato, Akira. "The Irony of Sampling Music Generation." *Brutus* (Tokyo) (1 August 1991).

Schjeldahl, Peter. "Do It Yourself: Biennial Follies at the Whitney." *The New Yorker* (25 March 2002): 98–99.

Schmidt, Christopher. "Tod durch ersticken." *Münchner Merkur*, 29 April 1996.

Schroeder, Ivy. "Phone Home." *Riverfront Times* (St. Louis) (6–12 June 2001): 49.

Schwendener, Martha. "Behind the Music." *Time Out* (New York) (2–9 August 2001): 52–53.

——. "'Pictures at an Exhibition': An Installation by Christian Marclay." *Time Out* (New York) (22–29 January 1998): 46.

Schwendenwien, Jude. "Christian Marclay: The Hirshhorn Museum." *Contemporanea* 22 (November 1990): 95.

Searle, Adrian. "Christian Marclay: Interim Art." *Time Out* (London) (20–27 March 1991): 42.

Sherburne, Philip. "Christian Marclay: San Francisco Museum of Modern Art." *Frieze* (October 2002): 89.

Shinkawa, Takashi. "Art 1." *Asahi Graph* (29 September 1999): 48.

Sinker, Mark, and Ed Baxter. "Artefacts and Fictions." *The Wire* 128 (October 1994): 24–28.

Smith, R. J. "Christian Marclay: Album Without a Cover." *Spin* (January 1986): 32.

Smith, Roberta. " Christian Marclay 'Video Quartet.'" *The New York Times*, 3 January 2003.

——. "Art that Hails from the Land of Déjà Vu." *The New York Times*, 4 June 1989, 29, 38.

——. "Christian Marclay: Tom Cugliani Gallery." *The New York Times*, 20 May 1988.

——. Review. *The New York Times*, 26 June 1987.

Soejima, Teruto. "Record Without a Cover." *Monthly Magazine* (Ensemble), no. 237 (September 1986): 21.

Soutif, Daniel. "Il Secolo del Jazz." *Musica Jazz* 58 (August/September 2002): 30–31.

Stals, José Lebrero. "Christian Marclay." *Lapiz* 76 (March 1991).

Steele, Mike. "Clear Image or Private Rantings? Performance Artists Run Gamut." *Minneapolis Star and Tribune*, 8 April 1986, 2C.

Stevens, Mark. "Irony Lives." *New York Magazine* (18 March 2002): 55–56.

Stock, Ulrich. "Christian Marclay: Records." *Die Zeit* (Hamburg), 10 September 1998, 77.

———. "Völker, seht die Signale!" *Die Zeit* (Hamburg), 6 August 1993, 60.

———. "Freude schöner Gotterfrrk." *Die Zeit* (Hamburg), 16 September 1988, 84.

Sullivan, James. "Symphony of Sights and Sounds." *The San Francisco Chronicle*, 11 April 2002, D1, D7.

Sumiyoshi, Chie. "While My Guitar Gently Weeps." *Brutus* (Tokyo) (15 June 2001): 151.

Suzuki, Fumi. "David Moss and Christian Marclay Duo." *Inaction* 45 (January 1987).

Tallman, Susan. "Always This Tüdeldität: Christian Marclay's 'Graffiti Composition.'" *Art on Paper* (July/August 2000): 28–33.

———. "Sound and Vision: Multiples by Not Vital and Christian Marclay." *Arts Magazine* 63 (May 1989): 17–18.

Troncy, Éric. "Not Quiet, Galerie Jennifer Flay." *Art Press* (June 1992).

Tysh, George. "Knights of the Turntable." *Metrotimes* (Detroit) (18–24 December 2002): 42.

Uhlmann, Tina. "Abendländischer Fetisch LP wird klangvoll rezykliert." *Berner Zeitung* (Bern), 10 June 1995, 3.

Umemiya, Noriko. "Christian Marclay." *BT* 712 (Tokyo) (September 1995): 45.

Uusitorppa, Harri. "Levyt ja Soittamisen Taide." *Helsingin Sanomat* (Helsinki), 12 February 1989, A21.

Vandamme, Fabien. "L'inaudible et l'invisible." *Briseglace* (June 2002): 70–76.

Vogel, Sabine. "In Record Time." *Artforum* (May 1991): cover, 103–107.

———. "Christian Marclay: Vom künstlerischen Umgang mit Kultur-Trash." *Artis* (May 1991).

Volker, Luke. "Im Partykeller der vereinten Nationen." *Der Tagesspiegel* (Berlin), 26 July 1993.

Wahler, Mark-Olivier, and Christian Marclay. "Ghost in the Shell." *Kunst-Bulletin* 6 (June 2001): 24–29.

Watrous, Peter. "Hip-Hop Meets the Modernists." *The New York Times*, 5 November 1989, 32.

———. "Short Jazz Takes." *Musician* 86 (December 1985): 110.

Welzenbach, Michael. "The Sound of Silence." *The Washington Post*, 7 July 1990.

Wiens, Birgit. "The Gender of Objects in Cultural Memory' — Zur Objectkunst Marcel Duchamps und ihrer Um-Schrift bei Christian Marclay." In *Körper — edachtnis — Schrift*, 254–75. Berlin: Erich Schmidt Verlag, 1996.

Wilcox, Brent. "Christian Marclay: Record Without a Cover." *Option Magazine* (1985).

Wilson, Peter Niklas. "Remix der Realität." *NZ–Neue Zeitschrift für Musik* 5 (September/October 1996): 14–17.

Wittwer, Jean-P. "Christian Marclay suspend les sons." *Journal de Genève* (2–4 February 1996): 12.

Yoshida, Mika. "Art NY." *Brutus* (Tokyo) (1 September 1999): 116.

Ziegler, Ulf Erdmann. "Symphonische Skulpturen." *Wolkenkratzer Art Journal* 6 (November 1988): 61.

Zuel, Bernard. "Stomp and Scratch the CDs: It's Sweet Music to His Ears." *The Sydney Morning Herald*, 21 March 2001, 18.

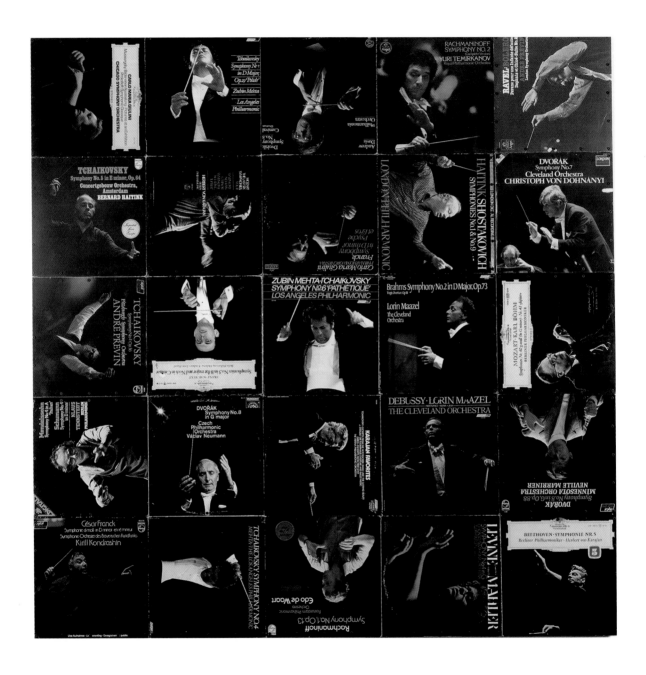

Dictators, 1990
Opposite: *Incognita*, 1990

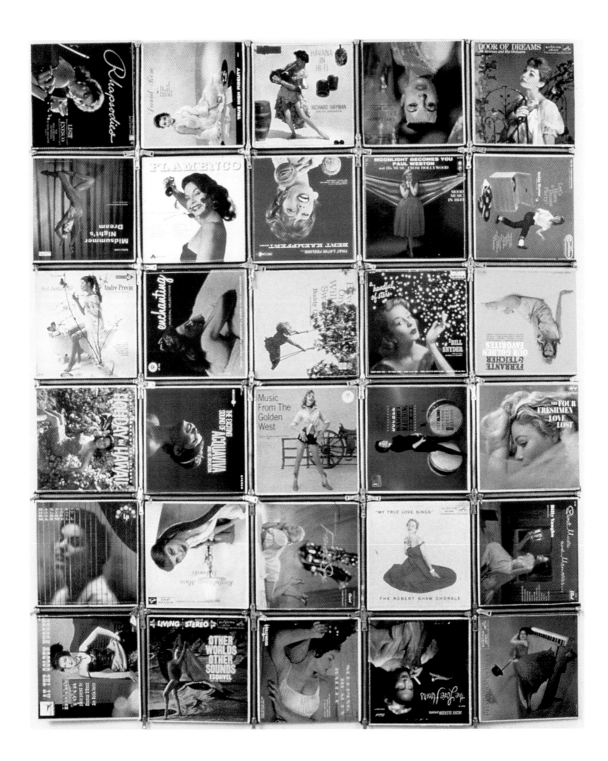

Guitar Neck, 1992
Opposite: *The Road to Romance*, 1992

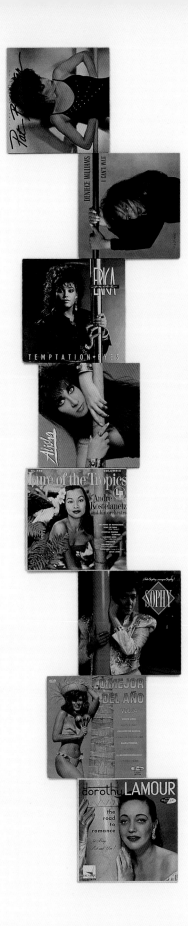

Discography

Solo Recordings

Records: 1981–1989. Atavistic Records (Chicago) CD 62, 1997.

Untitled. Robert Shiffler Collection and Archive, Ohio, 7-inch LP, 1996.

Footsteps. Rec Rec Music (Zurich) single-sided LP 26, 1989.

More Encores. No Man's Land (Würzburg, Germany) 10-inch LP 8816, 1988; ReR Megacorp (London) 10-inch LP CMV1 and CD CM1, 1997.

Untitled (record without a groove). Ecart Editions (Switzerland) LP, 1987.

Record Without a Cover. Recycled Records (New York) LP, 1985; Locus Solus (Japan) picture disc LP, 1999.

Compilations

Soundworks. CD, 2002. Included in exhibition catalogue for the Whitney Biennial at Whitney Museum of American Art, New York.

Adventures, The Wire: 20 Years 1982–2002. Mute Records, Ltd. (London) 3 CD set STUMM220, 2002.

Paletten Ljudkonst (with Lee Ranaldo and Alan Licht). CD, 2001. Magazine insert for *Paletten* (Götberg, Sweden), nos. 245–246.

Sonic Boom. CD, 2000. Exhibition catalogue for "Sonic Boom: The Art of Sound" at Hayward Gallery, London.

Turntable Solos. Amoebic (Japan) CD AMO-VA-01, 1999.

Christian Marclay/Yoshihide Otomo. Gentle Giant Records (Chicago) split 7-inch single GG024, 1999.

Because Tomorrow Comes #2. BTC (Cologne, Germany) CD 02, 1999.

Frei Sicht aufs Mittelmer: Various Artists. CD, 1998. Exhibition catalogue for "Frei Sicht aufs Mittelmer" at Kunsthaus, Zurich.

Verona Jazz. Nettle (Italy) CD 001, 1996. John Zorn and the music of Ennio Morricone.

Plunderphonia & Vox. CD MW60, 1994. Magazine insert for *Musicworks* (Toronto).

Deconstruct. Blast First/Disobey (London) CD BFFP105, 1994.

Pièces pour standards et répondeurs téléphoniques. Nouvelles Scènes (Dijon) CD 01, 1992.

A Confederancy of Dances, Volume One (with Ikue Mori). Einstein Records (New York) CD 001, 1992. Live recordings from Roulette Series, New York.

October Meeting 87 (with Louis Sclavis). Bimhuis Records (Amsterdam) CD 001, 1992.

Guida Nonesuch alla musica d'avanguardia. Arcana Editions (Italy) book and CD A1, 1991.

Beets, A Collection of Jazz Songs (with Tom Cora). Elemental/T.E.C. Tones (USA) LP 90901 and CD 90902, 1990.

Absolut CD #2—The Japanese Perspective. Absolut CD#2 for *Ear Magazine* (USA), 1990.

Untitled, 1987

Untitled, 1990

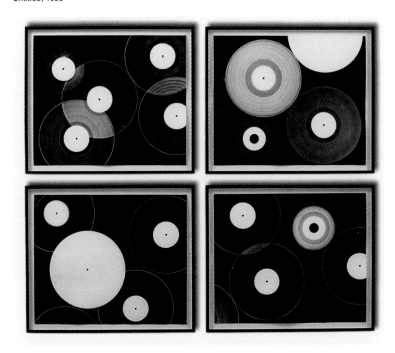

What Else Do You Do?
(with Catherine Jauniaux).
Shimmy Discs (New York) CD SDE 9021,
audiocassette SHM5034, 1990, and LP.

Live at the Knitting Factory, Volume 2
(with Samm Bennett). A&M Records
(Hollywood) LP SP 5276 and CD 5276,
1989; Knitting Factory Works (USA)
CD 98 and 5 CD set 12345, 1991; Enemy
(Germany) LP EFA
03512-08 EMY 112, CD EFA 03512-26
EMCD 112-2, and 4 CD set EMCD 120
KFW B1234, 1991.

Imaginary Landscapes. Elektra/Nonesuch
(New York) CD 9 79235-2 and
audiocassette, 1989.

La Nuit des Solos. Vandoeuvre (France)
LP 88021, 1988.

Audio by Visual Artists (with John
Armleder). Tellus (New York) audio-
cassette 21, 1988.

*Island of Sanity: New Music from New
York City.* No Man's Land (Würzburg,
Germany) double LP 8707d, 1987; No
Man's Land (Würzburg, Germany)
CD 8707, 1991.

Captured Music. Selektion (Germany) LP
019, 1987; RRR Records (USA) CD, 1995.

P16.D4: Tionchor. Selektion (Germany)
LP 013, 1987.

The Improvisors. Tellus (New York)
audiocassette 15, 1986.

Visuele Muziekzesdaagse. Audiocassette,
1986. Stichting Shaffy Theater,
Amsterdam.

Plow!. Organick (Switzerland) LP 25-1,
1985.

USA/Germany. Tellus (New York)
audiocassette 8, 1985.

Bad Alchemy Magazine + Tape.
Audiocassette for *Bad Alchemy*
(Würzburg, Germany), no. 3, 1985.

*Unique No. 1—The Cops Are Coming...
In Town.* Ephemere Enregistrements
(France) audiocassette 3, 1984.

State of the Union. Zoar Records (New
York) LP 10, 1982; Arrest Records (USA)
CD (with additional tracks) 003, 1992;
Muworks Records (New York) CD 1016,
1993; Atavistic (USA) double CD 69,
1996; EMF (Albany, New York)
3 CD set 028, 2001.

The Bachelors, even. *Light Bulb 4:
Emergency Cassette.* Los Angeles Free
Music Society audiocassette, 1981.

Collaborations

With Barbara Bloom
The French Diplomat's Office: Soundtrack.
Blumarts Inc. (New York) CD, 1999.
Signed edition of 250.

With CCMC (Michael Snow, John Oswald, and Paul Dutton)
CCMC + Christian Marclay. Art Metropole
(Canada) double CD 004, 2002.

With Jean Chaine
Sunk in the Sun. Atonal (Germany)
CD 3020, 1997.

With Clonicos
Esquizodelia. Triquinoise Produciones
(Madrid) CD 024, 1995.

5 Cubes, 1989

With Nicolas Collins
100 of the World's Most Beautiful Melodies. Trace Elements Records (New York) CD 1018, 1989.

With Corin Curschellas
Valdun Voices of Rumantsch. Migros Genossenschaftsbund (Switzerland) CD 9701, 1997.

With Andres Bosshard, Günter Müller, Jin Hi Kim, et al.
Telephonia: Selected Soundscape No. 2. For 4 Ears Records (Switzerland) CD 408, 1991.

With Fred Frith
The Technology of Tears. Rec Rec Music (Zurich) double LP 20 and double CD 20, 1988; SST Records (USA) double LP, double audiocassette 172, and double CD 172, 1988.

With David Garland
Control Songs. Review Records (Germany) LP 95 and CD 95, 1986.

With Takashi Kazamaki and Kalle Laar
Return to Street Level. Ear-Rational (Berlin) CD 1022, 1990.

With Guy Klusevseck
Manhattan Cascade. Emergency Music, Composers Recordings Inc. (New York) CD 626, 1992. Package designed by Christian Marclay.

With Chris Mann
Chris Mann and the Use. Lovely Music, Ltd. (New York) CD 3091, 2001.

With Meltable Snaps It (Michael Lytle, George Cartwright, and David Moss)
A Classic Guide to No Man's Land. No Man's Land (Würzburg, Germany) CD 8813, 1988.

Points Blank. No Man's Land (Würzburg, Germany) LP 8604, 1986; No Man's Land (Würzburg, Germany) CD 8604, 1993.

With Sato Michihiro
Rodan. Hat Hut Records (Basel) CD hat Art 6015, 1989.

With Lawrence "Butch" Morris
Testament: A Conduction Collection (collaborated on Conductions nos. 22, 39, and 40). New World Records (New York) 10 CD set 80478, 1995.

Current Trends in Racism in Modern America. Sound Aspects (Germany) LP 4010 and CD 4010, 1986; Studios Bauer, J. Wohlleben digitally remastered CD, 1990.

With David Moss
Time Stories. Intakt Records (Switzerland) CD 054, 1998; Intakt Records (Switzerland) CD, 1999.

Dense Band-Live in Europe. Ear-Rational (Berlin) LP 1004 and compact disc 1004, 1988.

Dense Band. Moers Music (Germany) LP 02040, 1985; Moers Music (Germany) CD 02076, 1992.

Full House. Moers Music (Germany) LP 2010 and CD 2088, 1984.

With Günter Müller
Live. For 4 Ears Records (Switzerland) CD 513, 1994.

With N.A.D. (Niu Abdominaux Dangereux)
Ghosts. Heron Music (Italy) CD 702, 1989; ITM (Germany) CD 1454, 1989; Basic (France) CD 50001, 1995.

With Yoshihide Otomo
Moving Parts. Asphodel Records (San Francisco) CD, 2000.

With Zeena Parkins
Something Out There. No Man's Land (Würzburg, Germany) LP 8712, 1987.

With poire_z
Poire_z + (with Günter Mueller, Erik M., Andy Guhl, Norbert Moeslang). Ertswhile Records (New York) CD 022, 2002.

With Lee Ranaldo
Acuarela Songs 2 (with Alan Licht). Acuarela, Red CD 100, 2003.

Bouquet: Live at the Knitting Factory (with William Hooker). Knitting Factory Records (New York) CD KFW-264, 2000.

Fuck Shit Up (with Thurston Moore). Victo Records (Canada) CD 071, 1999. Live recording of Victoriaville Festival performance.

With Jon Rose
Forward of Short Leg (with David Moss, et al). Dossier Records (Berlin) LP ST7529, 1987.

Techno mit Störungen (with Frank Schulte, Otomo Yoshihide, Marc Ribot, Fred Frith, Chris Cutler, et al). Plag Dich nicht (Austria) CD 002, 1996. "Music Unlimited Festival," Wels, Austria.

With Elliott Sharp

High Noon. Intakt Records (Switzerland) CD 063, 2000.

Acoustiphobia (with Ikue Mori). Sublingual Records (Cambridge, Mass.) CD SL009/010, 2000.

In the Land of the Yahoos. Dossier Records (Berlin) LP ST7536, 1987; SST Records (USA) LP 128 and CD 128, 1987.

(T)here. LP Zoar Records LP 14, 1983.

With Sonic Youth

Goodbye 20th Century. SYR Musical Perspectives series (Hoboken, N.J.) double CD 4 and double LP 4, 1999.

With Tenko

Slope. RecRec Music (Switzerland) LP 16, 1987; Kinniko Bijo Records (Japan) LP 301, 1987.

With John Zorn

Godard/Spillane. Tzadik Records (New York) CD 7324, 1999.

The Bribe. Tzadik Records (New York) CD 7320, 1998.

Filmworks III. Toy's Factory Records (Japan) CD, 1996; Evva (Japan) CD 33006, 1996; Tzadik Records (New York) CD 7309, 1997.

Filmworks 1986 – 1990. Evva Records/Wave (Japan) CD, 1992; Elektra/Nonesuch (New York) CD 79270-2 1992.

Cynical Hysterie Hour. CBS/SONY (Japan) CD 24DH 5291, 3-inch CD 10EH 3327, 1989; Tzadik Records (New York) CD 7315, 1997. Soundtrack to Kiriko Kubo's cartoons.

Winter Was Hard (with Kronos Quartet). Elektra/Nonesuch (New York) CD 9 79181-2, 1988.

Cobra. Hat Hut Records (Basel) double LP hat ART 2034, 1987; Hat Hut Records (Basel) double CD (with additional tracks) hat ART 60402 and 60403, 1991/ 2CD: hat ART 2-6040.

Spillane (with Kronos Quartet). Elektra/Nonesuch (New York) LP, 1987.

The Big Gundown: John Zorn Plays the Music of Ennio Morricone. Nonesuch/Icon (New York) LP 79139-1, CD 79139-2, audiocassette 79139-4, 1986; Tzadik Records CD (New York) 7328, 2000.

Godard Ça Vous Chante?: Tribute to Jean-Luc Godard. Nato (France) LP 634, 1986; Nato (France) CD 53004.2, 1992; Tzadik Records (New York) CD 7324, 1999.

Locus Solus. Rift (New York), LP, 1983; Evva Records/Wave (Japan) CD WWCX 2035, 1991; Tzadik Records New York) CD 7303, 1995; Evva (Japan) CD 33003.

Untitled, 1991

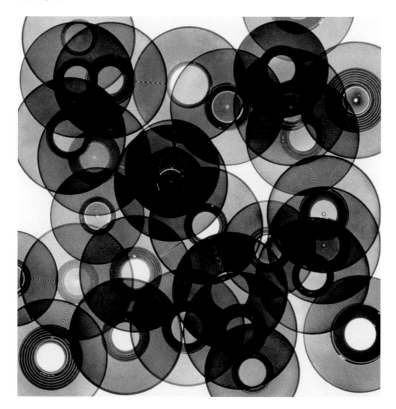

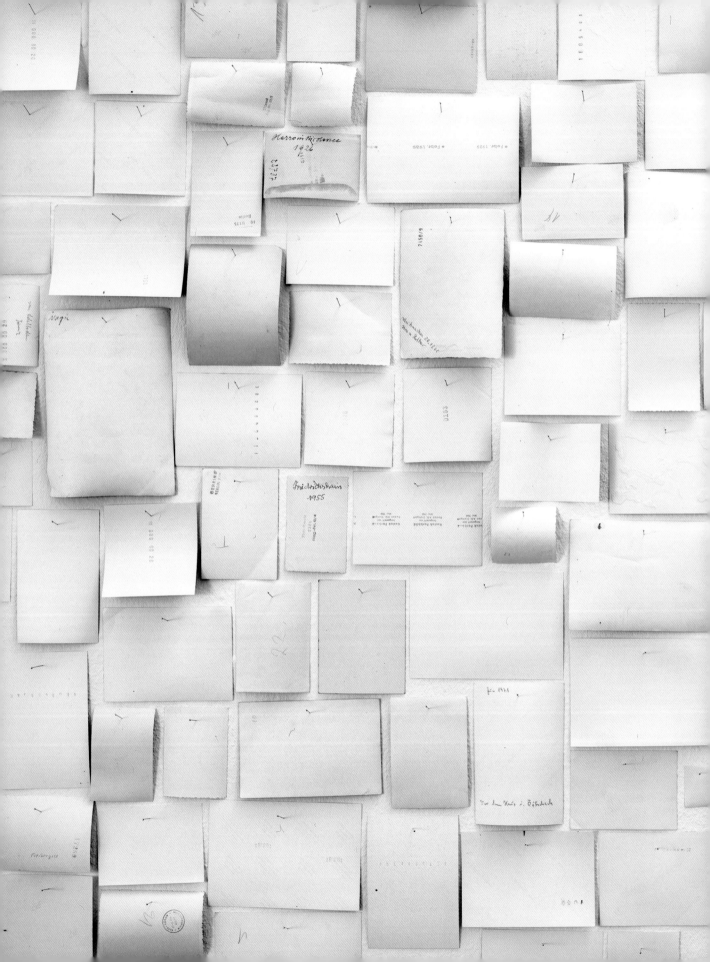

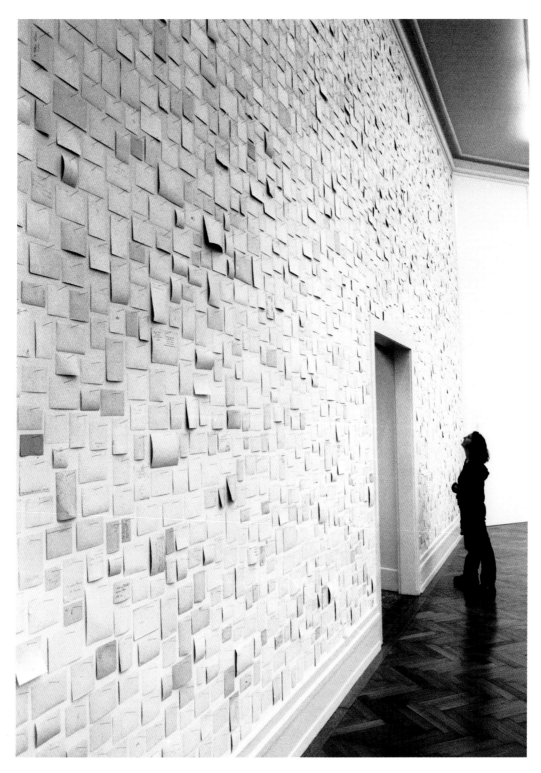

White Noise, 1993. Installation views at
the Kunsthalle Bern, Switzerland, 1998 (Above),
Fawbush Gallery, New York, 1994 (Opposite), and
at daadgalerie, Berlin, 1994 (Following Spread)

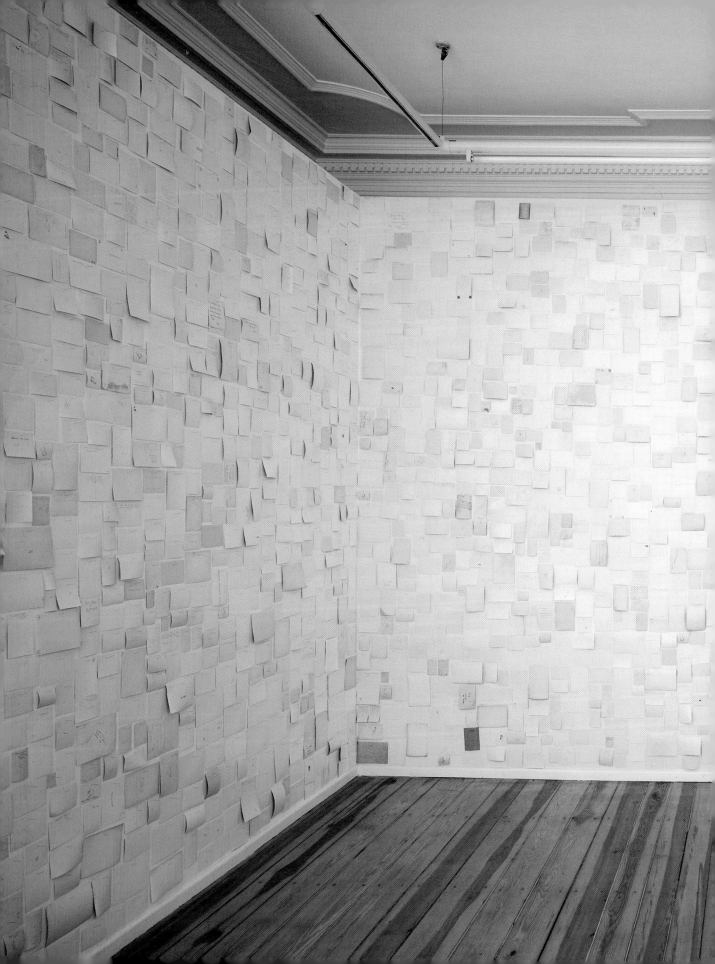

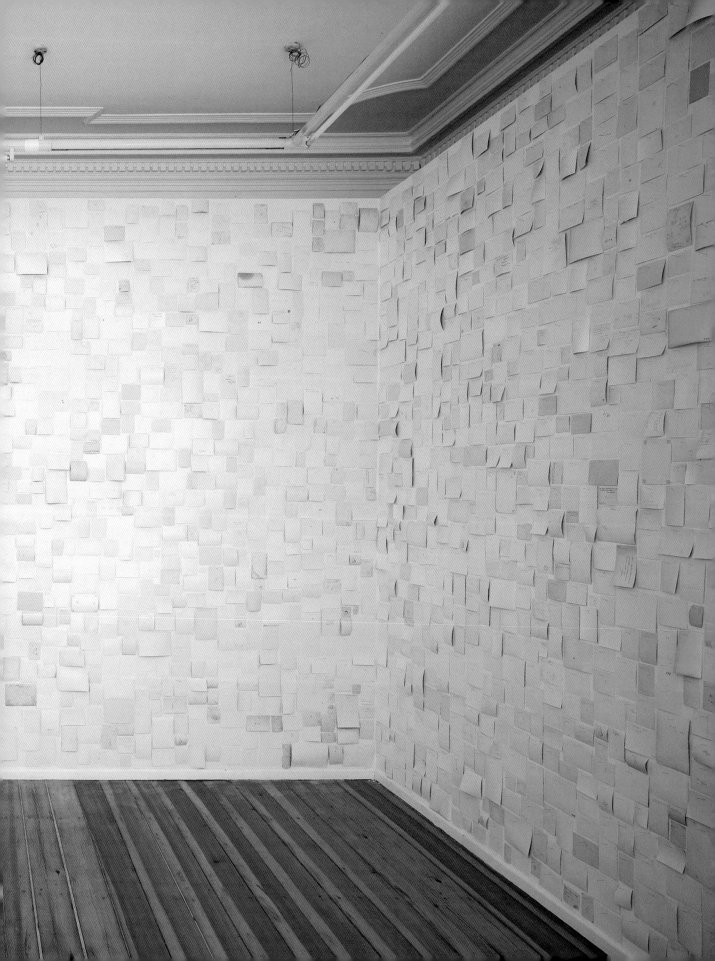

Selected Performances

2002

djTRIO. The Andy Warhol Museum, Pittsburgh, 5 July; Hirshhorn Museum and Sculpture Garden, Washington, D.C., 21 September; The Detroit Institute of Arts, 21 December "Black Bonds," The Swiss Institute, New York, 19 November

Mixed Reviews (music by Fabian Neuhaus and Marclay), performed by Asko Ensemble; *Graffiti Composition*, performed by E-RAX. "November Music 2002," 's-Hertogenbosch, The Netherlands, 7 November; Essen, Germany, 8 November; Ghent, Belgium, 9 November

"Look at the Music/SeeSound," Konstmuseum, Ystad, Sweden, 11–12 October

Music by Takehisa Kosugi and Marclay for Merce Cunningham Dance Company. Kalamata, Greece; Palermo, Italy; and Paris, 3–14 August

"Sónar Festival," Museu d'Art Contemporani, Barcelona, 13 June

Graffiti Composition, conducted by Butch Morris, performed Shelley Hirsch, Anthony Coleman, and Zeitkratzer. "Maerzmusik—Festival für Aktuelle Musik," Neue Nationalgalerie, Berlin, 11 March

The Sound of Money, 1991 Performance with Alder Buebe at Musée Cantonal des Beaux-Arts, Lausanne, 1991

2001

Text of Light, The Knitting Factory, New York, 23 August

djTRIO. "Bienal de Maia," Porto, Portugal, 22 June; Naumburg Band Shell, Central Park, New York, 17 August

Rainforest (by Takehisa Kosugi and Marclay) for Merce Cunningham Dance Company. Porto, Portugal, 20 June

Text of Light. Tonic, New York, 29 May

With Toshio Kajiwara. Museum of Contemporary Art, Chicago, 4 May

With Lee Ranaldo. Star Pines Café, Tokyo, 23–24 March; Club Metro, Kyoto, 25 March

With Lee Ranaldo. "Art>Music," Sydney Opera House, Sydney, 20 March

With Ikue Mori and Elliot Sharp. Tonic, New York, 7 March

2000

djTRIO. "Electroluxe," Tonic, New York, 17 September

"Electronic Evolution," Lincoln Center, New York, 15 July

With Arto Lindsay. Tonic, New York, 16 June

With Chris Mann. Tonic, New York, 31 May

"Festival Archipel," Geneva, 26 March

djTRIO. Centre Georges Pompidou, Paris, 11 February

With CCMC (Michael Snow, John Oswald, and Paul Dutton). The Rivoli, Toronto, 6 December; and Tonic, New York, 11 October 2001

1999

With Arto Lindsay, DJ Olive, and Shelley Hirsch. Tonic, New York, 14 November

With Hans-Peter Litscher, presenting the music of Sarah Mandelblut. "Do Chinese Postmen Ring Twice Too?," The Kitchen, New York, 26–30 October

Music by Takehisa Kosugi and Marclay for Merce Cunningham Dance Company. Luzerner Theater, Lucerne, Switzerland, 25–26 September

Japan Tour: Bessie Hall, Sapporo, 10 September; BOP, Hakodate, 11 September; City Art Hall, Kushiro, 12 September; Club Metro, Kyoto, 14 September; Tokyo Opera City Art Gallery, Tokyo, 16 September; and Star Pines Café, Tokyo, 18 September

With Jim O'Rourke. Tonic, New York, 27 July

"Festival Agora," IRCAM, Paris, 26 June

With DJ Soulslinger, Elliott Sharp, and Erik M. Tonic, New York, 26 May

With Thurston Moore and Lee Ranaldo. "International Festival Musique Actuelle," Victoriaville, Canada, 24 May

With William Hooker and Lee Ranaldo. The Knitting Factory, New York, 24 April

With Christian Wolff. "Duo for turntables, piano and guitar," Columbia University Faculty House, New York, 26 March

With Erik M. Les Instants Chavirés, Montreuil, France, 3 February; Musée d'art moderne et contemporain, Strasbourg, France, 4 February; Centre Culturel André Malraux, Nancy, France, 5 February; 102 Rue d'Alembert, Grenoble, France, 6 February; and Musée d'art contemporain, Lyon, France, 12 February

Marclay performing at St. Marks Church, New York, 1983

1998

"Cinema: Three Deejays and Fifteen Flutes," Kölner Philharmonie, Cologne, Germany, 11 November

Music by Takehisa Kosugi, Marclay, and Jim O'Rourke for Merce Cunningham Dance Company. "Great Dance in the Bandshell," Lincoln Center, New York, 7 August; "Event for the Garden," Walker Art Center Sculpture Garden, Minneapolis, 12 September

With Shelley Hirsch. Akademie der Künste, Berlin, 29 August

With Hans-Peter Litscher, presenting the music of Sarah Mandelblut. "Do Chinese Postmen Ring Twice Too?," Semperdepot/Kunsthalle, Vienna, 25 May

With Otomo Yoshihide. Tom Cora Memorial Concert, "Festival International des Musiques Nouvelles," Vandoeuvre, France, 23 May

djTRIO. Fri-Art, Fribourg, Switzerland, 15 May

djTRIO (with Toshio Kajiwara and Otomo Yoshihide). "Sergey Kuryokhin International Festival," The Cooler, New York, 8 May

With Christian Wolff. The Knitting Factory, New York, 7 April

Music by Marclay, Yasunao Tone, and Christian Wolff for Merce Cunningham Dance Company. Flynn Theater for the Performing Arts, Burlington, Vermont, 29 January

1997

With Elliott Sharp. The Knitting Factory, New York, 3 December

djTRIO. Performance on 42nd, Whitney Museum of American Art at Philip Morris, New York, 20 November

"Wirbel," Semperdepot, Vienna, 7 November

"Christian Marclay Project," FabrikJazz, Kunsthaus Zurich, 26 October

"Hissing Records," Pfeifen im Walde Internationale Musikfestwochen, Lucerne, Switzerland, 30 August

"Tourbillon," Kunsthaus, Aarau, Switzerland, 24 August

"Music in the Anchorage," Brooklyn, New York, 5 June

With Shelley Hirsch. Marstall, Munich, Germany, 26–27 April

djTRIO. Virginia Museum of Fine Arts, Richmond, 22 March

Marclay performing at The Kitchen,
New York, 1985

1996

djTRIO. Roulette, New York, 7 November

With Chris Cutler. "Jazz Kartell,"
Sauschdall, Ulm, Germany, 29
September

Swiss Mix, Festival du Belluard, Fribourg,
Switzerland, 28 June

Les Sortilèges: Im Bann des Zaubers,
Marstall Theater, Munich, 26–30 April

"Salon," The Clocktower, P.S.1
Contemporary Art Center, New York,
12 March

1995

With Chris Cutler and Peter Hollinger.
"Music Unlimited Festival," Wels,
Austria, 12 November

"La guerre des platines," La Friche,
Marseille, 20 June

The Cooler, New York, 10 February

1994

With Günter Müller. The Swiss Institute,
New York, 10 December

"Before and After Ambient," The
Kitchen, New York, 4–5 November

"Allen Ginsberg: Holy Soul Jelly Roll,"
The Poetry Project, St. Mark's Church,
New York, 26 October

1993

With Butch Morris. *Conduction #39 & #40*,
Thread Waxing Space, New York,
11–12 November

"The Stockholm Electronic Music
Festival XV," Lido, Stockholm, 25
September

Berlin Mix, Strassenbahndepot, Berlin,
24 July

With Günter Müller. "Art Basel 24,"
Basel, Switzerland, 18 June

With Steve Beresford and Günter Müller.
"Doubletake," Kunsthalle, Vienna,
7 January

1992

With Günter Müller. "Nouvelles Scènes
92," Dijon, France, 17 October

With Third Person, Tom Cora, Samm
Bennett, and Ned Rothenberg. The
Knitting Factory, New York, 21 July

With Alder Buebe. *The Sound of Money*,
"Visionaire Schweiz," Centro de Arte
Reina Sofía, Madrid, 10 March; and
Städische Kunsthalle, Düsseldorf,
25 June

With J. A. Deane, Butch Morris, and
Günter Müller. *Cardinal Points*,
Raiffeinsenhalle, Frankfurt, 22 June

*Gloves and Mitts: Butch Morris Conduction
#21*, Documenta 9, Kassel, Germany,
14 June

With Günter Müller. Teatro Pradillo,
Madrid, 12 March

With Nicolas Collins. Fri-Art, Fribourg,
Switzerland, 7 March

Mary Had a Little Lamb, "Doubletake,"
Purcell Room/Hayward Gallery,
Southbank Centre, London, 28 February

1991

"Burp: Soup and Tart Revisited,"
The Kitchen, New York, 24 October

With Alder Buebe. *The Sound of Money*,
"Extra Muros: Art Suisse
Contemporaine," Musée Cantonal
des Beaux-Arts, Lausanne, 13 June

With Andres Bosshard et. al. Telefonia,
New York Hall of Science, Queens,
New York, 31 May–1 June

With Nicolas Collins, Jazzy Joyce, and
Perry Hoberman. *One Hundred Turntables*,
Tokyo P/N, Japan, 24–25 May

Collaboration with Kronos Quartet.
Hancher Auditorium, Iowa Center for
the Arts, University of Iowa, 26 January

1990

With Anthony Braxton and Ron Kuivila. "Experimental Music," Wesleyan University, Middletown, Connecticut, 9 November

With Martin Tétreault. "Broken Music," Musée d'Art Contemporain, Montreal, 4 November

"Recycled Records," The Knitting Factory, New York, 29 May

Collaboration with S.E.M. Ensemble. Paula Cooper Gallery, New York, 3 April

1989

With Perry Hoberman. *No Salesman Will Call*, The Kitchen, New York, 19–22 October; "Steirisches Herbstfestival," Graz, Austria, 30 October; "Musique Action 90," Vandoeuvre, France, 22 May 1990; Theatre de La Criée, Marseilles, 17 May 1990

With Haruna Miyake and Tenko. Romanisches Café, Tokyo, 19 November

"Kafka Prozess: John Zorn," Tokyo Yuraku-cho Asahi Hall, Tokyo, 18–23 November

With Butch Morris and Günter Müller. *Chemin de Croix*, L'église des Jésuites, Sion, Switzerland, 29 June

"Christian Marclay: Improvised Duos" with Samm Bennett, Nicolas Collins, Zeena Parkins, and Elliott Sharp. The Knitting Factory, New York, 30 April

The Center for Contemporary Arts, Santa Fe, 6 May

1988

Württembergischer Kunstverein, Stuttgart, 16 August

Institut Unzeit, Freunde Güter Musik, Berlin, 14 August

"Bang on a Can Festival," New York, 8 May

1987

"Captured Music," "Wintermusik '87," Karlsruhe, Germany, 26 February

"October Meeting," Bimhuis, Amsterdam, 16–24 October

With David Moss, Wayne Horvitz, and Jon Rose. "Dense Band Tour," Nijmegen, The Netherlands, 11 May; Lindau, Germany, 13 May; Ulm, Germany, 14 May; Basel, 15 May; Bern, 16 May; Linz, Austria, 17 May; Budapest, 19 May; Vienna, 20 May; "Music Action Festival," Vandoeuvre, France, 22–23 May; "Festival Ljubljana," Ljubljana, Slovenia, 27 May; Hamburg, 28 May; Rotterdam, 29 May; Amsterdam, 30 May

Centre Culturel Suisse, Paris, 9 April

With Nicolas Collins and Elliott Sharp. "Jazz Now Bern," 28 February

1986

Japan Tour with David Moss. Crocodile, Tokyo, 5 November; Studio Denega, Hirosaki, 7 November; The Loft, Hakodate, 8 November; "Festival of Now Music," Otani-Kaikan, Sapporo, 9 November; Monbetsu, 10 November; Studio 200, Tokyo, 12 November; Fukuoka, 15 November; Hiroshima, 16 November; Tokushima, 18 November; Yokohama, 20 November; Tokyo, 21 November; Shizuoka, 22 November; City 8, Hamamatsu, 23 November; and "Actual Music Festival," Nikkatsu Studio, Tokyo, 24 November

"Bollwerk Festival," Fribourg, Switzerland, 28 June

Centre d'art contemporain, Ancien Palais des Expositions, Geneva, 10 June

"Ooyevaer Muziek Festival," Gemeentemuseum, The Hague, 3 June

Pyramid Arts Center, Rochester, New York, 11 April

Dead Stories, The Performing Garage, New York, 21–23 March; Walker Art Center, Minneapolis, 5 April

Performance view, *Les Sortilèges: Im Bann des Zaubers*, Marstall Theater, Munich, 1996

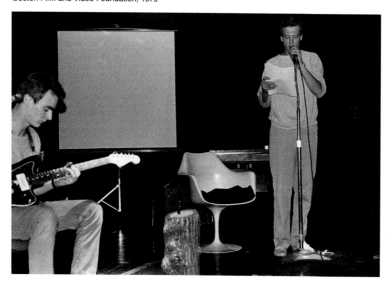

1985

"Jazz Now Bern," Schweizerbund, Bern, 20 December

"Record Player," Het Apollohuis, Eindhoven, The Netherlands, 15 December; Diogenes, Goem Galerie, Nijmegen, The Netherlands, 16 December; Grand Theatre, Groningen, The Netherlands, 17 December

"Stephanie & Irving Stone Festival," Roulette, New York, 8–10 November

"New Music America Festival," Los Angeles, 5 November

8 B.C., New York, 11 September

Tower of Babel, Rote Fabrik, Zurich, 28 May; "Moers Festival," Moers, German 7 May

With John Armleder and Christine Brodbeck. "Fri-Art Festival," La Mama Etc., New York, 1 May

Dead Stories, 8 B.C., New York, May

Ghosts, The Kitchen, New York, 9–10 March

"Current Trends in Racism in Modern America: Butch Morris," The Kitchen, New York, 1 February

"Artists Make Noise," Spit, Boston, 9 January

1984

With David Moss. Centre d'art contemporain, Geneva, 24 November

Roulette, New York, 27 October

With David Moss, Arto Lindsay, and John Zorn. "New York Objects and Noise," Walker Art Center, Minneapolis, 20 October

"John Zorn: Cobra," Roulette, New York, 13 October; The Boston Shakespeare Company Theater, Boston, 20–24 February 1985

Maxwells, Hoboken, New Jersey, 14 September

With David Moss. 8 B.C., New York, 8 September

"Willisau Festival," Willisau, Switzerland, 31 August

"John Zorn: Rugby," "New Music America Festival," Hartford, Connecticut, 5 July

"New York Noise Projekt," "Moers Music Festival," Moers, Germany, 10 June

"John Zorn: Cebastopole," Roulette, New York, 27 April

With Craig Burk. "Festival of Voices," Studio P.A.S.S., New York, 26–28 April

Hallwalls, Buffalo, 14 April

"John Zorn's Darts," Taller Latino Americano, New York, 7 April

With Roberta Baum, Arto Lindsay, David Moss, and Susie Timmons. *Dead Stories*, The Plug Club, New York, 23–24 March

1983

"Houdini Jazz Festival," Im Kino Theater, Zurich, 15 December

"New Music America Festival," Washington, D.C., 8 October

With Tom Cora. The Pyramid Club, New York, 22 September

With Ikue Mori. Folk City, New York, 24 August

With Elliott Sharp. The Saint, New York, 22 July

With Michael Lytle, George Cartwright, and David Moss. Experimental Intermedia Foundation, New York, 24 June

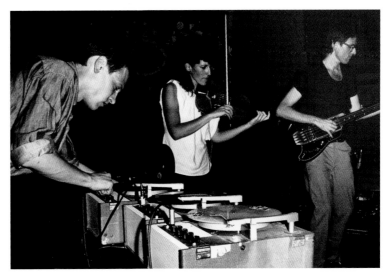

Mon Ton Son performing at CBGB,
New York, 1982

P.S.1, Institute for Art and Urban
Resources, Long Island City, New York,
5 June

With David Moss. Studio P.A.S.S., New
York, 20 May

Five Car Pile Up: Yoshiko Chuma &
The School of Hard Knocks (music by
Marclay). Danspace, New York, Project
at St. Mark's Church, New York,
14–17 April; "Dance Umbrella Festival,"
Riverside Studios, London, 15–18
November 1984

Mon Ton Son with Kinematic (Tamar
Kotoske and Mary Richter). The Bowery
Project, New York, 8–9 March

Mon Ton Son. Danceteria, New York,
2 March

Mon Ton Son. Mudd Club, New York,
8 February

Mon Ton Son. "Music for Dozens,"
Folk City, New York, 5 January

1982
"His Master's Voice: The Art of Record
Players," The Kitchen, New York, 24–25
November

John Zorn, *Track & Field*, The Public
Theater, New York, 5 November; Dance
Gallery, New York, 11 March 1983

Performance view of *Record Players*,
The Kitchen, New York, 1982

With Yoshiko Chuma. *Guitar Crash*,
Armageddon, New York, 22 September;
Danceteria, New York, 23 September;
The Bowery Project, New York, 15–16
February 1983

Mon Ton Son. Tompkins Square Park,
New York, 11 July; CBGB's, New York,
18 July; Inroads, New York, 7 August;
Tramps, New York, 20 September;
Pyramid Club, New York, 17 November;
The Kitchen, New York, 28 December

Le Palladium, Geneva, 10 FebruaryWith
Christine Brodbeck. Austellung Raum
Kaserne, Basel, 30 January; Raum für
Aktuelle Schweizer Kunst, Lucerne,
5 February

Disc Composition, The Kitchen, New York,
16 January

1981
"Sunday Night at the Furnace," Franklin
Furnace, New York, 25 October

1980
The Bachelors, even. Club Foot, San
Francisco, (with Bruce Conner); Savoy
Tivoli, San Francisco, 10 July; Mabuhay
Gardens, San Francisco; Club Foot, San
Francisco, 28 June

The Bachelors, even. "Eventworks '80,"
Bradford Hotel, Boston, 12 April

1979
The Bachelors, even. "Red Alert," Boston
Film and Video Foundation, Boston,
30 November

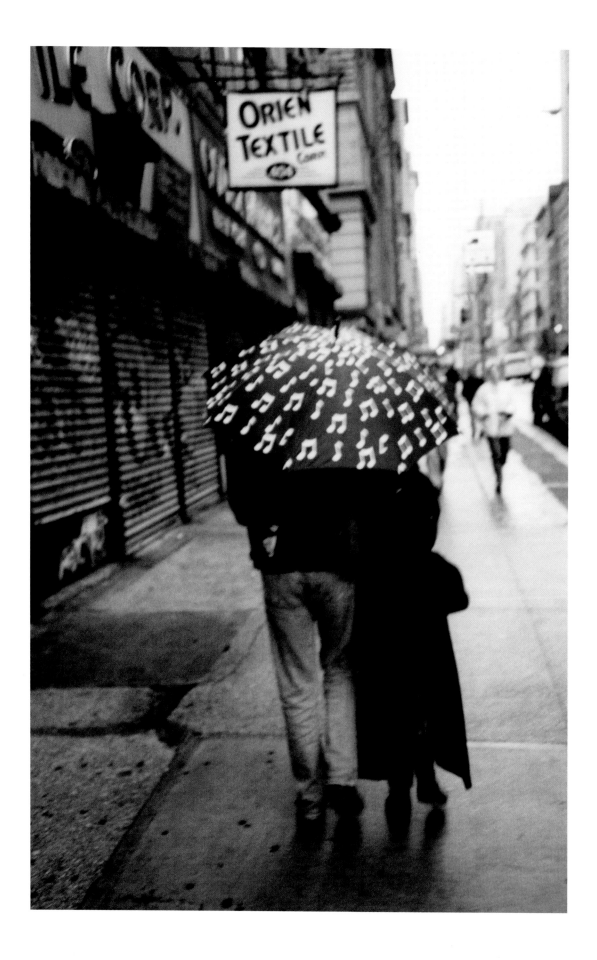

New York, 2002
Opposite: *New York*, 1998

195

Bavaria, 1996
Opposite: *Vienna*, 1998
Following Spread: *Los Angeles*, 1999

Contributors

Russell Ferguson is Deputy Director for Exhibitions and Progams, and Chief Curator, at the UCLA Hammer Museum, Los Angeles.

Douglas Kahn, Director of Technocultural Studies at University of California at Davis, is author of *Noise, Water, Meat: A History of Sound in the Arts* (MIT Press, 1999) and coeditor of *Wireless Imagination: Sound, Radio and the Avant-garde* (MIT Press, 1992).

Miwon Kwon is Assistant Professor in the Department of Art History at UCLA. She is a founding editor and publisher of *Documents*, a journal of art, culture, and criticism, and serves on the advisory board of *October* magazine. She is the author of *One Place after Another: Site-Specific Art and Locational Identity* (MIT Press, 2002).

Alan Licht is a musician who writes frequently for *The Wire* and other publications. His latest recording is "A New York Minute" (XI), and he is the author of *An Emotional Memoir of Martha Quinn* (Drag City, 2000).

Photo Credits

All photos courtesy the artist and Paula Cooper Gallery, New York unless otherwise indicated. P. 1-2 and 4, Rüdiger Lange; p. 14-17, Pierre-Antoine Grisoni and José Staub; p. 20, courtesy of Acconci Studio; p. 22, courtesy Margo Leavin Gallery, Los Angeles, photo: Douglas M. Parker Studio; p. 24-25, and 27 (top) Tom Warren; p. 29, courtesy Christopher Evans, ©2003 The Josef and Anni Albers Foundation / Artists Rights Society (ARS), New York; p. 32, bottom, courtesy of the Philadelphia Museum of Art, ©2003 Artists Rights Society (ARS), New York / ADAGP, Paris / Succession Marcel Duchamp; p. 38, Arno Garrels; p. 39, Adam Reich; p. 41 (top) courtesy of the Hirshhorn Museum and Sculpture Garden, photo: Lee Stalsworth; p. 41 (bottom) courtesy of the Philadelphia Museum of Art, ©2003 Artists Rights Society (ARS), New York / ADAGP, Paris / Succession Marcel Duchamp; p. 42, Tom Powel; p. 43, courtesy of the Gilbert and Lila Silverman Fluxus Collection, Detroit, photo from postcard; p. 44-47, John Berens; p. 49, Tom Warren; p. 50, Steven Gross; p. 51, courtesy of Canal Street Communications, photo: Bob Bielecki; p. 54-55, Arno Garrels; p. 61, Mimi Young; p. 63, courtesy of Manfred Montwé; ©Manfred Montwé; p. 64-66, Reto Klink; p. 67, Uwe Seyl, Stuttgart; p. 68-69, George Hirose; p. 70, Dominik; p. 71, (top) Tom Powel, p. 71 (bottom), photo courtesy of Oldenburg Van Bruggen Studio; p. 75, Courtesy Margo Leavin, Los Angeles, photo: Douglas M. Parker studio; p. 78, ©2003 Artists Rights Society (ARS), New York / ADAGP, Paris / Succession Marcel Duchamp; p. 82-87, photos courtesy of the San Francisco Museum of Modern Art; photos: Ben Blackwell; p. 89, Catherine Ceresole; p. 90, courtesy of the Gilbert and Lila Silverman Fluxus Collection, Detroit, photo: George Maciunas; p. 91, Siri Howard, p. 96, Stephen Gross; p. 98, bottom, photos courtesy of Bruce Conner and Canyon Cinema, San Francisco; p. 99, Werner Graf, p. 100 courtesy of ArtPace, A Foundation for Contemporary Art, San Antonio, Texas; photo: Ethel Shipton; p. 101, Phil in Phlash; p. 114, Tom Powel; p. 115-117, courtesy of ArtPace, A Foundation for Contemporary Art, San Antonio, Texas; photo: Ansen Seale; p. 118-119, courtesy of Paula Cooper Gallery, photo: Tom Powel; p. 121, courtesy of the Contemporary Museum, Baltimore; p. 123 (bottom), courtesy of Ubu Gallery, New York; photo: Ali Elai, Cameraarts, Inc.; p. 128-133, Anno Dittmer, D+Q, Stefan Doblinger/Paparazzi; p. 148, Ondrej Polák; p. 150-151, Foto Wimmer, Buchkirchen; p. 153, Uwe Seyl, Stuttgart; p. 154, courtesy of Paule Anglim Gallery, San Francisco; photo: Joe Schopplein; p. 156-157, Arno Garrels; p. 158, courtesy of Paula Cooper Gallery, New York; photo: Tom Powel; p. 162-165, John Berens; p. 188, Jean-Claude Ducret; p. 190, Lona Foote; p. 191, Erika Fernschild; p.193 (top), Jennifer Kotter; (bottom), Paula Court; Inside back cover, Hope Sandrow.